Centerville Library
Washington-Centerville Public Library
Centerville, Ohio
DISCARD

WORKING WITH CLAY

An Introduction

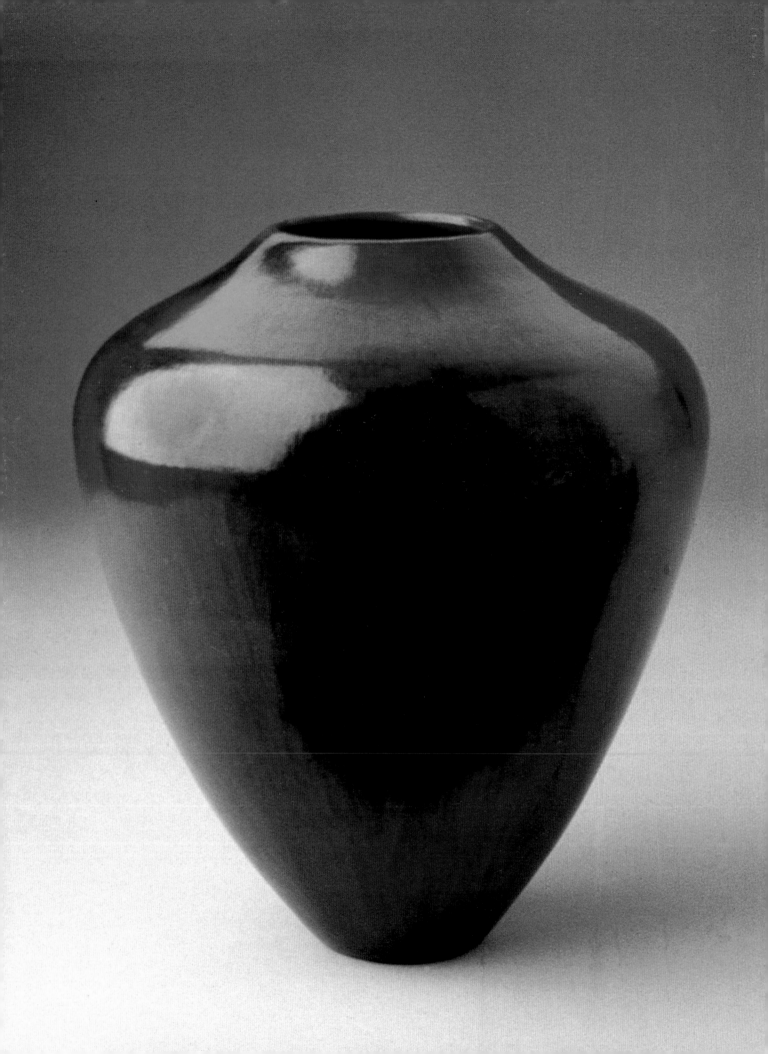

WORKING WITH CLAY

An Introduction

Susan Peterson

Professor Emerita, Hunter College at the City University of New York

THE OVERLOOK PRESS
WOODSTOCK • NEW YORK

Published 1998 by The Overlook Press
Woodstock, New York

Copyright © 1998 Calmann & King Ltd

All rights reserved. No part of this publication may be reproduced or transmitted in any form or by any means, electronic or mechanical, including photocopy, recording or any information storage and retrieval system, without permission in writing from the publisher.

Library of Congress Cataloging-in-Publication Data

Peterson, Susan (Susan Harnly)
 Working with clay: an introduction/Susan Peterson.
 p. cm.
 ISBN 0-87951-903-7
 1. Pottery craft. I. Title.
TT920.P42 1998 738
738—dc21 Pete 98-15477
 CIP

This book was designed and produced by
Calmann and King Ltd
71 Great Russell Street
London WC1B 3BN

Project manager Elisabeth Ingles
Designed by Karen Stafford
Typeset by Fakenham Photosetting Ltd, Norfolk
Printed in Italy

FRONT COVER (*main picture*) A clay pot in the wet state by Susan Peterson;
(*insets, top to bottom*) Aztec bottle by Michael Frimkess; Hakami pot by Warren MacKenzie;
detail of Helen Slater's wall piece; porcelain vessel by Fritz Rossmann

BACK COVER (*top, left to right*) Traditional coiled pot; black pot by Maria Martinez, 1935;
(*below, left to right*) carved celadon lidded jar by Elaine Coleman; raku-fired vessel by Kevin Nierman

FRONTISPIECE Hand-built coiled pot, burnished, bonfired, and coated with piñon pitch, by Alice Cling, Navaho potter

TITLE-PAGE Detail of Jun Kaneko's stoneware plate showing his technique of "striking", a process of reducing the kiln
atmosphere on the cooling cycle of the firing at 1300°F to produce the copper red line

CONTENTS PAGE 5: *left* Village potter, India;
center top Floor vase by Susan Peterson;
center below Lucy Lewis' fine-line pot;
right above Kirk Mangus, "Dead Soldier";
bottom right Detail of wall by Robert Sperry

CONTENTS PAGE 6: *top left* Ernst Häusermann's pyramid sculpture;
bottom left Robert Brady's 5 ft tall coil sculpture;
center Bruria Finkel, "Introspection";
right Delft plate, Holland, c.1500

CONTENTS

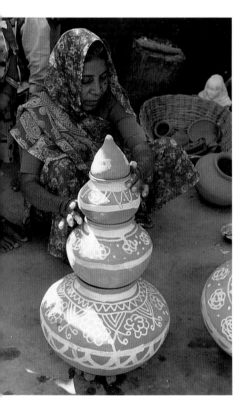

CONTENTS

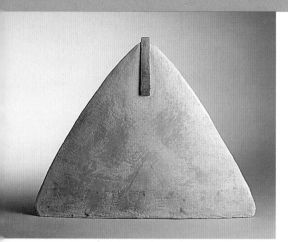

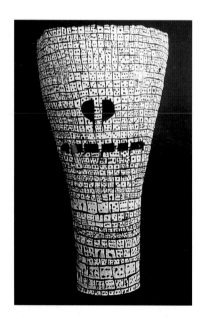

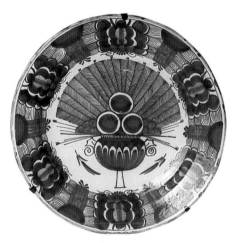

PREFACE

I have written this book to inspire and to teach the beginner about working with clay through colorful photographs and anecdotal descriptions of the various processes involved. I also aim to appeal to the collector, who can make use of this analysis to gain an indepth perspective on historical and contemporary ceramics. The practical photographs are set off by copious illustrations of what can be achieved, from everyday items such as plates and bowls to international examples of the potter's art such as sculpture and site installations. Beginner students and all those who appreciate the art of ceramics will find many illuminating insights into this endlessly fascinating world.

My long career as a professor of ceramic art and a practicing potter has enabled me to pass on the benefits of my experience to students and aficionados at all levels. I have five books in print, apart from this one: *Shoji Hamada, A Potter's Way and Work*; *The Living Tradition of Maria Martinez*; *Lucy M. Lewis, American Indian Potter*; *The Craft and Art of Clay*; *Pottery by American Indian Women.* I have a video in circulation from film made at Hamada's studio in 1970 when I did the notes for his book, and a series of 54 videos on ceramics, called "Wheels, Kilns, and Clay." Thanks are due to the many artists all over the world who have helped me with suggestions and by sending me their own examples. I am grateful to Laurence King, Lee Ripley Greenfield, Judy Rasmussen, Janet Pilch, and the staff at Calmann & King in London who package the book; to Elisabeth Ingles, my editor, and Karen Stafford, who designed the book; to Craig Smith, who photographed the process shots of me working in my studio, to Bud Therien at Prentice Hall, and to Overlook/Viking. I also acknowledge the help and encouragement of my three children, Jill Peterson Hoddick, Jan Sigrid Peterson, and Taäg Paul Peterson, plus five grandchildren, Annah Gerletti, Kayley Hoddick, Alexander and Calder Peterson, and Augustus John Gerletti. I would not have got so much done without assistants Nori Pao, Judith Schreibman, and Tony Mulanix.

Finally, a fond remembrance and deep gratitude to my deceased parents, Iva and Paul Harnly, and my late husband Robert Schwarz Jr.

SUSAN HARNLY PETERSON
Carefree, Arizona, June 1998

THE SAFETY ASPECT

It is important to be aware that there are potential hazards involved in creating ceramics. Common sense is essential.

▲ *This symbol is used in the Table of Contents to indicate potential hazards in the processes described.*

1. If you have allergies or respiratory problems, wear a mask when handling or working in the same room as powdered materials and clay dust, and while mixing glazes or spraying. Have a respiratory check every few years if you work in ceramics regularly.
2. Wear surgical gloves if you have skin troubles.
3. Keep all working areas well ventilated, preferably by opening windows. Gas or oil-fired kilns are best set up out of doors.
4. Never light a closed kiln, only a partially open one.
5. Do not use electric tools or switch on electric kilns with wet hands, or if the tools are damp for any reason.
6. Some glaze formulas are highly toxic. Take great care with glazes that have cadmium, chrome, barium, and lithium in the formula; treat lead-based glazes with extreme caution or, better still, substitute non-lead formulas. Do not brush face or handle food until you have thoroughly removed all trace of glaze from your hands, and do not bring food or drink into the studio. Dispose of toxic mixtures sensibly; do not pour them down the drain where they will contaminate water supply (this is illegal anyway).
7. Remember that toxic fumes may be given off during firing; excessive reduction in a kiln produces the deadly gas carbon monoxide, and requires good ventilation.
8. Take basic precautions around all machinery; watch for sharp edges; keep hair, long sleeves, and so on, tied back.

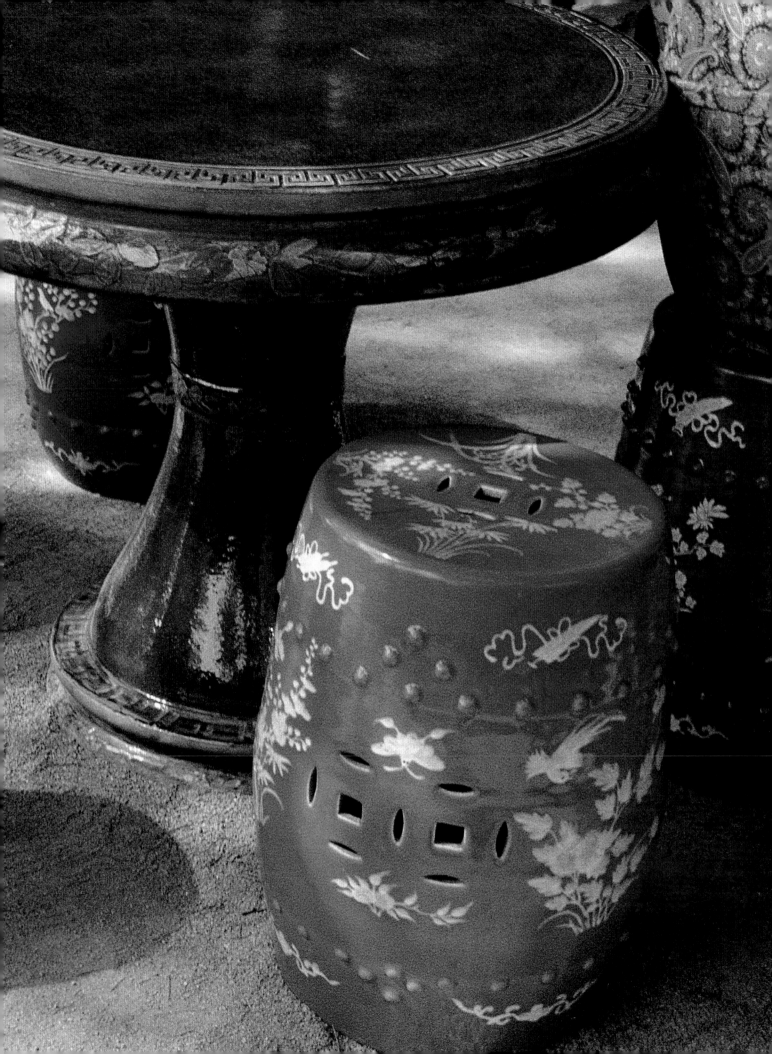

1
THE WORLD OF
CERAMICS

CLAY AND POTTERY

The art of the potter dates from the beginning of humankind. From earliest times people knew that a certain kind of "mud" could be molded into any shape and would retain that shape on drying. Some time later in pre-history the potter understood that fire would harden the clay shape so that it was no longer fragile and would hold liquid. For 30,000 years or more, the working properties of clay and fire, and the necessary processes and tools, have been directed toward specific functional needs such as pots and water pipes in most traditional societies of the world.

Today these age-old concepts and methods are still valid. The artist-craftsperson or anyone who explores clay-work uses the same materials and techniques as our long-ago ancestors. To work in ceramics is to know the whole world and to learn about all times and cultures.

In recent years scientists have discovered new elements to be added to the atomic table, and have reexamined old ones.

FACING PAGE Ching dynasty stools, Suchow, China

RIGHT Clay can do many things, including make musical instruments that really play: Brian Ransom's ceramic flugelhorn, earthenware, mixed media

The new knowledge has expanded our understanding of what constitutes ceramic products. In addition to the familiar brick and flowerpot of low-fire ceramics, called "earthenware," the utilitarian jugs and heavy clay products produced in "stoneware," and the fine, dense, sometimes translucent clay body termed "porcelain," many new products exist today of even higher-fired ceramics made of non-clay refractory materials.

The space age is the ceramic age. Computer chips, airplane parts, machine components, submarines, and space vehicles are routinely made of high-temperature ceramics. We live in the age of ceramics, no longer in the age of metals. Ceramic materials are the materials with the highest melting point known on the face of the earth.

The potter works in a temperature range of 1300° to 2500° F (700° to 1370° C), and space scientists, with their esoteric ceramic materials, probably (it's classified information) use several thousand degrees of temperature higher. Here we are concerned only with the potter's range.

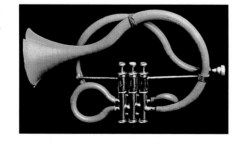

Geological types of natural clays and the temperatures to which they are fired in kilns are the two determining factors that produce the common coarse brick or the delicate piece of porcelain. A brick will never be a piece of porcelain because the type of clay is different, and usually the firing temperature is different too.

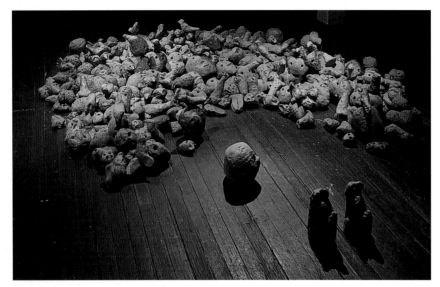

Kirk Mangus, earthenware heads, 10 ft x 12 ft installation

Nino Caruso, "Dionysos Arch with Bacchante," stoneware installation, Italy

Kripal Singh, porcelain plates with overglaze enamel painting, Jaipur, India

As any kind of pure clay dries, it shrinks and becomes hard. Clay has no real strength until fired in "red heat" (1300° F or 700° C) or above. In the firing process the clay mass fuses into a compact structure, with the glaze and decoration forever fired in, making a product of strength and durability that will never change. Because of this fact, a piece of ancient pottery appears today as fresh as when it first came from the fire.

THE AESTHETIC OF CONTEMPORARY CLAYWORK

At the beginning of the twentieth century ceramic products were much used in daily life, but objects of clay were now taking a more important place in our aesthetic lives. Ceramic vessels, bricks, mosaics, and even huts had been part of the human environment

for thousands of years. The Chinese developed a porcelain clay body and glazes about 3,000 years ago; the Egyptians probably made the first potter's wheels about 5,000 years ago, and developed glass too; then came a long period during which most of the world used the low-fire rust-colored clays common everywhere for utilitarian wares, while the Asian countries used their white clays.

Marco Polo carried Oriental porcelains to Europe in the thirteenth century, which prompted Europeans to look for white clays and to try for the density and translucency they saw in the porcelain wares with cobalt blue brush decorations.

The Persians prospected cobalt and began to paint blue decorations on low-fire white clays; the Dutch and later the English took over this technique and transformed it into Delft ware. The Persians also developed luster glazes, and the Italians found that metallic oxides could be painted on top of white glazes to give fused lines or crisp drawings, a technique called majolica.

Bernard Palissy in the 1560s in France experimented, and J. F. Böttger in Meissen, Germany, succeeded in making porcelain about 1710. In 1760 Josiah Wedgwood discovered how to make a porcelain clay body from English china clay and bone ash, and to fire it to high density. These discoveries yielded varied aesthetic results according to what each country believed was important in ceramic design.

After the furious pace of mass-production resulting from the industrial revolution that was completed by the 1850s, history witnessed a period of revolt against everything looking alike. William Morris, in England, was one of the first to call for a return

of the individual craftsperson and craft techniques. In the 1860s he reestablished the "workshops" and "guilds" we had seen in Renaissance times, and craftspeople began to collaborate. In 1925 a large German workshop, the Bauhaus, inspired a revolutionary new trend in design that is still influential today; the school at Weimar laid emphasis on ceramic art among other art forms.

Before and after World War II, various countries began to investigate new ideas and to become known for their own design criteria. Scandinavian design, especially that of Sweden, promoted bright colors and simplicity of form; the ritual of the tea-ceremony emphasized the role of clay in Japanese culture; folk art, particularly ceramics, in such countries as Mexico and other parts of Central and South America, Morocco, Turkey and the like, exerted great influence on their other arts. Europe in general responded to the Bauhaus influence, while the trend in the United States

Nature is a design influence:

1. Waterlilies in Saigon

2. Golden Barrel cactus, California

3. Detail of Arizona cactus

1

was toward Abstract Expressionism in painting and in craft. All these trends continue today.

Early American ceramics came with the European settlers after 1620. From that point up to the 1800s ceramics began to be made in small potteries on the eastern seaboard: slipware, salt glaze, Delft, peasant redwares, luster, some with an aristocratic aesthetic.

2

3

Ceramic chemistry in the New World embraced the three types of wares already current across the Atlantic ocean – earthenware, stoneware, and porcelain.

The western coast of the United States was influenced by Spanish and Mexican earthenwares, and by the porcelains brought by early Chinese settlers. The USA became a melting pot of world clay styles and cultures, until in the early 1950s a change occurred, causing a revolution in ceramic art that still goes on.

In California, about 1953, a young Pied Piper named Peter Voulkos began to handle enormous chunks of clay in a radical manner on a potter's wheel and to alter the shapes created on the wheel by cutting them, slashing them, beating them, and combining them into large sculptural forms. Better electric wheels, able to hold hundreds of pounds of clay, were built, and fast-firing updraft kilns six or more feet tall were developed to fire the huge hollow ceramic sculptures and vessels that other artists were also tackling.

1

Surfaces reflecting the design ideas of nature:

1. Detail of weave from a clay basket by Rina Peleg

2. Detail of stain drawing with hypodermic needle over a coiled, glazed surface by Bruno Lavadiere

3. Unglazed colored paperthin porcelain layers, detail of a sculpture by Marylyn Dintenfass

2

3

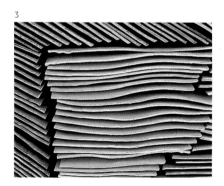

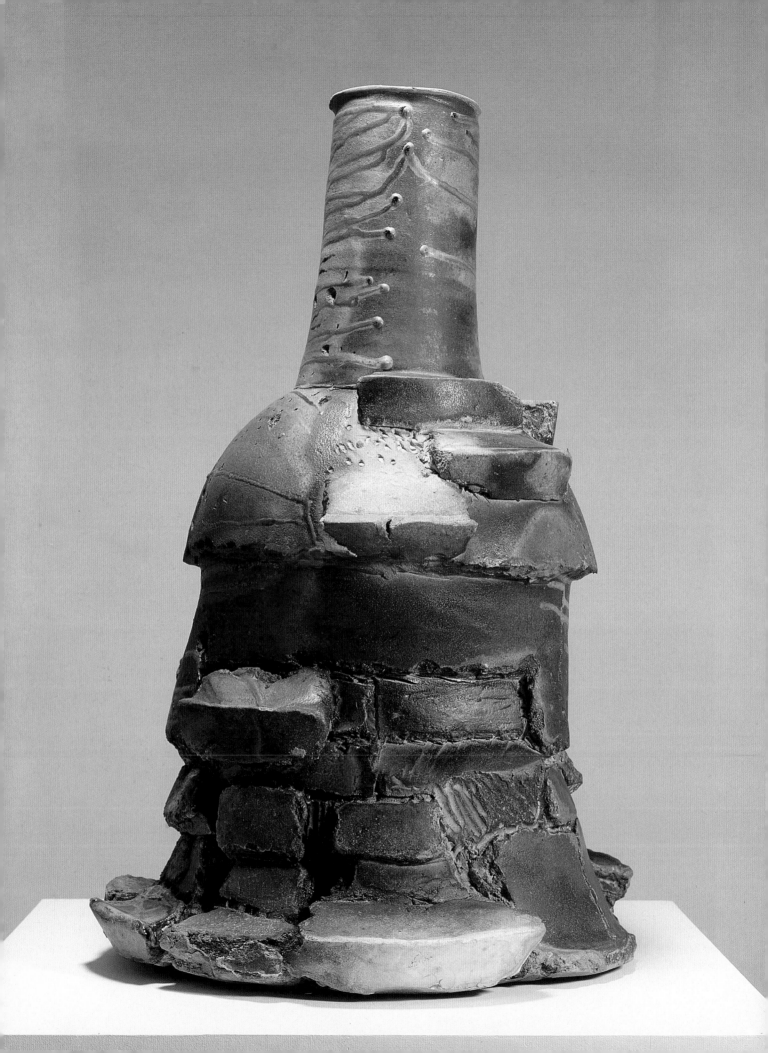

LEFT Ken Price's recent ceramic sculpture bears the illusion of glaze, about which this artist knows a great deal, but the surface is in fact a meticulous rendering of various acrylic paints on fired clay

RIGHT John Mason's vertical sculpture, 59 inches high, is a brilliant example of slab-building technique, astonishingly engineered to stand upright at 2300° F

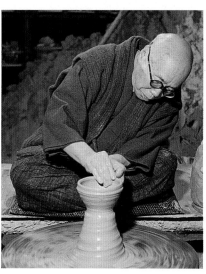

LEFT Shoji Hamada, the famous potter and ceramic National Treasure of Japan (d.1978), at his Chinese chestnut hand-powered wheel, throwing a tea ceremony bowl in his studio at Mashiko, c. 1970

FACING PAGE Peter Voulkos's thrown and altered wood-fired stoneware "stack", 45 inches high; a magnificent piece that illustrates how influential this artist has been in the ceramic world

LEFT Bernard Leach (1887–1979), the so-called father of "studio pottery", worked in stoneware and porcelain at his well-known pottery in St Ives, Cornwall, from 1920 to his death; this stoneware pot with engobe and sgraffito design dates from 1950. He wrote an early handbook for potters, which remains hugely influential

Remember

- Creative expression is an individual need; it is not a specialty reserved for the "fine artist."
- Clayworkers direct their materials, their processes, and their techniques into an expression of their personalities.
- There is no definite line between craft and art, they are both of a piece.
- A "pot" is not necessarily a container, nor any longer needs to be thought only functional.
- Today ceramic art is a characterization of our time, continuing to be an energizing and captivating challenge to clayworkers as one of our most important methods of self-expression.

A group formed around Peter, each experimenting individually, that included myself (I came to Southern California in 1950 and was already teaching at Chouinard Art Institute when he came to teach at the nearby Los Angeles County Art Institute), Paul Soldner, Jerry Rothman, Henry Takemoto, Mac Maclain, Michael Frimkess – Pete's students – and John Mason and Ken Price, my students, among others.

About the same time I brought Bernard Leach, who had written the formative *A Potter's Book* in 1943, his old friends Shoji Hamada, the foremost potter of Japan, and Soetsu Yanagi, the scholar of Zen Buddhist aesthetics, to Chouinard for several weeks of lectures and demonstrations before an invited audience of clayworkers. The work, writings, and philosophies of these three mentors spread across the world and, even after their deaths, are a powerful inspiration for potters today.

Of course there were other important clay artists in the world at the same time, but the force of the Voulkos personality, and the awesome work that was flowing out of the group in Southern California, provided the major factor in the rapid evolution of ceramics from a functional, utilitarian concept to an art form.

The world has become smaller, communication is easier, ceramic schools, workshops, suppliers, and museums proliferate across the globe. The transformation is spectacular. Ceramic art can vie for the same prices and clientele as painting or sculpture. Furthermore, working in clay is a fascinating experience for nearly everyone who comes in contact with it.

WHAT IS CLAY?

As long as we have a world, there will be clay. Clay is a mineral mined or dug from the earth, composed of alumina, silica, and hygroscopic water. Its chemical formula is $Al_2O_3–2SiO_2–6H_2O$. Clay is continuously being formed from igneous rock – granite, which itself was formed through a process of fire. The great granite mountains of the world decompose, so to speak, through physical processes, such as rain, wind, earthquake, and glacial movement, and chemical processes, such as weathering from the acids and alkalis of the earth's atmosphere. How clay has been weathered and where it moves to determines its ultimate color and workability; the more impurities it has, the more plastic it is, while the fewer impurities, the less plasticity.

Geologically speaking, all native clays fall into five general categories.

1. The first clay that forms at the base of the mountain is virgin, with few impurities. It is the whitest-burning, most heat-resistant, least plastic, and rarest on the face of the globe, and

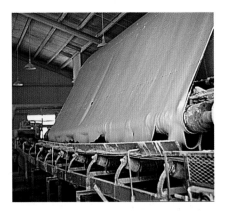

The commercial process of washing china clay (kaolin) removes all impurities

Yellow and beige fire-clay deposit being commercially mined

Slaking and screening natural clay in Kitagoya, Japan; after about three weeks in water the clay slurry is ladled into plaster tubs to dry to the plastic state

we call it "kaolin" or china clay. Clay that has not moved from the spot where it was formed is termed "primary" or "residual"; hence primary kaolin. When primary kaolin is carried away by whatever natural means, contamination occurs, the clay becomes more plastic from the movement, and the color on firing is somewhat off-white. Clays that have been moved are called "secondary" or "sedimentary." Secondary kaolins are not as rare, and are more workable than primary china clays. Both types of kaolin become hard, dense, and vitreous (glassy) by themselves when fired at temperatures of 3100°–3300° F (1740°–1785° C).

2. "Ball" clays, the next in purity and the most plastic of all clays, are always secondary clays and have always been moved by water. Because of their fine particle size, brought about by water movement and rock-grinding, these nearly white-burning clays have high shrinkage in drying and firing, and become dense at 2300°–2500° F (1260°–1370° C). Kaolins and ball clays are the usual components of porcelain.

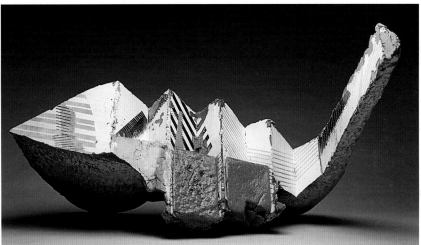

1

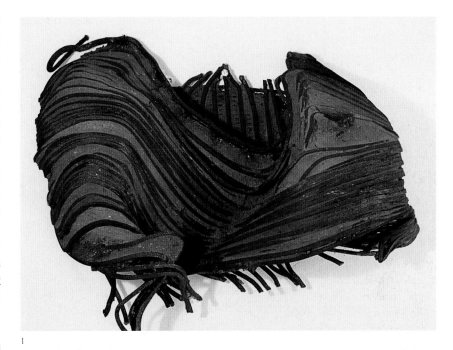

2

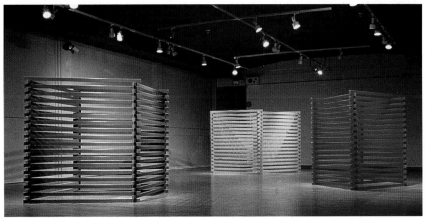

3

Many types of clay and combinations of clay with other materials are used to make ceramic art:

1. Joyce Kohl's sculpture of steel with fired adobe

2. Ron Fondaw's earthenware sculpture has additions of turquoise "Egyptian paste", which was developed over 3,000 years ago by the Egyptians (see Chapter 7)

3. Jun Kaneko's museum installation of 8ft by 2-inch slabs was constructed in a non-shrink clay body at the Otsuka factory, Shigaraki, Japan

3. "Fire clays," readily found in mountain and desert areas of the world, are the work-horses of ceramics. These clays have particle sizes of varying coarseness and flat or round platelets depending on their formation. In addition to the clay molecule, fire clays include extra uncombined silica. Beige, tan, gold, red, brown, are the colors that these clays fire; most become dense and vitreous around 2200°–2400° F (1205°–1260° C). Potters like these clays for their resilience, their strength, and their ability to stand tall. Industry uses fire clays for firebricks, flue linings, blast furnaces, and other heavy clay products.

4. A category of clay called "stoneware" is debated by geologists: is it really a separate kind of natural clay? So-called stoneware clays are very rare – in the USA we have Jordon (not mined now), Perrine, and Monmouth. A few other stoneware clays have been found in Europe, China, Japan, and India. Because stoneware clays are a cross between ball and fire clays with the properties of each, they are remarkably workable, firing dense, in off-white to brown colors, around 2200°–2300° F (1205°–1260° C).

5. The most common clays on the earth, under your feet everywhere, are rightfully termed "common surface" clays. Because they are rich with impurities, and have enjoyed millions of years of movement, they are very workable, and are generally the only clays that can constitute a "clay body" and be used entirely by themselves with no additions of flux or filler (see below). All indigenous societies use common surface clays, with little or no addition, to make functional vessels, effigy figures, bricks, and water pipes. The usual fired color is rusty red, but common surface clays can fire to any color depending on the metal-

lic oxides that have combined with them in the earth.

Clay, as opposed to dirt, when mixed with water will form a plastic mass that can be molded into any shape and will hold that shape. When left to dry, most clays will shrink in size as much as 10%. Further shrinkage takes place in the firing. When fired in a bonfire, approximately 1300° F (700° C), all natural clays become somewhat hard and durable, but probably will not hold liquid for longer than it takes to have a drink from a vessel.

WHAT IS A CLAY BODY?

Inert or active materials can be added to natural clays to alter the basic properties of the original clay. This combination of clay and other ingredients is called a "clay body," and is built according to the visual and structural needs of industry or artists.

1. To subdue the sticky quality of highly plastic natural clays, we add sand, dirt, ground-up fired clay particles (called grog or temper), or pure silica (SiO_2), as **filler**.

2. To change the firing temperature of a given natural clay or group of clays, we add **flux**. This can be feldspar, found all over the world, or bone ash, or ground glass, or combinations of other low-melting minerals such as soda ash.

3. The clay body composition should contain at least 50% clay plus added materials, in order to maintain plasticity; a better ratio is 70 to 80% clay plus added materials, for maximum workability. The 50% or more clay con-

Some clay bodies exist already composed by nature, like the famous Yi-Xing clay deposits in China and Taiwan, which are used particularly for teapots. Richard Notkin has made a similar clay by mixing 50% of two fine-grained cone 6 commercial white clay bodies with 30% red clay and 20% ball clay for casting or hand-building his teapots

tent can consist of one or several clays for different reasons.

A clay body consists of:
the plastic material – any clay or clays;
the flux – feldspar, glass or bone ash;
the filler – silica, sand, ground shards, or grog (also called chamotte).

Most clay artists know exactly what they want in a clay body. The artist sets up standards for a clay body to suit a particular kind of claywork: how pliable does it need to be? Must it stand up and hold weight? Is color important? What density or porosity is required for the finished product? The artist then makes up his or her own mix.

Clays of all five geological types are mined all over the world and can be purchased in bulk, or dry, ground to 200-mesh, easy to mix. Feldspars, ground glass, and other fluxes exist everywhere; everyone likewise has access to various fillers. Make up a clay composition, test it and revise it until you like it. Anywhere in the world you can buy these materials, or even prospect your own from the earth.

Alternatively, a ready-mixed clay body can be purchased from a ceramic supplier, ready to use in the plastic state in 25 lb/11 kg bags, or dry in larger quantity. In this case you need to specify the degree of workability, the fired color, and the temperature of firing, and hope the supplier can give you the correct composition, although the company will keep the ingredients secret.

A good clay body is paramount in doing good claywork. A bad clay body will present problems from start to finish. If you can grasp this, you will be miles ahead. However, some artists – especially traditional ones – have enjoyed the challenge of working with poor clay bodies. Shoji Hamada, one of this century's best-known and finest potters, said of the coarse, unreliable clay that was dug for him on a hillside near his studio in Mashiko, Japan: "It is better to make good pots out of a bad clay than to make bad pots out of a good clay."

An example of a generic clay body that will fire at any temperature is:

70% clay (any kind or combination)
20% feldspar (any kind)
10% silica or sand

At low fire this clay will be porous and at high fire it will be dense.

METHODS OF MIXING CLAY BODIES

Natural clays dug from the ground should be dried out and pounded into small bits, then screened to remove sand, leaves, and debris. Next, add water and test the clay for workability by making a small pinch-pot. If the clay is sticky, add filler. Fire the pot if you can, and if it is too porous or fragile at the temperature to which you fired it, add flux to the clay, make corrections, work it, and fire a new sample. Repeat until you have a good, usable clay body mixture.

Whether you use materials from nature or buy 200-mesh refined materials, if your clay body needs several ingredients you must:

1. Mix dry – thoroughly – by stirring, sifting, or rolling in a closed container. If you have a clay-mixing machine, all ingredients can be dumped in and mixed dry or wet.

2. Next, hand-mix wet: a) add water and make a very liquid mix, then dry it to the plastic state on plaster bats or any porous surface;

or b) make a 4-inch high mound of the dry clay body, preferably on a cloth surface, make a depression in the center, add water and mix water and clay body together by hand, kneading to the plastic stage – a large quantity of clay can be mixed this way on the floor with a rake;

or c) use a mechanical blunger for liquid clay;

or d) use a cement mixer, dough mixer, or commercial clay-mixing machine to mix large quantities of plastic clay body.

STORING THE CLAY

Clay dries when exposed to air, but will keep moist if it is stored airtight. Metal garbage cans used for clay storage should be galvanized and lined with several sheets of plastic. Plastic containers are satisfactory if lined with sheets of plastic and kept moist with damp towels. Other possible storage containers are wooden tubs, bath tubs, old sinks, or the like. If the clay does dry out, pound it into bits, remoisten, and keep it airtight a few days until it becomes plastic again.

WHAT IS GLAZE?

Glaze is a type of glass, which melts in a fire at a given temperature, but does not melt enough to run off the object it coats.

Unlike glass, which stands alone, glaze needs to be bonded to something like clay or metal.

Jane Ford Aebersold's flamboyant earthenware plaque is coated with colorful low-temperature glazes and china paints. Higher-temperature stoneware and porcelain glazes are more muted because the metallic oxides that provide the color begin to fire out at high temperature

Glaze is made of silica (the glass-forming oxide), plus other oxides that will cause the refractory silica to melt at lower temperatures. In glass the fluxes are generally soda or lead. In glaze the fluxes vary according to the temperature required to fire the clay.

Glaze contains one more component than does glass. It needs the addition of an oxide that will hold the molten glass on a surface. That oxide is alumina, which acts as a binder and a viscosity controller. Remember, clay contains alumina. It turns out that clay is one of the important constituents of a glaze, in addition to silica, which is the same oxide that is a filler in a clay body. Both clay and glaze therefore contain these two ingredients in different proportions.

Glaze can be matt (dull) or glossy; transparent (see-through) or opaque in varying degrees; rough or smooth; colored with metallic earth oxides or left uncolored. Glazes can be mixed

FACING PAGE White earthenware clay body vase with low-temperature glazes by Elisabeth van Krogh, Norway

Kripal Singh, the well-known porcelain potter of Jaipur, India, tending his updraft kiln

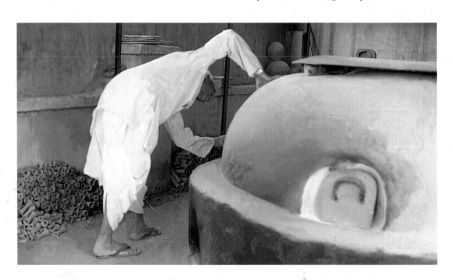

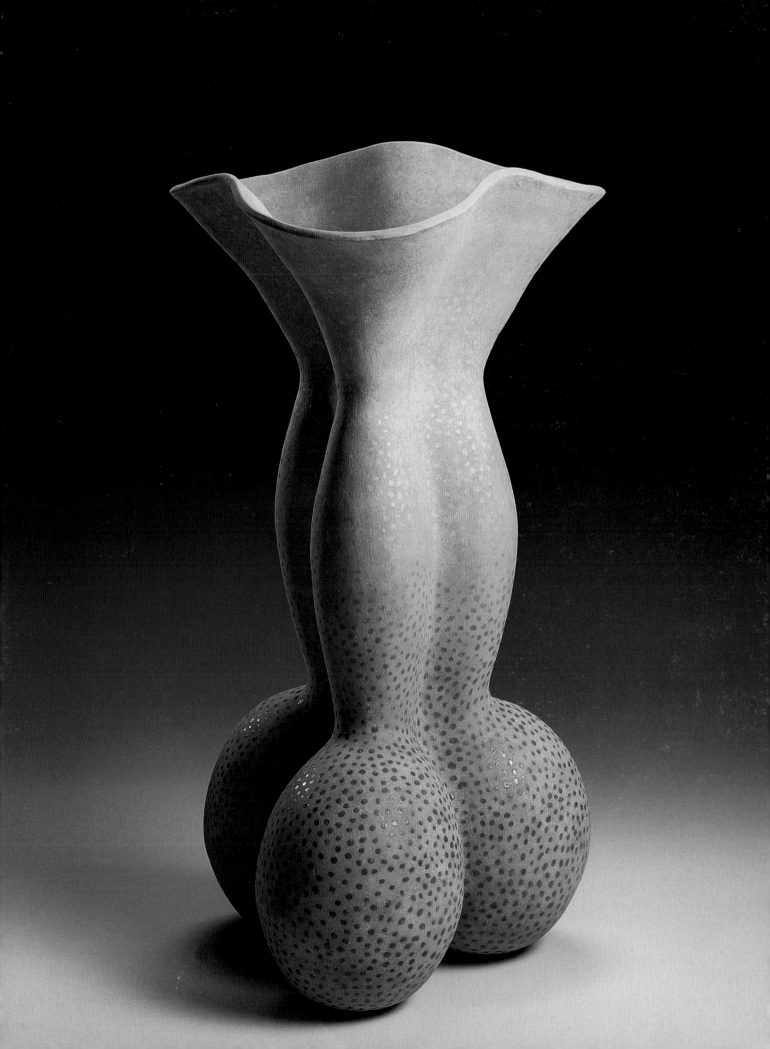

by you or commercially purchased ready-mixed.

Glaze provides:
• an easily cleaned, sanitary coating;
• a vehicle for decoration and color;
• acid and chemical resistance;
• durability.

Glazes can be "made up" from:
• an original molecular oxide formula;
• experimental tests of various raw materials in different percentage combinations;
• batch "recipes" found in ceramic books or magazines;
• original batches, altered according to experience or caprice.

FIRING CERAMICS

After humans first made pottery it was probably many years before they understood that mere sun-drying would not make the pieces durable. Of course, no one knows how the ancients discovered that clay needed the heat of a real fire to invoke the silicate chemistry that combines the ingredients of a clay body into a hard, dense, and, given enough heat, eventually vitreous substance.

Red heat, as we call it, will register about 1300° F (700° C) if the temperature of the flame is measured. At this temperature most clays will achieve a minimum durability, but the ware will be fragile and easily destroyed with use.

When potters learned to enclose the heat, they were able to achieve more hardness and permanence. For thousands of years people around the world struggled to find ways to heat-treat their ceramic works.

Potters found that different degrees of temperature would yield different clay colors; white-burning clays did not change, but colored clays stayed light at low fire and darkened as the temperature rose, or as the heat was better contained. As evidenced by what we see in museums, potters in some countries also learned to control the heat and atmosphere in order to achieve certain colored glazes or decorations.

Clay does not like thermal shock. Ancient potters learned to put ground-up shards of broken, fired pots, pulverized nutshells, grains, ground bones, or volcanic ash into the clay to make it more resistant to the sudden shock of the bonfire flame. When potters learned to use an enclosed chamber, now called a "kiln," they also worked out how to control the heat with flues and dampers, and experienced less breakage in firings.

In a kiln, clay can be fired slowly, especially in the initial stages, to expel the moisture that made it workable and the water that is combined chemically with the alumina and silica in the clay molecule. Generally a six- to eight-hour firing curve, consistently rising to top temperature, is sufficient for normal claywork; cooling must be slow also. Exceptionally large works require much slower firings, which can take several days or even weeks.

TYPES OF CERAMICS

As previously stated, the differences between the red brick and the white translucent porcelain cup are different clay and a different firing temperature. All clay products, ranging from bricks to porcelain cups, are the result of the same two variations.

Clay is clay (and a clay body composition acts as its principal component clay type acts) and heat is heat – more or less – but it is the variations between the two factors that cause the differences in the end products.

Earthenware

A fired claywork that is porous, relatively light in weight, easily chipped, and makes a clunking sound if tapped with your fingernail is called "earthenware." Most tribal societies such as Native American, African, Aboriginal, and other outback peoples use common surface clays because they are at hand, and fire them in low-temperature open fires to produce earthenware. So-called sophisticated societies make earthenware plant pots, inexpensive dinnerware, common red bricks, and similar items, because they want to.

The technical definition of earthenware is that it will have an absorption of 10 to 15% of its unglazed weight when boiled one hour in water. China/ball clay bodies fired low will be very porous; most earthenwares are made from common surface and fire clays.

Stoneware

A fired claywork that is quite hard, holds liquids, is not easily broken, and rings when tapped is called "stoneware." Stoneware developed in China over 2,000 years ago, and in Europe during the Middle Ages; the technique was brought to North America by the early settlers who arrived from Europe. For a clay body to become stoneware a higher firing temperature is needed than for earthenware, or more flux can be added to high-temperature clays to make them dense at low heat.

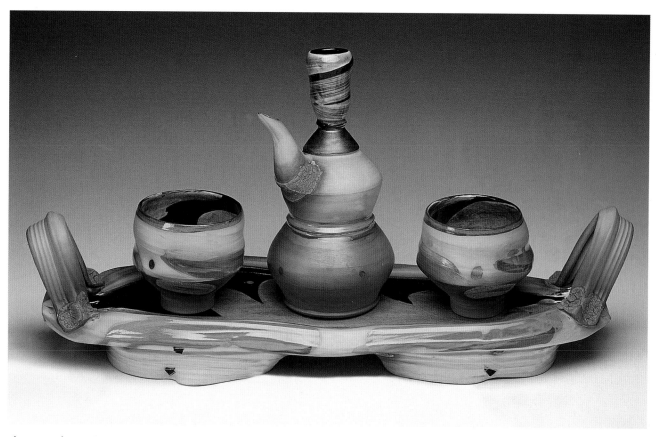

Thrown earthenware tray set, partly glazed with brush-strokes of commercial low-fire glazes, by Woody Hughes

Burnished earthenware, raku-fired bowl with stain decoration by Carol Rossman, Canada

Collage earthenware plaque with commercial glazes by Annabeth Rosen

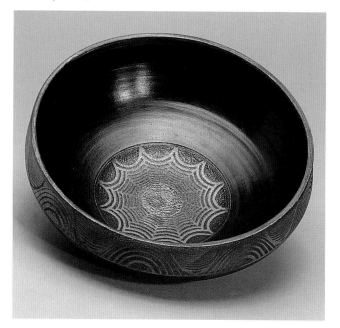

The technical definition of a stoneware piece is that it absorbs 2 to 5% of its unglazed weight when boiled in water for one hour.

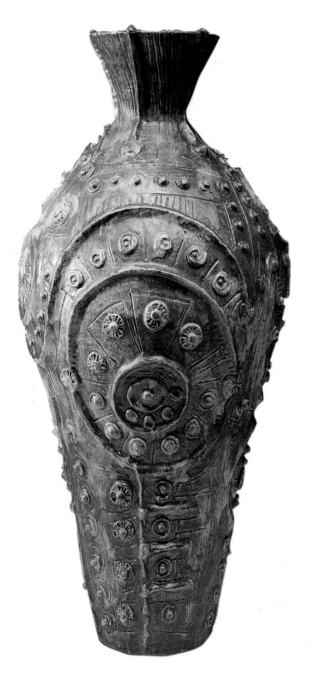

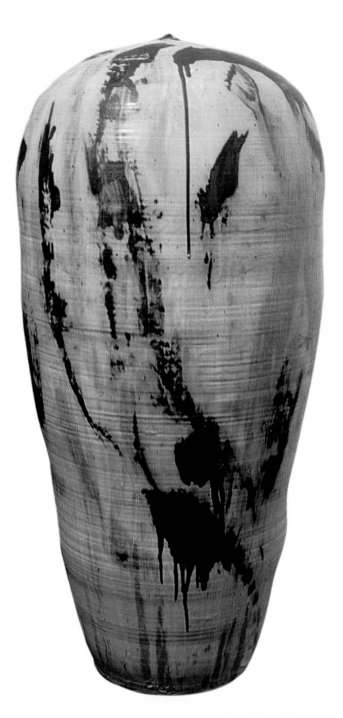

A huge coiled and thrown stoneware sculpture by Toshiko Takaezu shows the throwing marks of centrifugal motion in contrast to the vertical splashes of glaze

FACING PAGE Hand-built matt black stoneware sculpture with shiny glaze by Mutsuo Yanagihara, Japan

Richard Peeler's stoneware bottle with appliquéd clay texture is coated with a copper and barium matt glaze of varying thicknesses

INSET This unglazed plaque shows a heavy, utilitarian stoneware body in a characteristically coarse texture, by Claudi Casanovas, Spain

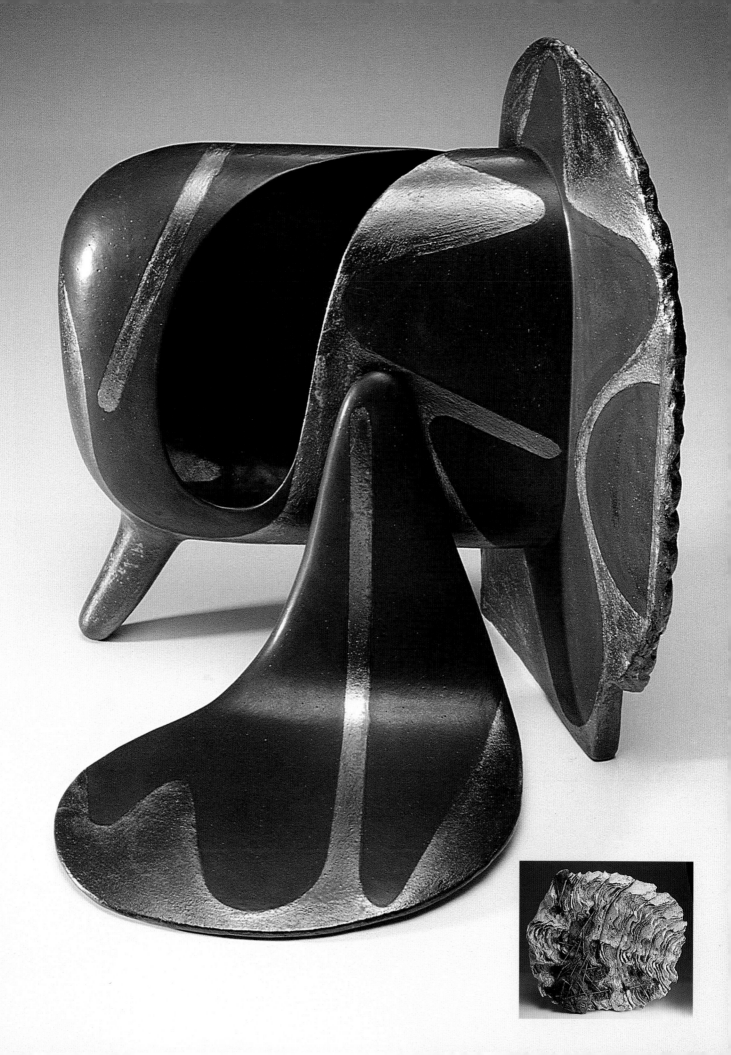

Porcelain

A fired claywork that is hard, dense, and vitreous, usually translucent if thin, and generally white or off-white, is called porcelain. As previously stated, we think that the Chinese were the first to make it, several thousand years ago; they were the first people to understand the effects of, and how to get, high temperatures in an enclosed chamber such as a cave or a kiln.

The technical definition of porcelain is 0 to 1% absorption of the weight of an unglazed piece after it is boiled in water for one hour. Because fired porcelain is so near to being vitreous and glass-like, ware fabricated in a porcelain clay body must be evenly dried to prevent warping and is likely to deform in the fire if the shape is not properly engineered. Because there is about 50% loss in the kiln, porcelain objects usually cost more than other claywares.

In the next chapters we will investigate ideas of hand-building ceramics, as well as plasterwork, throwing on the wheel, decorating and glazing, and firing, with photographic examples of the processes. We will make a brief tour through the history of ceramic art and folkways, with further visits through photographs to the work of a number of clay artists. Finally, for help along the way, a glossary and index are provided, with a bibliography of important books for your research, as well as a list of ceramic periodicals around the world.

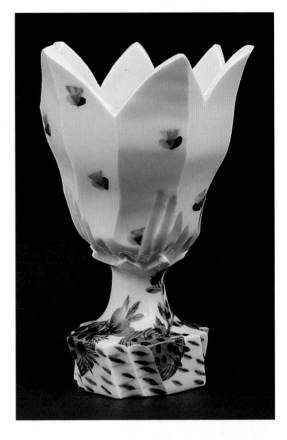

Underglaze blue and overglaze enamel colors in a porcelain vase by Heidi Manthey, Germany

Wayne Higby's solid carved porcelain sculpture, reduction fired

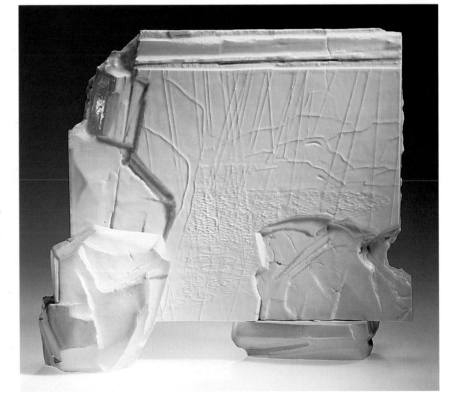

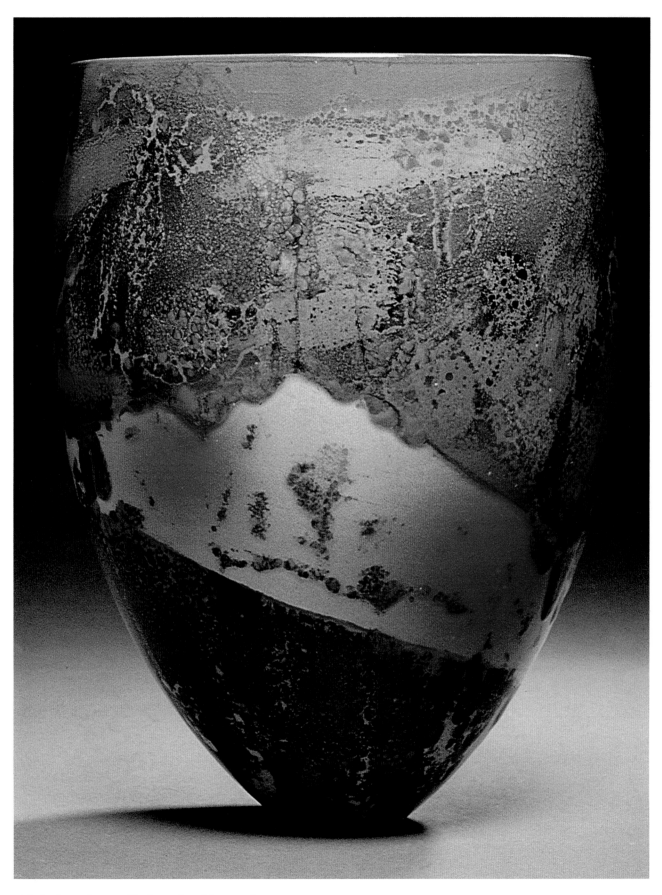

Multi-fired porcelain vessel by Pippin Drysdale, Australia

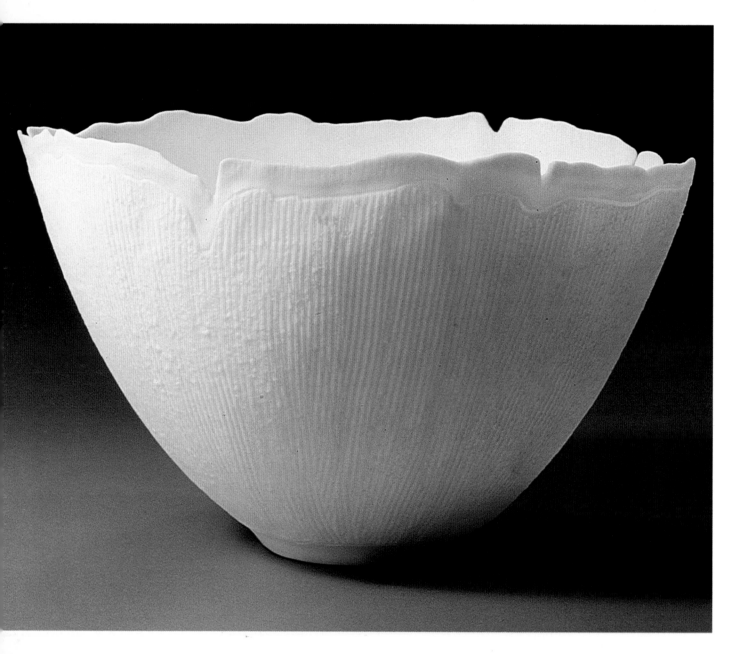

Enid Legros-Wise, Canada, has carved and textured her hand-built bisqued porcelain bowl so that it is translucent

FACING PAGE Elsa Rady's thrown porcelain bottles, oxidation fired, make an arresting installation on their painted aluminum base

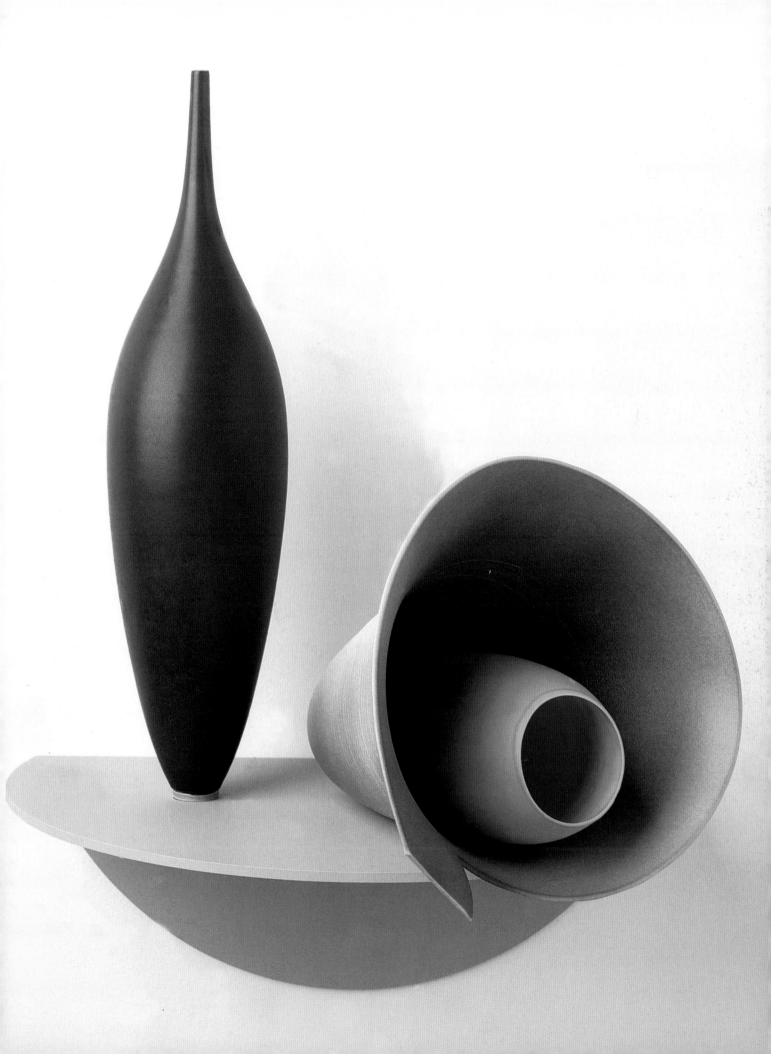

1

2

3

2

THE CRAFT OF
WORKING WITH
CLAY BY HAND

GETTING STARTED

Hand-building is the oldest method of clayworking, probably beginning at least 30,000 years ago.

Throwing developed in Egypt, China, and Mesopotamia about 5,000 or more years ago. Throwing on the potter's wheel (see Chapter 3) is the most direct way of shaping a clay piece. Thrown work made round on the wheel can be altered to make other shapes. Working on the potter's wheel is a skill that requires many years of practice, but it is only a skill and anyone can learn it.

FACING PAGE Another extraordinary vertical sculpture by John Mason, 62.5 inches high

INSETS The techniques shown here for making large pots are necessary because the wheels are too imperfect to throw the shapes. Beginners can take advantage of these methods, too:

1. A potter at Tulsi Farms, Delhi, throws and coils a large container

2. In Nepal a potter paddles a shape both inside and outside from the thickly thrown cones visible at the rear, stretching the clay by hand in an almost unbelievable fashion

3. A potter in Indore paddles from the thrown shape you see in front of him to the shape you see at the far right

Pressing over or into another shape is a way to design clay. The earliest humans probably pressed clay against rocks, or turned round shapes in a basket or another clay form, using a part-hand, part-wheel technique.

Reproducing the same shapes in a fired-clay or plaster mold is ancient too. The Egyptians and Greeks mastered mold-making by 2000 B.C. Today commercial ceramics are made mechanically, by mold reproduction processes called slip-casting, jiggering, and ram pressing. Some processes are done by machines, turning out hundreds of wares automatically every day. Potters can use hand variations of these methods.

Space ceramics involve other ways of forming, which may one day be part of the potter's vocabulary.

The clayworker decides which method to use according to the special requirements of the piece that is to be fabricated. His or her emotional response to a particular method may also affect the decision.

If the skills are not known, then they should all be learned and practiced in order that an intelligent choice of method can be made. The clay body, as I have said, must be the best, or the best pieces will not be made. It behoves you to take time to find a good clay body. If you are a student you may be limited to what is in your school. If you are working on your own, you can afford

the time to experiment and test until the right mixture proves itself.

TOOLS FOR WORKING

Potters can use many tools, or just a few, or none. Most clay artists make collections all their lives of various tools – or objects that will function as tools – from the hardware store, from their attics and garages, and from nature. A basic set of tools for handbuilding could be:

metal knife and wood knife
small sponge or chamois
cutting wire
half-moon-shaped wood or rubber rib
texture tools such as rocks, sticks,
 buttons, shells, etc.
metal scraping tool, wire-end tool,
 hack-saw blade, or metal rib
silver or steel fork, knife, spoon
wooden paddles

Water is essential in the hand-building process, but should be used very sparingly. A plastic squirt bottle of some sort is required to spray water, as work must be kept uniformly damp throughout construction.

BUILDING BY HAND

Because ancient peoples first made pots and clay figures by hand processes, and only later on the wheel, we sometimes think that the making of pottery by coil and slab techniques is easy.

 Actually, learning to control shapes made from coils, slabs, and pinches by hand, or learning to support the line of the profile and the weight of

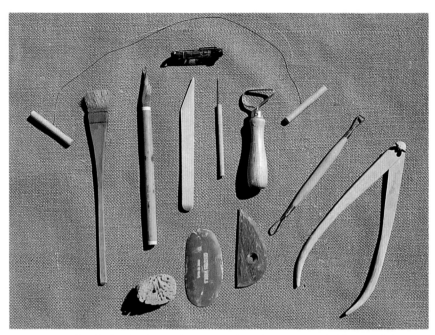

Potters can use hundreds of tools, or a few, or none, but a basic set is probably a good idea. Shown here are a flat and a round brush for decorating, a twisted cutting wire, a small finishing sponge, a wood knife for texturing and trimming, a rubber and a wooden rib for shaping, a needle on the end of a stick for cutting, a small level, a small and a large wire-end trimming tool, and a calliper for measuring lids or attachments

1. Marilyn Levine's slab-built suitcase with slab buttresses is encased in plastic to keep it damp and ready for the top to be added

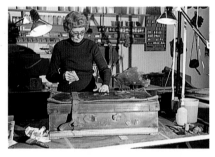

2. The artist applies an oxide patina

3. The finished suitcase in the kiln ready for firing

4. Detail of "leather" finish, "stitching", and "metal" hardware – all clay

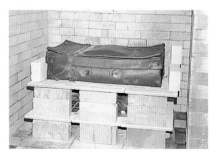

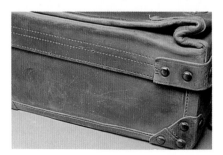

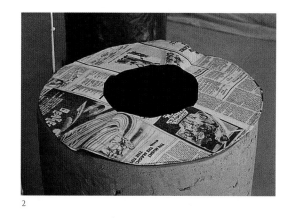

2

1. Elsbeth Woody begins an installation of columns by pinching cylindrical sections

2. Newspaper dividers keep the sections from sticking during construction

3. Each section is begun over the previous one

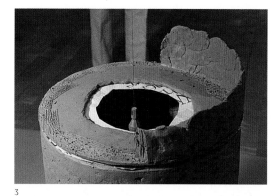

4. The finished installation

1

3

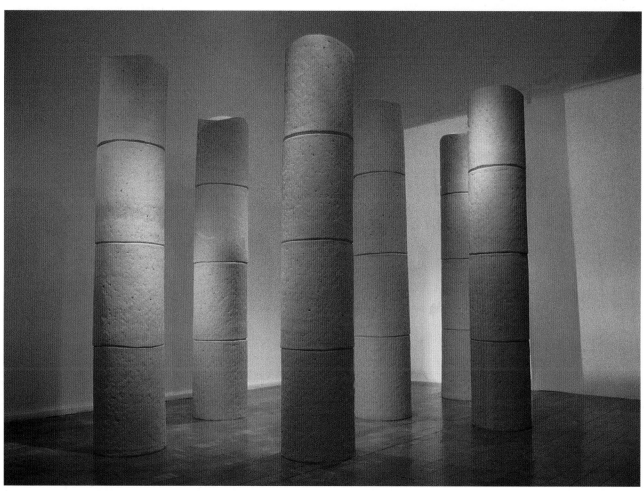

4

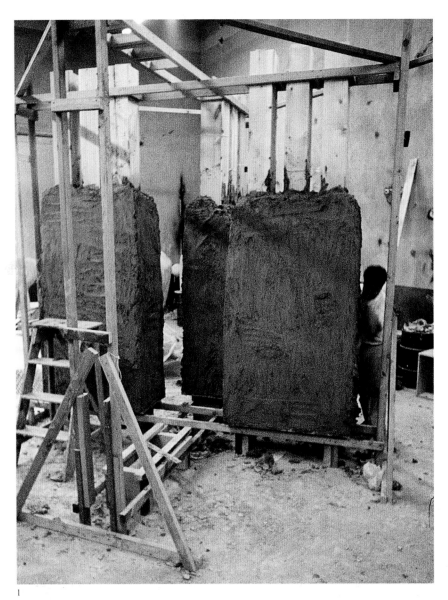

1

moves because it shrinks physically from the wet to the bone-dry stage; more shrinkage takes place chemically in the course of the firing. The maximum shrinkage that a potter will experience, over the wet-dry-fired sequence, takes place in a vitreous porcelain piece.

Allowing for shrinkage movement is crucial to the fabrication and the design in all claywork. Cantilevered shapes, that is, wide bowls on tiny feet, or potbellied bottles on small bases, are likely to slump or warp in any direction, or to crack. It simply is not feasible to create the same shapes in clay that can be achieved in wood or metal.

Weight and thickness – that is, the cross-section of the clay wall – are important. Like a tree, clay shapes need to be somewhat heavier at the bottom and lighter toward the top, not vice versa. Clay movement (shrinkage) should take place evenly, which

LEFT Jerry Rothman has built a huge wooden scaffold which supports the clay slabs for an enormous triptych fountain

BELOW As the clay stiffens, the scaffold struts are removed, and the clay units are smoothed for carving

2

the form, are techniques probably more difficult to master than wheel-throwing.

Solid clay shapes are used for making plaster molds, into which clay, plaster, or even molten metal may be cast. Clay shapes that are to be fired, on the other hand, whether vessel forms or sculpture, must normally be built hollow, as solid shapes produce various difficulties. Some clayworkers build forms solid but carve them out while the clay is still moist; this does not allow for an even cross-section, and disas-

ter is likely in the firing. Thick, solid clay shapes cannot be fired in a normal 24-hour kiln firing and cooling period. Bricks, one of the thickest clay shapes, may take weeks to fire. The larger and thicker the clay form the more slowly it must be fired.

Furthermore, clay shrinks as it dries. Thin walls dry and fire most easily. Understanding the movement of clay from wet to dry to fired is the first and most necessary step in thinking of clay shapes. Clay is a living, moving thing until after it is out of the kiln. Clay

implies that the clay wall should be even. Thickness of the wall should be ideally not more than ½ inch.

If cross-sections vary too much from thick to thin over the entire piece, then drying and shrinking will also be uneven. This is almost always the reason for cracked pots. Cracks resulting from uneven drying may not be seen until the first firing, the so-called "bisque" firing. Sometimes the clay waits to crack until there is further shrinkage, at the stage when the glaze is fired to higher temperatures. But the strain will almost always have been the potter's mistake, set up during the fabrication and the drying.

The clayworker is in total control when using the basic hand methods such as pinch, coil, and slab. In throwing, the wheel determines a great deal of the weight and wall of a piece.

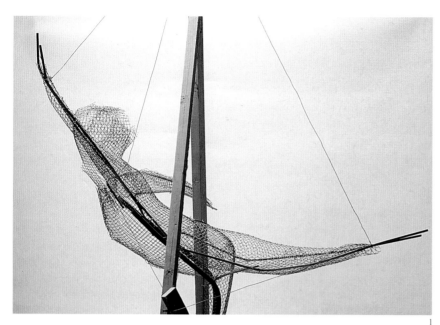

Jerry Rothman's non-shrink clay body will be laid over this stainless steel armature that will remain in the piece while it is fired at a median stoneware temperature

Clay on the steel armature is supported by wood while it dries

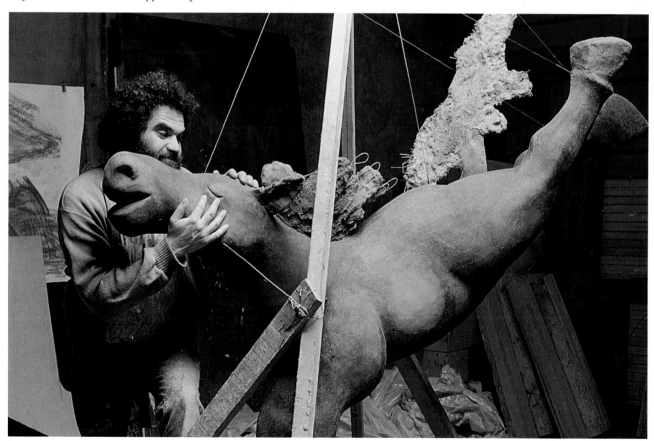

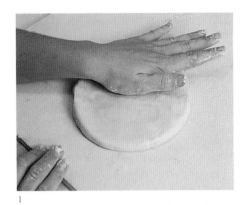

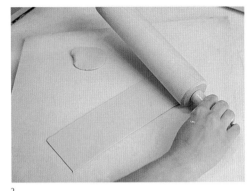

1. Using a very clean canvas board, Jan Peterson pats out a porcelain clay pancake

2. She rolls very thin slabs and cuts them to size for a tumbler

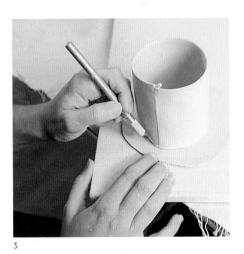

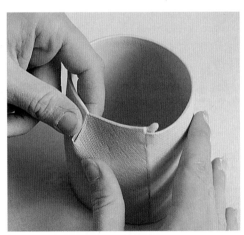

3. The cylindrical shape, thin enough to be translucent, is placed on an equally thin slab base, and the two are scored and luted together

4. She cuts and folds the edge to alter the shape

5. Finished tumblers, glazed inside, unglazed outside, with airbrush and resist stain decoration

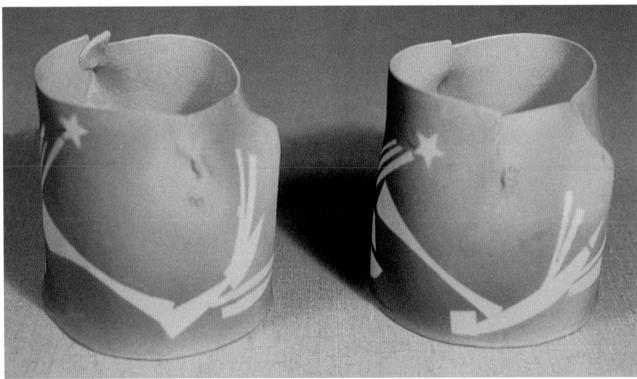

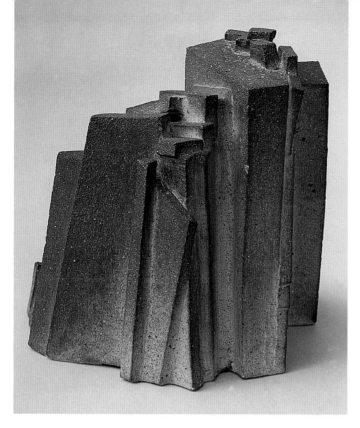

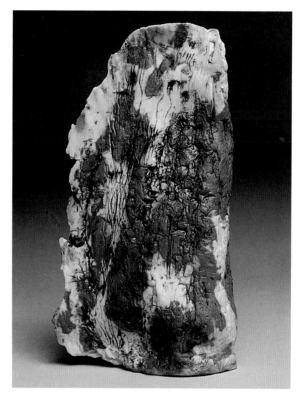

While solid clay shapes pose problems of construction and firing, the look of a really solid form cannot be achieved any other way:

ABOVE Lilo Schrammel, Austria, makes an angular unglazed stoneware sculpture that shows the changing patina of the woodfire

RIGHT Arthur Pogran's porcelain iceberg is hand-built, with reduction copper glaze

BELOW Solid shapes can be forced out of a pug-mill or similar device. This stoneware sculpture by Vaea is constructed of carved extruded shapes

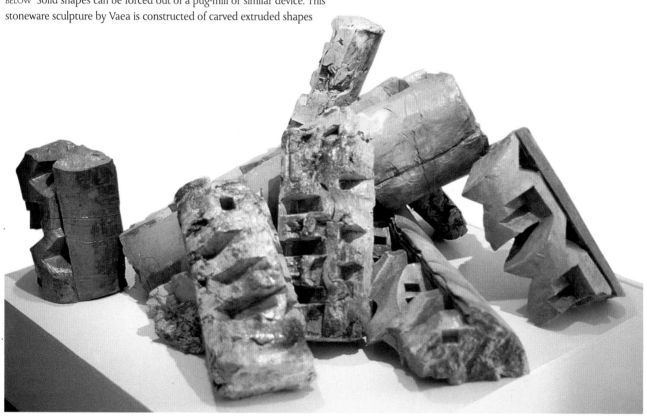

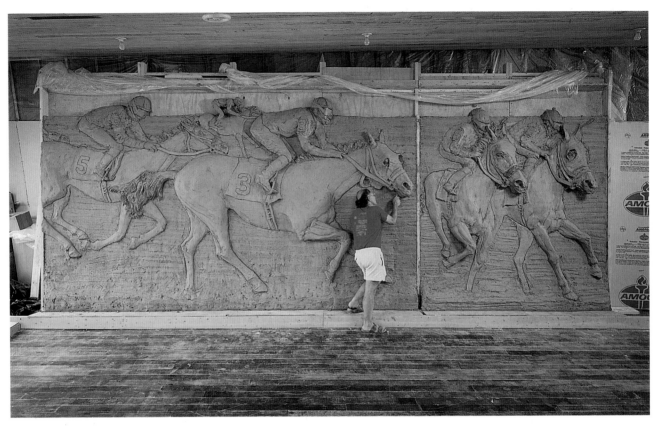

Bruce Howdle builds a wall 23ft long against a wooden easel, carves directly into the moist clay, keeps it damp with plastic covers for the weeks of work, and will cut it into sections for firing

It is possible to use **combustible cores** for construction of hand-built pottery. Again, you have to know what you are doing. If clay is fastened against paper, cardboard, or fabric without room to move, then it cannot shrink properly and it will crack at the pre-fire drying stage. Combustible cores are supports that burn out in the fire, but they must be soft enough to allow movement of the wet to dry clay before firing, or must be covered with layers of soft paper or cloth that will give as the clay moves.

Wooden or metal armatures are too unyielding to be used for claywork that will be fired in a kiln, unless they can be removed before the clay dries. Sculptors who work in stone or bronze often make solid clay models on metal armatures as "sketches," or they work clay on metal armatures from which a mold will be made for further casting in metal. Potters are limited to hollow, relatively thin and even-walled work. Ceramic sculpture is best made by building hollow, bottom to top, controlling wall thickness and weight all the while.

Children enjoy making small clay figures or objects solid, and they can be successful, especially if they are shown how to poke needle or pin holes through the thick clay for even drying and firing. Something they particularly like is to put the little groups of figures or objects together on a flat clay pancake, making a whole story on a stand of clay.

Some of the most beautiful objects ever made in clay have been made by hand techniques, without the use of a wheel or template. Today some of the best ceramic sculpture on an architectural scale is made this way. If you respect the technique and learn to use it properly, if you understand the principles of hand-building, there is no limit to size or design.

HAND-BUILDING TECHNIQUES

Pinching clay

Pinching a ball of solid clay into a hollow form, with the fingers and without tools, is one of the oldest methods of building with clay. Pinching can be

combined with coiling or with paddling, so that larger shapes can be obtained. Much satisfaction – akin to meditating – can be gained from holding a ball of clay in the palm of one hand, making a hole in it with the thumb of the other hand, and then rotating the form and pinching the wall up and out with the thumb and fingers.

Pinching is the first technique to use with any new clay, or with clay you have just prospected in nature. It is the ideal method for developing that absolutely vital sense of the clay wall thickness. The best way to measure

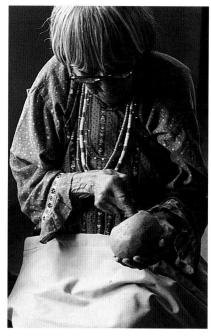

clay thickness is by feel, although you can push a needle through the clay wall to measure it. Feeling the wall is also the proper method of teaching yourself to sense whether the clay is in good condition, that is, without lumps or air bubbles that will cause trouble in firing. Gaining these perceptions takes practice; pinching a clay form is a good way to practice.

Coil method

As old as time, this is one of the most difficult ways of making clay forms. We give kindergarten children the assignment of making a coil pot, and then expect them to do it!

Ropes of clay are rolled out, one at a time, and attached to each other by a process called **luting**. Each coil is scored with a knife, the tines of a fork,

Richard DeVore's thinly pinched, articulated vessel is coated with a crackle glaze enhanced with black pigment

The late Maria Martinez, San Ildefonso Pueblo, New Mexico, pinching a small pot from a solid lump of clay

A large pillow form by Marea Gazzard, Australia, illustrates the pinching technique and is a good example of the concept of enclosed space. It is quite difficult to give the feeling of volume in clay sculpture

The late Lucy Lewis, Acoma Pueblo, New Mexico, coils and textures a storage vessel. In order to achieve the traditionally rounded bottom, she is working in an old clay shard

RIGHT A traditional coil pot by Lucy Lewis

a coiled piece will stand up without cracking or warping in the fire. The texture and pattern of the coils can be kept as part of the design of the work, or the coils can be smoothed inside and out with a tool. Evenly rolled coils make evenly controlled lines, but unevenly rolled coils can be interesting too. Coils rolled into rosette shapes, or snakes, or U's and W's, laid sideways or vertically, will achieve pattern and structure at the same time.

If a smooth surface is desired on very large works, build with fat coils that can be flattened before they are attached. Usually one coil is wound round to form one circle and the two ends are luted together. More complicated forms are possible if the coils are kept narrow in diameter, but

a comb, or a similar tool. The scored edges are moistened with water or with a clay slurry (a thickish mixture of clay and water) and attached sturdily. Scoring must be deep so that each coil mates solidly with the other.

Coils placed one on top of the other will cause the vessel to grow tall and straight; a coil edge placed outside the previous one will expand the vessel outwardly; a coil edge placed inside the previous one will move the shape inward. Thus a shape is easily controlled, whether straight up or out and in. Coils must be added while the clay is moist, or "leather-hard," not dry. Because clay shrinks and must dry uniformly, the piece must be constructed all at once in the same state of wetness, even if this means keeping it damp for weeks until the fabrication is finished.

Weight, thickness of the wall, and the profile line of the form are the determining factors in whether or not

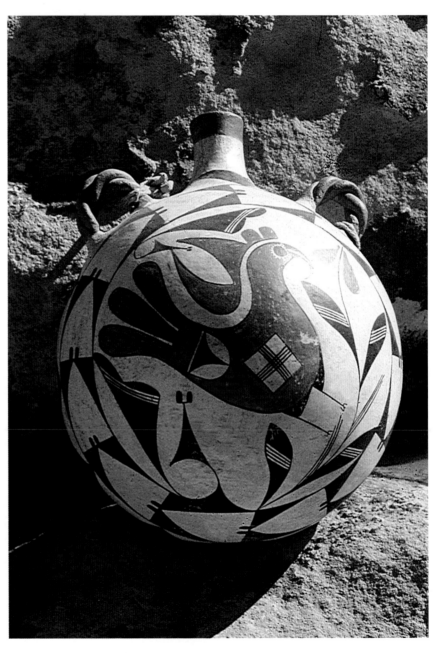

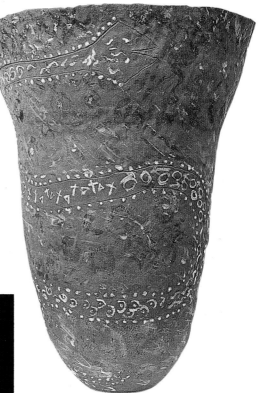

Joanne Emelock's large coiled floor pot, meticulously carved and textured, has been coated with low-fire earthenware glazes

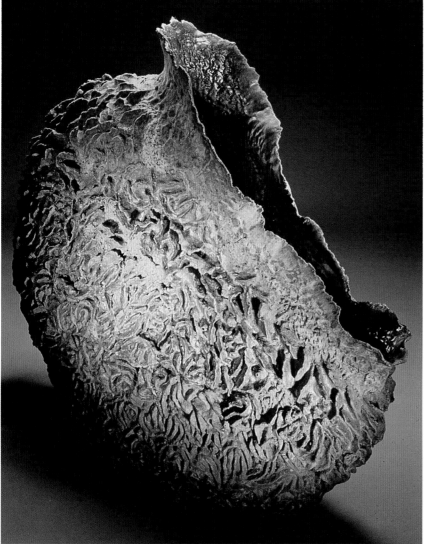

Sandra Shannonhouse's coiled vessel is marked with textures and engobes, but the effect of the horizontal coil technique remains part of the aesthetic

Basket sculpture by Rina Peleg

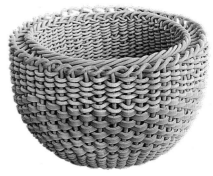

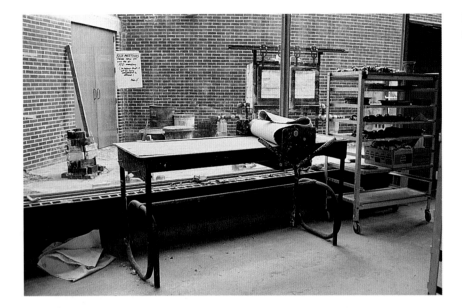

Slab roller, a mechanical means of producing slabs of varying thicknesses

the building process is slower. It is also possible to wind the pieces round and round in a continuous coil, which will create a different kind of texture and form.

Slab building

Coil building is for round shapes, slab building is for squares or angles and sharp edges. However, slabs can also construct round forms where there is not much profile change, and coiled shapes can be pounded into off-round objects.

Depending on the size of the work to be constructed, one slab can become one whole wall, or a number of slabs may be laid one on top of another in a manner similar to building with the coil process. A natural line-change takes place where slabs join, making an artful conjunction. Fabricate slabs against a canvas board, or other porous surface from which the clay will be easily released, in one of the following ways:

1. Roll a lump of clay flat between two horizontal sticks; the width

of the sticks will determine the thickness of the slab, usually ½ to 1 inch.

2. Shape a lump of clay into a rectangle; hold two sticks upright either side of it, with a string or wire stretched between them; pull the string or wire through at different levels to obtain a number of slabs.

3. Pound a lump of clay into a flat slab with your fist; turn it over and pound the opposite side; repeat several times for structural strength.

4. Several slabs can be luted together to make one large clay blanket.

5. "Throw" out a slab: hold a flattened lump of clay from its top with both your hands and fling the clay down toward the table, repeating several times until it has expanded to the desired size. This method works for small or huge slabs, once you get the hang of it, and yields a relatively even cross-section.

6. Use a rolling pin and roll a lump of clay as if it were biscuit dough.

7. A "slab rolling" machine helps, especially in making extra-large slabs.

8. Cast a liquid clay slab against plaster.

9. Cast a thicker slab into a sand mold.

10. Press a slab from plastic clay in a mold.

Some of these methods will give a more even, some a relatively uneven result. Select the method most suited to your design concept.

Slab construction is ideal for large scale; it is a faster method of building than pinch or coil. Slabs for large work can be laid over combustible cores made of cardboard wrapped in fabric, or scrunched-up paper, or sand-stuffed pillows – the sand must be let out as the piece reaches leather-hardness. Clay can be rolled against nylon screens, which burn out, or against stainless steel screens, which will stay in the structure up to 2150° F (1175° C).

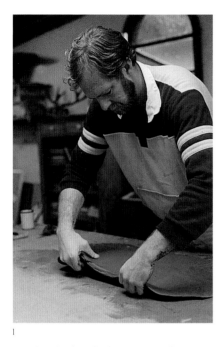

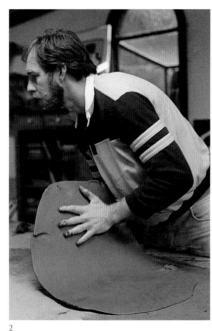

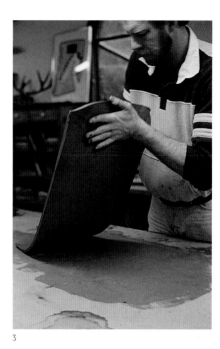

1

2

3

David Middlebrook "throws" out a slab:

He picks up the flattened slab and . . .

. . . flings it down on to the table. If you throw the slab in the same direction each time it will become longer; if you throw it in opposite directions it will become round or square. Several slabs can be luted together to make one huge slab

John Mason's large pentagonal form is a virtuoso piece of slab-building, as well as of graphic surface decoration

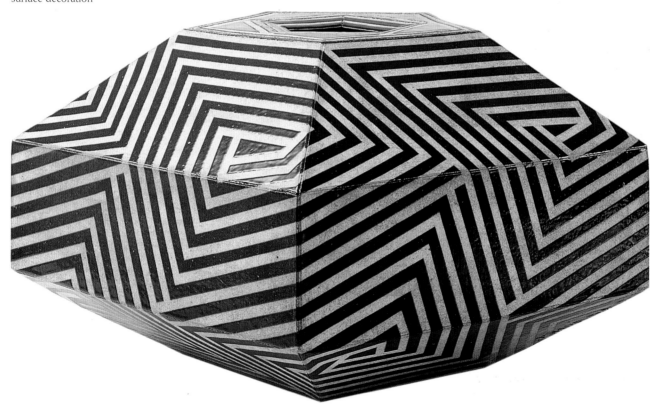

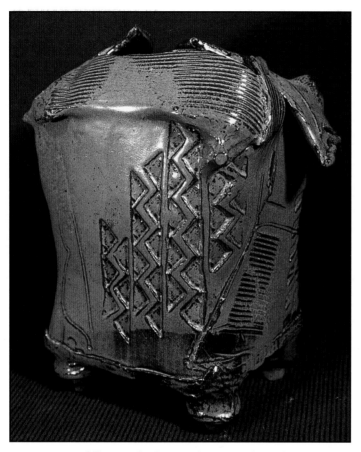

At a workshop in Prague, Dennis Parks invented a method of building slab forms inside large paper bags

BELOW The forms with the paper bags removed

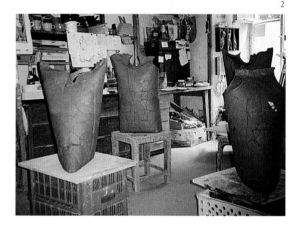

Bing Davis's vessel illustrates the slumping that occurs when slabs are handled wet; the glaze becomes much thinner over the sharp edges of the texture

LEFT Judith Salomon's thinly constructed slab teapot and cups are coated with commercial glazes over white earthenware

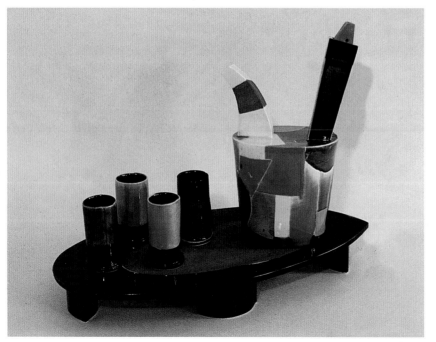

Potters through the centuries have added inert materials to the clay body to enable the handling of large, weighty constructions in the moist plastic state. Today short nylon fibers can be wedged or mixed in clay bodies to serve this purpose. Clayworkers need to become magicians with inventive ideas when constructing big works.

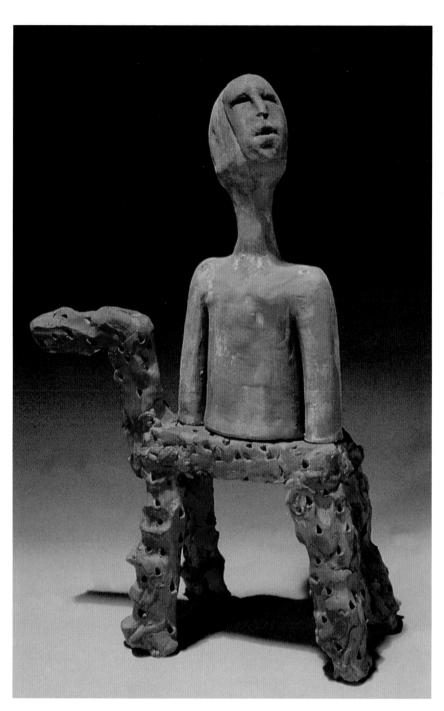

Christine Federighi's unglazed figure is
built over a cardboard core which
burns out in the firing

Hammock method

Drape a cloth to form a sling of desired
depth and width by pinning or nail-
ing the fabric to the inside of a card-
board or wooden box, or suspend
material from the legs of an upturned
stool, or in any way you can, as a recep-

Susan Peterson lays a textured clay slab into a
burlap hammock draped in a cardboard box

BELOW She uses newspapers under a moist
clay slab to give form, then draws on the
surface

tacle for a slab of clay. Platter and plate shapes are easily made in this manner. Alternatively, the slung clay can become the base for a sculpture, with pinch, coil, or slab additions. The hammock supports the clay until it is dry enough to be moved.

Several slings can be utilized at once, so that the clay forms may be joined together into hollow vessels or sculptures.

Over-the-hump method

Choose a contour – a rock, a pot, a balloon, or the like – that will create the interior shape of the vessel when a slab of clay is placed over it. The form must be such that the clay will be released from the hump without getting stuck. It must therefore have no "under-cuts" (see page 51), or the clay cannot be removed. You can also create your own solid form from clay instead of using a found object; fire

Jan Peterson hand-builds a porcelain plate from slip-cast slabs:

1. Pouring liquid clay on to plaster to create flat, thin slabs

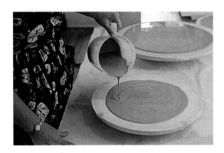

2. Leather-hard slab cut into patterns, laid over a plaster hump form; moist slabs are rolled together for strength and design

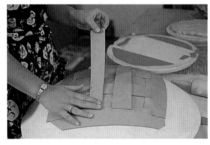

3. Plate turned right side up shows pressed pattern created by the slabs; edges are smoothed with a damp sponge

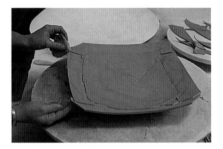

4. Finished porcelain platter, fired and glazed

it if you want to keep it, or use it moist for one time only.

Place a sheet of plastic or paper or fabric over the hump before laying the clay slab on top, so that it will be released easily when it is lifted off. The hump method, the opposite of the sling method, provides the opportunity of working on the back of the shape, for instance if you want to add a foot or any other appendage to the vessel.

Ceramic sculpture

Any method of clay construction may be used for the purpose of sculpture, but hand-building techniques are probably the most versatile. A misconception is that sculpture must be large. If the piece is small and narrow, or if long-time firing is possible, the work could be solid. However, as we have said, it is best to think of ceramic sculpture as hollow, like a pot, and to build it bottom to top as a pot is built.

Making a small solid clay model prior to constructing the large sculpture will help in the complicated thought process of building hollow from the bottom up. Parts of a sculpture can be made separately and attached when the clay is leather-hard. Any size of work is possible, the only limitation being the kiln size. In fact, this can be overcome by making your piece in units that will fit the kiln and can be fired separately. These can be combined after firing by non-clay methods. The only real limitation is the clayworker's imagination, and even that can be strengthened and enriched with knowledge and time.

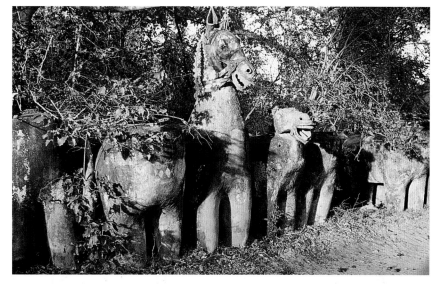

Several hundred centuries-old oversized coil-built Ayyanar horses in a hidden shrine in south India

TECHNIQUES USED BY ANCIENT PEOPLES

These techniques are still applicable today, and are well worth practicing whether you are a beginner or not.

Methods of forming

A: Using a natural form as the interior shape:
1. coil over a convexly curved rock;
2. lay clay over or into a reed basket;
3. shape clay over a ball of wax, melt wax out;
4. form clay over a ball of bark, twigs, or string, pull the fiber out of finished piece;
5. lay slabs or coils of clay over fruits or vegetables such as melon or squash.

An Indian pot at Tulsi Farm Pottery, Delhi, is supported on a grain bag while it is burnished with a smooth stone

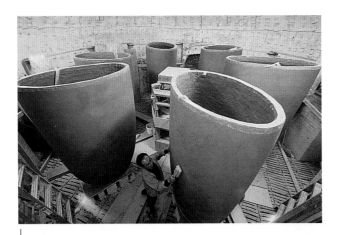

1

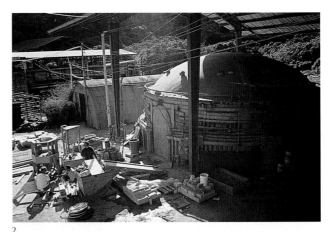

2

In one of the largest ceramic projects ever undertaken, Jun Kaneko creates monolithic shapes of extraordinary technical difficulty with conspicuous success:

1. His slab and pinch-built "dango" shapes, 11 ft 6 inches high, are constructed within a sewer-pipe kiln in Fremont, California

2. The beehive sewer-pipe kiln in which the dangos are built and fired is 30 ft in diameter

3. Jun decorates bisqued dangos with vitreous engobes, which will be glazed and fired to cone 6. The project took two years

B. Pushing natural forms into solid lumps of soft clay to create a pot shape:

1. use sticks, starting with thinner ones, working up to sticks of successively larger diameter up to log-size;
2. ram solid clay with smooth, elongated rocks;
3. dig down into a soft lump of clay with clam shells or pot shards, turning the clay and widening it with the shape of the shell;
4. shape a hollow piece by paddling the outside with a stone.

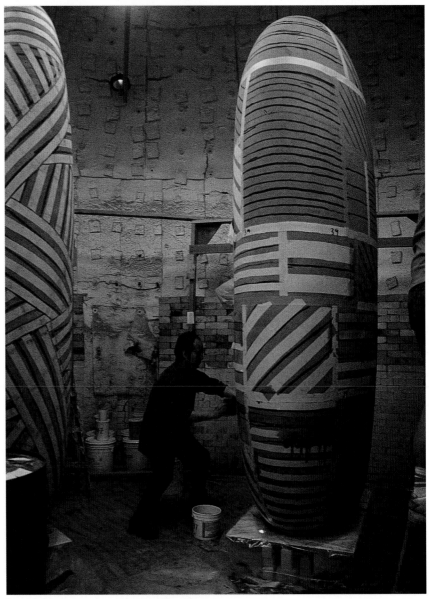

3

Methods of decorating

Texture a fresh clay surface with:

1. paddles: carved of wood in various shapes, or wrapped with string, weeds, or fabric, or made of bark from different trees or brush;

2. roulettes: natural forms that can be rolled against soft clay, such as bones, pine cones, seed pods, animal teeth, wads of leaves, rocks, carved wood rollers;

3. combing: pull a toothed or serrated edge across a clay surface;

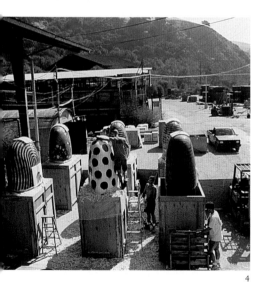

4

4. Dangos packed and ready to be trucked for storage in Kaneko's Omaha studio

5. One of the finished, glazed dangos; the glaze firing took seven weeks

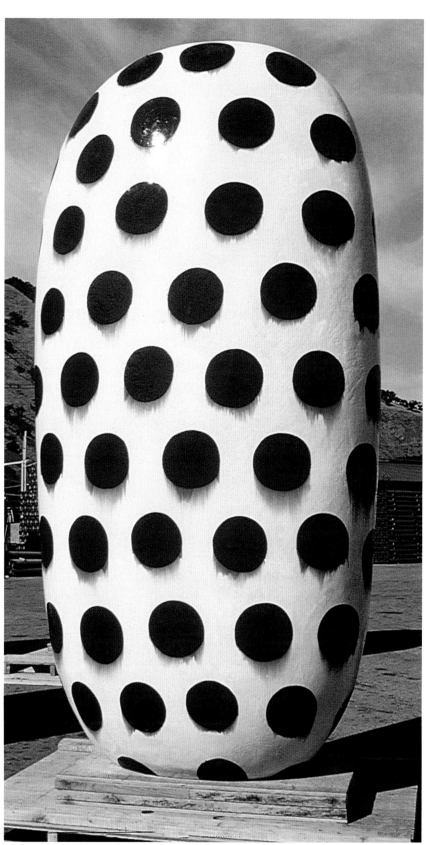

5

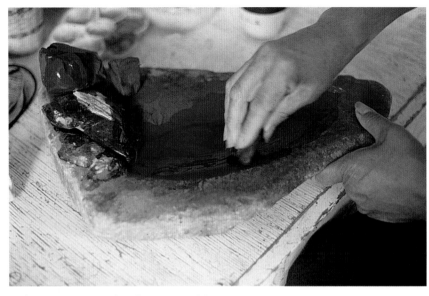

Rocks containing mineral oxides are ground for paint pigment on a stone *metate* at Acoma Pueblo

favorite – painted against a burnished surface to produce a dull matt design; in some cases plant juices cause color on the clay in the fire;
3. change all the clay colors by smothering the fire or making smoke.

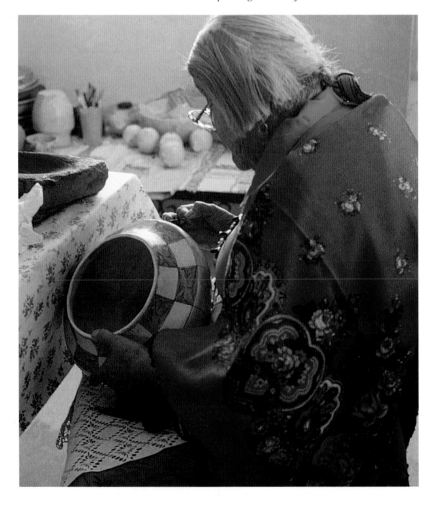

Lucy Lewis uses the ground pigment for painting with her yucca-frond brush

4. stamping: use carved clay stamps, dried or fired, or vegetables, shells, bone ends, twigs, or broken pots.

Changing clay surface

1. burnishing: polish the leather-hard clay with a smooth water-washed stone or a gourd to produce a sheen;
2. resin: drip tree resin or pitch against a hot pot as it is pulled from the fire.

Coloring with minerals

1. Add the powder from grinding metallic oxide rocks such as hematite, copper, and the like, to the clay surface;
2. use plant juices – almost any plant will do, but yucca is a

It is stimulating to increase your awareness of all the ceramic processes that have been in use for centuries by primitive and studio potters. If you have a chance to travel in rural areas or in countries where clay is still the prime material for functional objects, take note of the various techniques and adapt them for yourself. Books and photographs of these areas are also a wonderful help.

WORKING WITH PLASTER

Potters use plaster as a means of reproducing ceramic forms, or as a form against which to work. Plaster can also be used as a mold for casting metal, but then so can bisqued clay. As potters we usually use plaster for making molds, into which liquid clay slip is cast, or into or over which plastic clay is pressed.

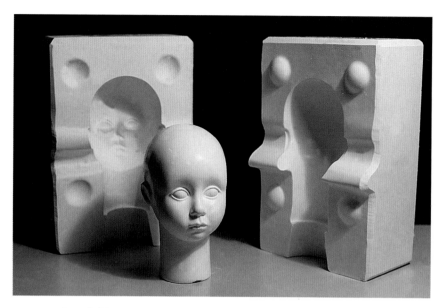

A Lennox china doll head model with its two-piece mold for hollow-casting

Hollow-cast molds – either one-piece or multi-piece – are open voids that form only the outside shape; clay slip is poured into the top of the shape and poured out as soon as a cross-section of ³⁄₁₆ inch or so sets against the plaster.

Solid-cast molds shape the inside and the outside form of the piece; the hollow between the two or more pieces of the mold fills with slip and nothing is poured out. Plaster is porous and absorbs moisture from the clay slip, so that the skin of the piece hard-

Victor Spinski's installation, assembled from ceramic objects which have been pressed or slipcast from plaster molds

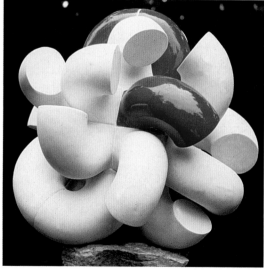

Mold forms of various units can be cast individually and assembled in different ways, as shown in this porcelain sculpture, one of a series of outdoor installations by Patriciu Mateiescu

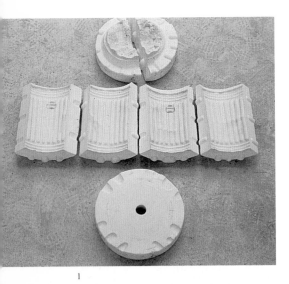

1

Richard Notkin casting the pieces to be assembled into a finished sculpture:

1. Exploded view of seven-piece hollow-cast mold

2. Pouring slip into mold

3. Draining slip from the huge mold

4. Mold pieces being removed from the cast garbage can

5. Finished object in porcelain, celadon glaze, electric hardware and wood

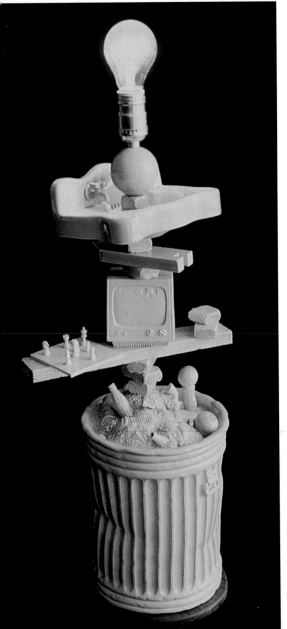

2

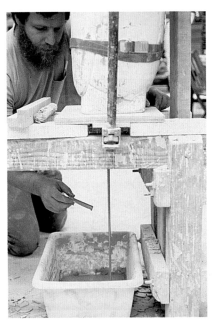

3

4

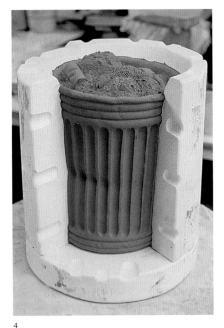

5

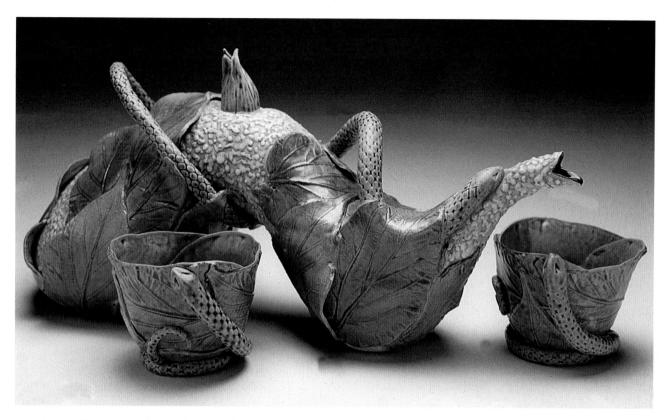

Betsy Rosenmiller's teapot and cups of cast porcelain with hand-built additions

ens in minutes. Molds cannot be used more than a few times a day or they become too wet.

Plaster is a gypsum (calcium) product, available from lumber yards, hobby shops, hardware stores, and the like. Good pottery plaster is not the same as dental plaster. Most pottery plasters are labeled as such in all parts of the world, yet there can be many types. For instance, in the United States, U.S. Gypsum and Blue Diamond, the most noted companies, have different trade-names for types with various setting times, and different plasters for degrees of hardness. Potters usually prefer a setting time of 20 minutes from when the plaster enters the water to when it is the proper consistency for pouring; stirring the plaster shortens the time, as does hot instead of cold water.

How to make a mold

To make a mold requires making or acquiring a model first. The plastic clay you use for hand-building is the usual substance for a **model** you create yourself, but Styrofoam, cardboard, sand, wood, newspaper, or fabric can be used, as well as "found objects" such as rocks, fruit and vegetables, tools, and so on, which can provide images for conceptual pieces.

"**Undercuts**" determine the number of pieces a mold will have. An undercut is a line that goes under from another line or curve. Your face would need at least a two-piece mold, divided either around the head or down the middle from the center of the top of the head, over the forehead, down the nose, over the lips, over the chin,

One-piece mold (left). A two-piece mold is necessary if there are "undercuts" (right)

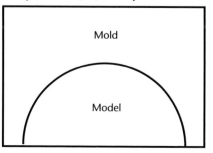

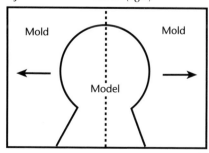

and down the neck. If you make a solid model of a head you will make all the planes and curves recede from that center line. Think about how you will detach the mold from the model. You must be able to lift it off, so if there are undercuts, necessary to form such features as nostrils or ears, they will necessitate further pieces of the mold.

If the model is made of clay, metal can be inserted to be used as a separation line, against which to cast the first piece of the mold. If the model is any other material, the separation line could be a slab of clay. After you have cast the first piece, use Vaseline or potter's soap between each section of the plaster mold to separate the pieces as you cast the plaster over your original model. You now have a mold. When the clay that is cast into the mold is set, the various parts of the mold come apart and are removed; the piece then stands alone.

Clay casting slip that is poured into hollow or solid-cast molds is a specially **deflocculated** clay body. If we make clay liquid enough to pour into a mold just by adding water – three to four times the weight of the clay would be needed – the proportion of clay becomes so tiny that when the water evaporates there is not enough clay left to hold the form together.

Deflocculating a clay slip means adding a catalyst, called an electrolyte. A percentage of 0.2 to 0.5% of this will make a batch of 100 parts of clay body plus a maximum of 40% water into a liquid that weighs 1.7 specific gravity, just a little heavier than water. The most satisfactory deflocculant is usually sodium silicate (also called waterglass) or soda ash, or a combination of both, although tea, dishwashing soap, or manufactured chemicals such as "Darvon" also work.

Any clay body will deflocculate, but tests should be made with small quantities before mixing a large batch. Store the casting slip as airtight as possible. If it seems less liquid when you come to use it, add a small quantity of water to the slip, or adjust it by weighing for specific gravity.

HOW TO MIX PLASTER

Some clay artists mix plaster and water willy-nilly, as bronze sculptors do, but sculptors use plaster as a throw-away material. Potters use the plaster they mix for models and molds that need to last a long time. Therefore it is important to use the proper plaster/water ratio your particular brand of plaster requires and to mix in a regulated manner that will produce the most durable mixture.

This is a regular mix for bats, models, and molds:

1. Calculate how much plaster is needed in cubic inches for the area to be poured. That is, measure the three dimensions of height times width times depth. If the area is round rather than cubic, multiply the cubic inch total by 0.8. As an example, 81 cubic inches of space require one quart of water plus 2¾ lb plaster (generic ratio for most plasters).
2. Measure the correct amount of cold or lukewarm water into a plastic, rubber, or metal container; weigh the correct amount of plaster.
3. Shake plaster into water slowly – not too slowly – so it mounds

Tiles for wall installations are slipcast in previously carved or textured plaster molds by Karin Bjorquist, Gustavsberg, Sweden

Karin Bjorquist's tile façade in Stockholm

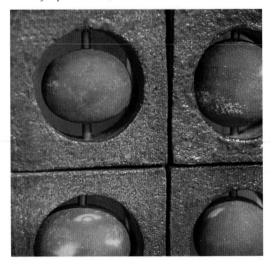

up in the bucket; allow plaster to slake a few minutes in the water until it all seems moist.

4. Begin to stir with your hand around the bucket in a wide motion, then a figure-of-eight motion on the bottom, palm up, moving upward to the top of the mix and around again. As bubbles come to the surface, scoop them off with a paper towel.

5. As soon as you can make a mark that holds its line slightly on top of the mix, the plaster is ready to pour. Pour down the side of the wood or linoleum coddle surrounding the model, or down the side of the mold area, so that the plaster fills up the space and air comes to the top; shake the bench or table under your mold, to break the bubbles. Remove the cast when the plaster becomes hot to the touch, at which point it pulls away most easily; otherwise you may need an air hose to part the plaster from its core.

6. If there is excess plaster, pour it onto newspaper to set, and discard it. Rinse the container in lots of cold water.

Making molds is a complicated process. Frequently, artists use casting or pressing mold techniques to create multiple images or exact replicas of objects for use in sculptures. Molds are also used as a means of reproducing forms when many similar items are needed, such as for dinnerware or accessory sets. Some artists use plaster as a sketch mechanism to see form quickly.

Carved plaster makes innovative stamps for decorative pressing into clay. To explore the capabilities and experiment with plaster requires

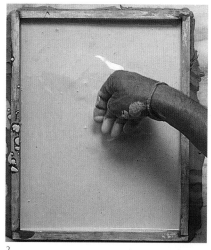

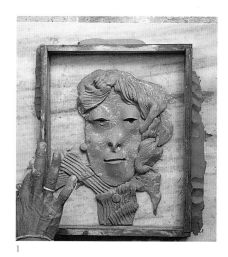

1

P. R. Daroz, a sculptor in Delhi, illustrates his technique of making molds for pressing images to construct a wall:

1. Clay model encased in wooden frame

2. Plaster is poured over the model within the frame; the image will be indented in the plaster

3. Pressing the clay slab over the image

4. Assembling variations of the molded tile into a wall piece

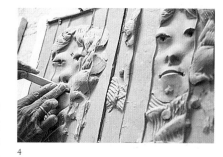

3

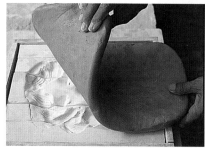

4

explicit instruction. Don Frith has written the definitive book on making and using plaster molds. Or refer to the detailed plaster section in my book *The Craft and Art of Clay* (see the bibliography).

BELOW Charles Nalle makes a number of different plaster models for a variety of vase shapes

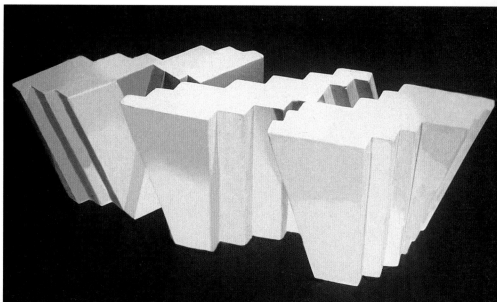

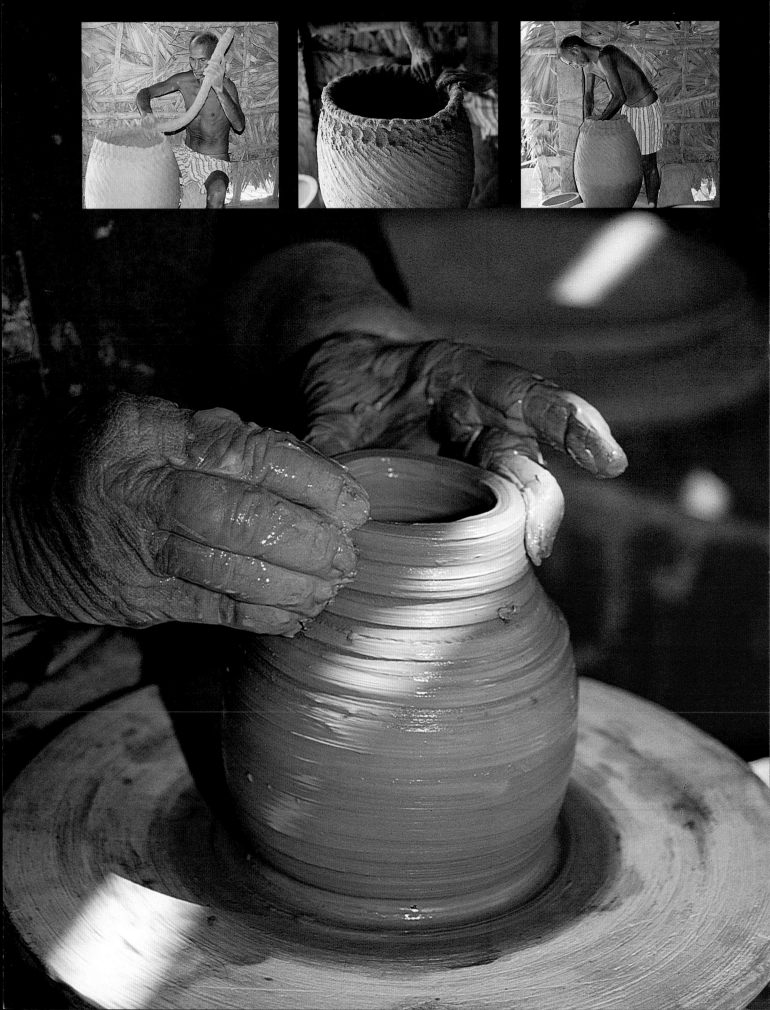

3

THROWING ON THE POTTER'S WHEEL

ANYONE CAN LEARN TO THROW

The potter's wheel has not changed much in 5,000 years. We think that in ancient times a large wooden or stone disk was placed on a rock or stick fixed in the ground, and it bounced as it rotated unevenly. More sophisticated means of achieving balance and stability were gradually incorporated, until thousands of years later, in the twentieth century, an electric motor was added. The purpose of the potter's wheel – to revolve evenly and smoothly under the pressure of the potter's hands – has always been the same.

FACING PAGE Susan Peterson throwing on the wheel

INSETS A village potter in south India using coil and throw technique: a long, fat coil is rolled from very plastic clay and attached to the previously thrown vessel. The clay is very soft and fingers pinch an even wall which the potter throws into symmetrical shape. Eventually the huge thrown vessel will be enlarged and refined by hand with a paddle

It is a good idea to hand-build before starting to work on the wheel. It is important to learn to feel the clay, and to gauge its reaction to your hand pressure. These sensitivities are important through all claywork, but really important in throwing. You should have made at least a pinch pot with the clay you will be throwing to test plasticity, before trying to use the wheel.

Throwing on the wheel is the fastest way to get a hollow clay shape, ready to be finished or to be combined or cut up and added to something else ("thrown and altered"). But it is the fastest method only when the potter is skillful and has total command of the wheel. In my view, this accomplishment can take ten years to acquire, although some people have a natural skill that allows them to develop faster.

Throwing is a process of working clay by hand on a revolving wheel that is kicked, rotated by hand, or motor-driven at speeds up to 120 rotations per minute. It is the only process by which a form can be so spontaneously created, so quickly made, involving the most direct communication between the creator and the material. Potters work a mass of clay under their hands, in tune with the speed of the wheel and the rhythms of their bodies, into a shape determined by their own sensitivity and skill.

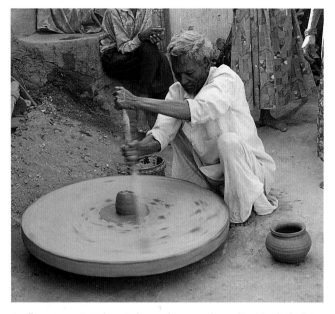

A village potter in Indore, India, working on a large disc wheel which is turned by hand with a stick. The wheel has to be this size to keep up the momentum

A potter at Tulsi Farm, India, wedging clay on the floor

During the process of learning, everyone will feel the sense of being one with the clay, of feeling the clay take shape – any shape – under the pressure of the hands. Not everyone will acquire enough skill to make thrown clay into an art, or be able to say the things an artist can communicate with this method, yet all who work on a potter's wheel will feel an expression of self. This degree of personal satisfaction can make throwing on the wheel an end in itself. M. C. Richards, a potter-poet, wrote a book called *Centering*, about the process of centering a ball of clay which she likened to centering oneself.

Consistency is very important. The clay must be soft enough to respond easily to any pressure. No hard lumps or foreign particles should be present in the clay body, except grog or sand or small natural impurities used for texture or color. Clay for throwing can be used much looser than clay used for hand-building.

Wedging

The process of making a ball of clay into just the right consistency for working is more important for throwing than for hand-building. If the clay consistency is uneven, a really centered form is impossible. Any method of kneading clay works, but wedging is best: one hand rotates a lump of clay and the other hand presses the sides in, giving a chrysanthemum-petal look. Clay should be wedged free of air so that subsequent moisture pockets will not cause the piece to "blow up" during the bisque firing. If the clay is too wet, wedging against a porous surface will stiffen it; if it is too dry, water can be wedged in to moisten it.

Position

The position of the potter at the wheel is crucial. Some wheels are made for sitting, some for standing, some for squatting; kicking a wheel usually requires

sitting and kicking a rotating flywheel. European wheels are often treadle-style, requiring a posture of standing on one foot and moving a treadle back and forth with the other foot.

Preferably, the potter should sit at the level of the wheel head, or above it, close enough and high enough to bend the back and shoulders over the clay. Arms should be relaxed but held against the body, and the whole body including the arms should move in toward the clay as hand pressure is applied; if the arms move alone, the body moves and the clay goes off-center. Hands, wrists, and arms must be steady and fairly rigid, although poised and relaxed enough to feel what the clay is doing. The body leans into the clay from the back and the shoulders, through the arms to the hands. A steady, centered "self" is essential in learning to feel every tiny response of the clay. It is important to stretch and relax the body now and then.

BELOW Taäg Peterson assembles previously thrown sections by luting and rethrowing. In order to be able to stand above the pot he has placed a rock on the wheel pedal to keep the motor moving

ABOVE Neil Tetkowski throws a large bowl on a huge wooden bat for one of his mixed-media wall pieces

In America the potter's wheel rotates counter-clockwise. In Britain, Japan, and some other countries it is rotated clockwise. It does not matter about the direction. The potter adapts to the motion and pulls up on the right side of the clay if the wheel goes counter-clockwise, or on the left side if it goes clockwise. The best spot for catching the clay with your pressure as it comes round is about 4 o'clock on the right side, or 8 o'clock on the left side.

It does not matter what shape the wheel head is, or the bat on which the throwing is done. What matters most is that the potter learns to feel the centrifugal motion of the wheel and the clay as it responds to that motion and the potter's pressure. Learning to feel is one of the big issues in clayworking.

If the potter stands to a low wheel, it is usually to handle a huge amount of clay. The stance will be solid, with legs apart, arms braced from the shoulders. You work bent over the clay until the wall rises as high as you are and eventually you are standing tall, parallel with the clay. To make really large vessels or sculptures you may need to throw several shapes and attach them together, or to cut, patch, or paddle forms into other forms.

**The left hand centers the clay.
The right hand lifts the wall.
The left hand makes a bowl.
The right hand lifts a bottle.
Two hands squeeze in to collar a neck.**

It is important to have only one pressure point on the clay at a time. If there are more pressures – more fingers or too much hand surface against the clay – the pot will absorb all those pressures and will be taken off-center.

BELOW Tetkowski's finished piece

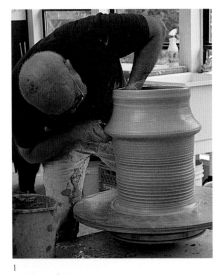

1

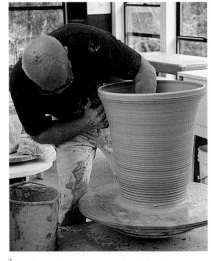

2

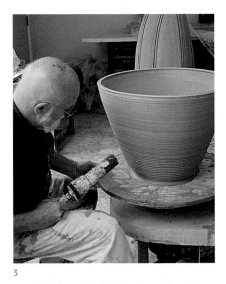

3

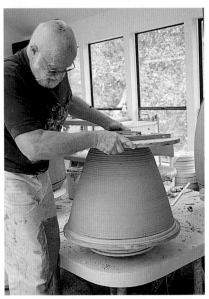

4

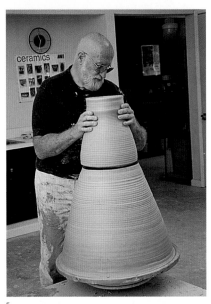

5

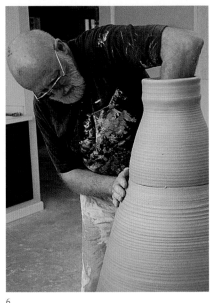

6

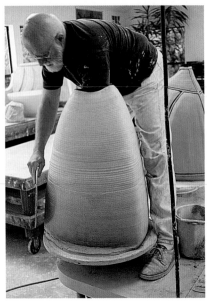

7

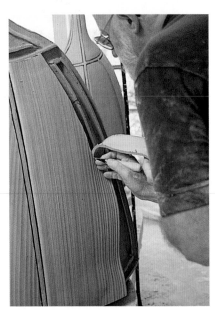

8

Bob Kinzie creates a large sculpture:

1. Throwing a huge piece on a low wheel; note the position of the potter in relation to the wheel
2. Raising and expanding the form
3. Stiffening the shape with a torch
4. Turning the leather-hard shape upside down on another bat on which the flat clay pancake base was thrown
5. Adding another shape, carefully measured to fit
6. Throwing the two shapes together
7. The top of the shape is cut off and reserved, then the remaining form is paddled into a triangle
8. The top is added off-center and the form is textured and carved
9. FACING PAGE, TOP The finished stoneware piece

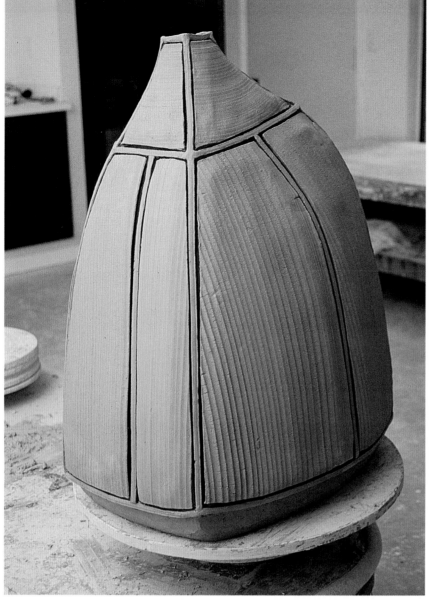

9

TO THE BEGINNER

If you will read the following pages on throwing many, many times over, you will fix the words and steps in your subconscious memory. Your fingers will respond quickly because they are really being told what to do by my words in your mind.

Throwing takes years of practice before you will be in complete control of the clay and the wheel. But even in the beginning you can respond to the clay, react to the motion of the wheel, and make something, or make something that you can make into something else, by hand. The pleasure of throwing will be enhanced as control and skill improve.

Practice the whole process of throwing. "The whole is greater than the sum of the parts," as the Gestalt psychologist says. Practice centering and opening the ball first. Then wedge five small balls of clay (approximately 5 lb/2 kg each) and **practice these five shapes**, one after the other, in this order:

(1) cylinder;
(2) half-sphere;
(3) whole sphere;
(4) sphere and cylinder combined;
(5) low open form.
Repeat every day or as often as possible until you feel mastery over these five shapes.

We could give functional names to the above shapes, such as bowl, round vase, bottle, plate, but I prefer not to do this. **I prefer you to think of the geometric form, not function, when you practice shaping on the potter's wheel.**

After some days of practice at centering and opening the ball, then practicing the shapes, now begin to analyze

1

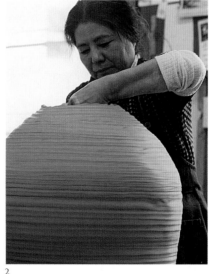

2

Toshiko Takaezu makes a 7-ft tall sculpture by adding coils and throwing them true. In the process of gaining height she stiffens the clay with a bonfire inside the vessel; eventually she encloses the form totally (see a finished piece by her on page 22)

where you are having problems and practice the trouble spots. When you have managed all the shapes pretty well, do the same thing again with balls of clay twice as large.

Remember the motion of the wheel. No change in the movement of your hands should be made until you feel that the clay has revolved under your hands one or more times, so that it has reacted to your pressure all the way round.

Remember that the smallest pressure point gives the most control. The smaller the area of clay that your hand or fingers touch, the less drag on the clay, and the better leverage you will have. Beginners tend to want to put their whole hand, or both hands, against the clay. This never works. Just a small point at the base of your thumb, or the tips of the fingers, should touch the clay.

Remember to pull from the bottom to the top every time you draw. This keeps the motion and rhythm of the lift. Finish the shape at the bottom first, then the top. Put your fingers on each side of the wall, feel the form from the bottom, as you move up, being careful not to exert pressure, except where you wish to add pressure to further the shape.

Once you know intuitively where the pressure really is, and can feel the clay respond immediately, then you can make your own way.

STEPS IN THROWING ON THE POTTER'S WHEEL

Wedging

1 The basic ball

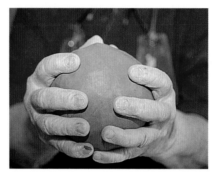

The photographs of processes in this and the next chapter by Craig Smith are of Susan Peterson in her studio

ABOVE The basic ball for beginning learners

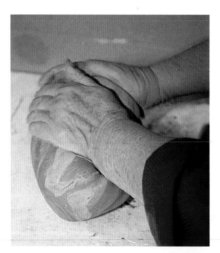

Beginners can check their wedging capability by using two different colors of clay and wedging until they are completely amalgamated into a single color:

Turn the ball of clay on its end, push the left hand down into the clay, and. . .

Take a lump of clay the size that your two hands will go round without quite touching.

2 Wedge clay
a. Left palm pushes into clay, right palm pivots the ball; continue and keep a steady rhythm.

b. Spiral shape develops which shows that the clay is moving and the whole chunk is being wedged.

c. Proper wedging removes air bubbles, puts clay in good condition for working; if dry, add water and wedge.

3 Put clay on wheel
Pat into a cone shape, and put the wide part down against the wheel head or bat. Turn the wheel on or begin to kick it; moisten the clay with water.

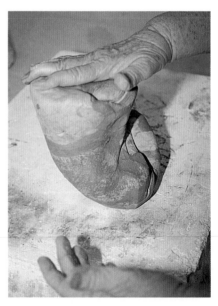

. . . pivot with the right hand. Repeat the process, left hand down, right hand pivot, until consistency is even

Centering

1 Begin centering

a. Squeeze the cone up with the base of the palms of both hands, squeezing into the clay and lifting up.

b. Push the cone down with the base of the left palm lying on top of the clay; the base of the right palm, held vertically, perpendicular to the other hand, also pushes down.

2 Lean in and center

Center by leaning in with the edge of the palm of the left hand, at the 8 o'clock position on the left side of the clay (if the wheel goes counter-clockwise), or 4 o'clock (if it goes clockwise). "On center" means running true with the centrifugal motion of the wheel – you must learn to feel that, but you can test it by holding a point against the clay; if it is centered the point will make a mark evenly all the way around.

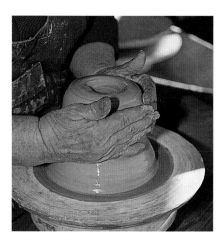

Begin centering:

ABOVE Squeeze the ball of clay up with the bases of the hands opposite each other

Press down to center by leaning into the clay with the wrist flexed, using the base of the left palm; wheel revolves counterclockwise

The base of the right hand lies opposite left thumb to push the clay downward

First finger of right hand, buttressed by second finger, pushes straight down from the top to true up the base

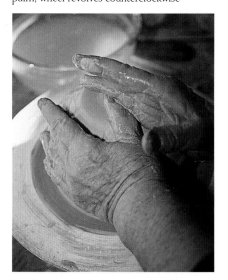

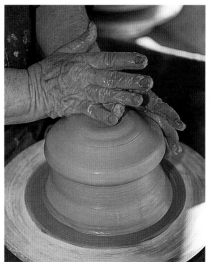

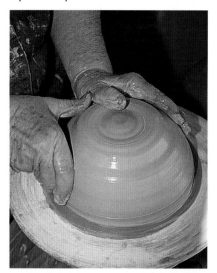

Opening the ball

1 Opening position 1

All directions are for counter-clockwise rotation. Reverse for a clockwise wheel. Left middle finger centered on top of the clay, with middle finger of right hand over it; hold left finger rigid and push straight down, right finger guides.

Open the ball by pushing straight down, (a) with the middle finger of the left hand supported by the middle finger of the right hand, or (b) by the tip of the left thumb supported by the right hand, and pull toward you to widen the hole

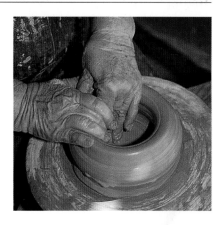

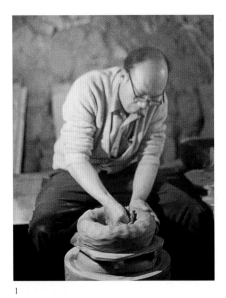

1

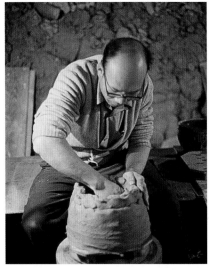

2

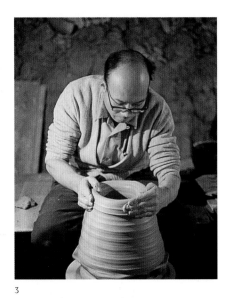

3

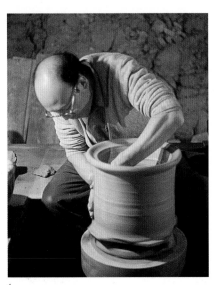

4

Shinsaku Hamada throws a 42-inch diameter bowl:

1. He punches a hole into a lump of clay, because his Korean kick-wheel moves too slowly for him to center a solid ball of clay

2. He adds coils to the first thrown base

3. He throws the coils true

4. After straightening the cylinder he sets a wide lip which will remain to reinforce the vessel

5, 6 He expands the bowl, being careful not to affect the lip

7. He smooths the interior with a thick wooden rib

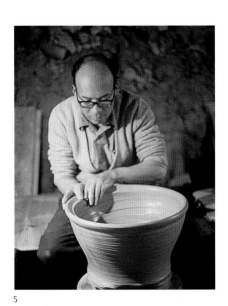

5

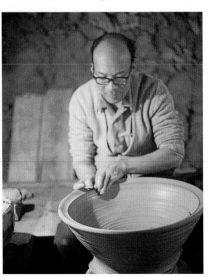

6

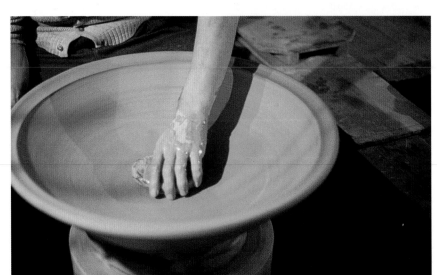

7

2 *or* **opening position 2**
Left thumb finds center on top of clay, middle finger of right hand on top of thumb; thumb pushes straight down, guided by right finger.

3 Push to bottom
Push down to within about ¾ inch (2 cm) from the bottom.

4 Open
Position 1: pull the middle finger toward you,
or Position 2: push thumb from the bottom center out to the left.

Pressure of either position will move to the wall of clay from the hollow now being opened; move far enough to make several inches of curved opening. Feel the thickness of the wall and try not to go all the way through.

Pull up (cylinder shape)

1 Hand position
Left middle finger-tip, buttressed by the left first finger, goes inside to the bottom and sweeps over to the right wall. Right first finger crooks toward you, the first finger-tip pushes into the clay on the outside for almost an inch (2.5 cm) and begins to lift upward. Fingernails must be short!

2 The first draw upward
Inside, the left finger is slightly above the outside right finger that pushes in. The outside finger does the lifting, pushing in enough to make the wall slant inward but without curving; the inside finger follows.

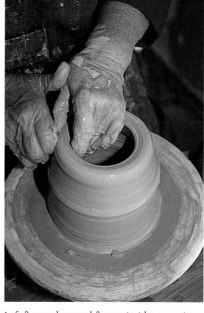

Left first and second fingers inside, opposite right first and second fingers outside, at 4 o'clock position; fingertips squeeze together and lift straight up into cylinder shape

Cut lip by holding needle tool at 4 o'clock position; left hand holds the edge while right hand pushes the needle through the clay to the inside finger

When the tool has cut through the clay, quickly pull the severed rim away

Trim the base of every pot by holding the wood knife pointing down, parallel to the profile shape, a few inches up from the base. The cutting edge of the knife must be toward you. Press the point of the tool down into the clay toward the base to cut the excess clay away and refine the form

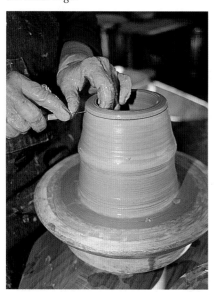

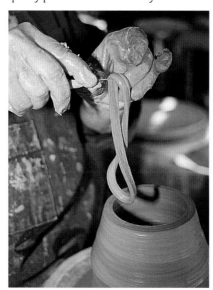

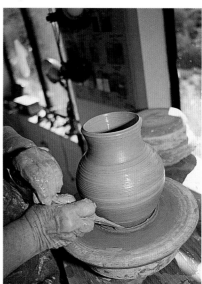

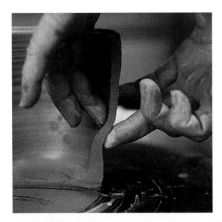

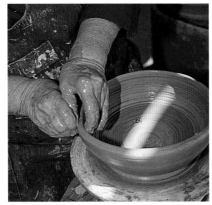

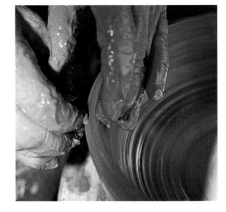

Cross-section of thrown piece; beginners should cut their thrown pieces from top to bottom with a wire to see how even the walls are

After opening a low, wide cylinder, expand the clay into a half-spherical shape with the fingertips of the left hand exactly opposite the fingertips of the right hand. Pull up and out three or four times, slowly, so that the clay will not fall

3 Continue up

Repeat, bottom to top each time, until the wall is as tall and the cross-section is as thin as desired.

4 True lip

If the lip is uneven, cut it with a needle or a wire. Hold the tool on the right-hand side of the clay (even if you are left-handed), with the point resting on your left thumb, which with the left middle finger holds the wall. Push the point into the clay, toward the left middle finger, rotate the clay at least once, and the lip is cut. Lift off the clay ring. Sponge the lip smooth.

5 Trim base

Trim excess clay from the base of the cylinder several times as you lift up, between lifts. At the end, trim once more, holding the wood knife on the right-hand side of the clay, *first parallel to the bat*, in for about an inch (2.5 cm) toward the clay base, *then vertically*, parallel to the cylinder. Press the point of the tool into the clay wall and curve in, to indent the base.

Half-spherical shape (sometimes called bowl)

1 Center a low wide mound

Push downward with the wrist-end of the left hand on the top center of the mound, the heel of the right hand against the left thumb; lower the mound. Push down to make the base of the mound as wide as you want the base of the shape to be.

2 Open the mound

Same method (1 or 2, 3, 4) as for the cylinder shape. The inside opening will be wider because this mound is lower and wider than that for a cylinder.

3 Pull up the wall

Lift a low fat wall, with three or four draws upward.

4 Shape the half-sphere

Inside, the left-hand middle finger, buttressed by the curled first finger, drops from the wrist; it moves from the center out toward the right side. When the fingers reach the wall, the right-hand first finger, on the outside, curled and with the fingertip

pointed into the clay, squeezes inward to meet the "feel" of the inside finger. On the inside, the left middle finger, buttressed by the first finger, pulls over to the right and up to the top. Pressure from the inside fingers controls the round shape. Both left- and right-hand fingers together, with the clay in between, draw out and up in the desired profile line.

5 Finish the shape

Continue bottom to top, pulling outward with the inside left finger toward the outside right finger, and upward until the half-sphere is shaped and the wall is thin enough. True up the lip, cut if necessary, smooth it, and undercut the base with the wood knife, as in the cylinder.

Full spherical shape

1 Begin a half-sphere

Make a basic half-sphere, leaving a fat roll on the top lip. Shape the half-sphere curve from inside out, using the fat roll to lift up out and in toward the center in a diamond shape.

2 Expand the diamond

Push outward with the inside hand for the half-sphere, then the outside hand takes over to pull the diamond shape taller, rounder, and thinner. Keep the curve moving up at all times; don't push in horizontally, or the wall will fall in. Keep the top opening narrow; if you widen it to get your hand inside, narrow it again at the finish of each draw.

3 Make the full sphere

With one last draw, push out with the inside hand up to the middle, rounding the half-sphere, then "draw" the profile shape of a full circle with your two fingers opposite each other, one inside, one outside. The opening should be as narrow as you can make it.

4 Keep practicing

This is a difficult shape. Do it over and over.

BELOW The five basic shapes a beginner should practice over and over have to do with form, not function; *cylinder, half-sphere, full sphere, full sphere and cylinder combined, low open form*

Sphere and cylinder combined (sometimes called bottle)

1 Center, open, lift

Pull a cylinder about as tall as you want this form to be. Don't pull all the way to the top – leave a fat roll at the top.

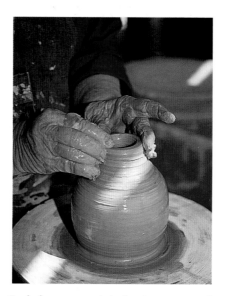

2 Shape the sphere

Go to the bottom with left fingers inside, opposite the first finger of the right hand outside, and expand the spherical shape, out and in, like a grapefruit.

3 Lift the cylinder

When the circle form is made, take the fat roll you left at the top and lift it into a cylinder.

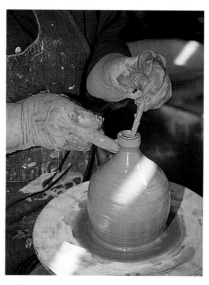

Bottle forms are made by keeping an extra roll at the top of the full spherical form from which to create the neck. Collar with the fingers of both hands squeezing in and lifting up. Use a tool such as a stick inside the bottleneck when your finger no longer fits in. Continue squeezing and lifting until the neck is the shape you want

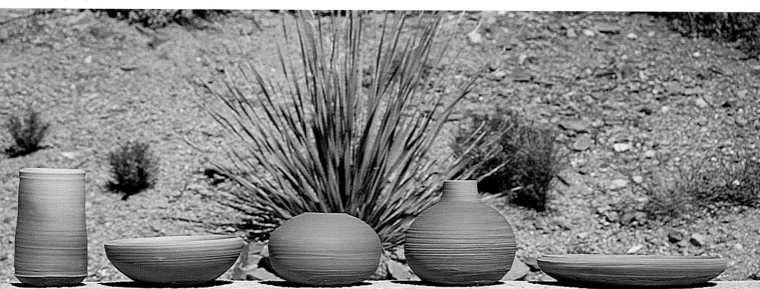

Linda Speranza's large platter is reduction
fired with cobalt and copper glazes

Stoneware bowl by Vivika and Otto
Heino, reduction matt glaze

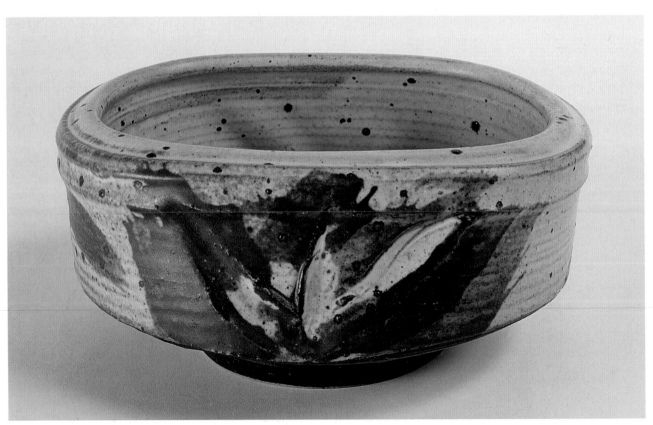

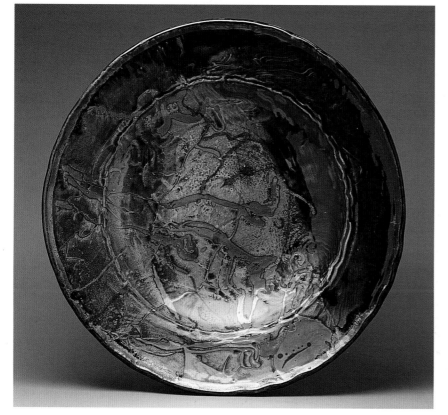

Susan Peterson's stoneware bowl is reduction fired with a copper glaze

John Glick's reduction fired platter illustrates multiple glaze techniques: trailing, wax resist, painting

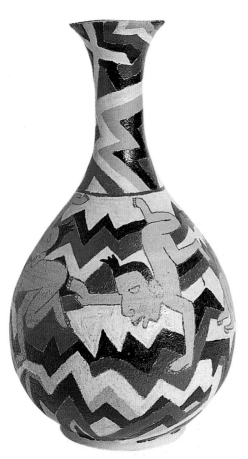

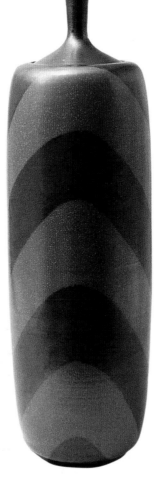

FACING PAGE Elsa Rady's wall piece is assembled of cobalt-glazed porcelain bottles on a painted aluminum shelf

INSET George Bowes's stoneware bottle, brushed with engobes and glazes

LEFT Harrison McIntosh's stoneware bottle has engobe pattern under a translucent matt glaze

Tor Alex Erichsen's bottle (Norway) is finished in unglazed engobes

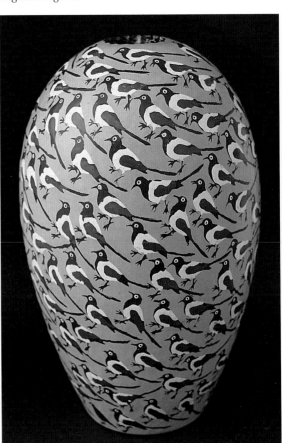

Michael Frimkess's stoneware bottle is decorated with an Aztec design in brushed glaze

Edoardo Vega's cast bottles (Spain) are decorated with low-temperature oxidation glazes

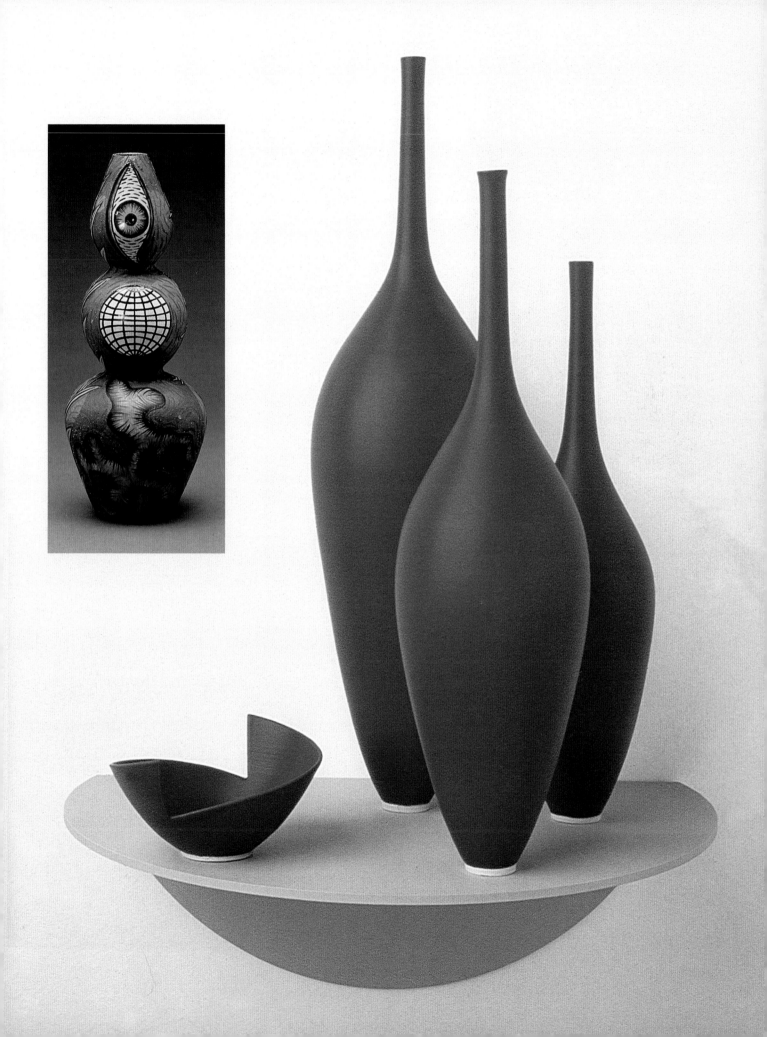

This shape will look like a ball with a stove-pipe on top. It will not look like a normal bottle, but as I said I want you to learn geometric form, not function, now.

4 Cut lip, trim base
Cut the lip even, sponge smooth. With wood knife, after cutting parallel to the bat, carve a nice indented line at the base by pointing the tool downward and cutting against the profile of the clay shape down and into the base.

Low open form (sometimes called platter)

1 Center a mound of clay
Press down to lower and expand the centered mound to the diameter you want the foot to be.

2 Open the low wide mound
Open and pull toward you to widen all the way; repeat several times to make the low wide cylinder. Press harder in the center, relax your stiff fingers as they pull toward you, so a shallow curve will develop from the center to the edge of the cylinder.

3 Lift once
Pull up the cylinder once and form the lip, rounding or beveling it to desired thickness.

4 Shape
Begin in the center, pull out to desired width, then pull up the short edge, refine the curve, shape the lip.

5 Cut under
With the sharp pointed wood tool, cut into the base down

toward the bat to shape the profile.

The five shapes you have just practiced are the basic shapes from which all pottery wheel forms come.

Other shapes are variations

A pitcher is a bellied cylinder with a flared top for the pointed pouring lip. Make this by holding the thumb and

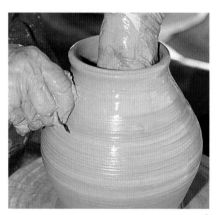

Most pitchers have a functional shape that 1
is wider at the bottom and collars in to a flared
neck which controls the liquid to be poured:
ABOVE Lift a narrowed neck from the full
sphere shape

Form the pouring lip by pushing in with the
outside thumb and first finger against the
inside finger, lifting and pulling over to form a
sharp point to cut the drip 3

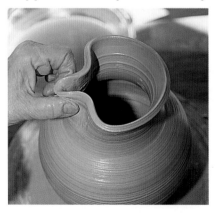

third finger of the left hand outside against the pitcher neck, and with the right-hand first finger down inside the neck, pull up and out into a lip-shape. This can also be done reversing the two hands, whichever you prefer. Sharpen and thin the lip to a sharp edge for pouring without dripping.

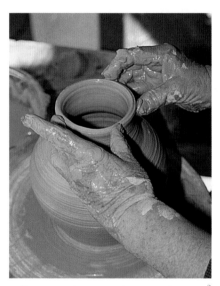

Collar in with fingertips of both hands and 2
flare the lip

Wire-cut to sever the bottom from the bat
and carefully lift the wet pitcher off 4

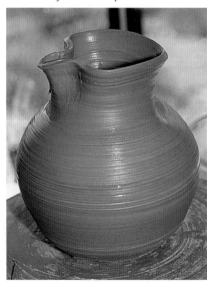

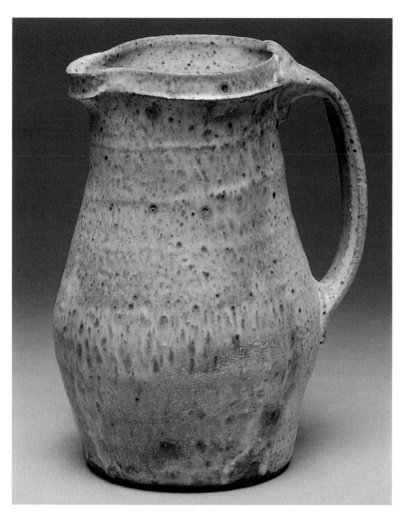

LEFT A classic matt glazed stoneware jug by Greg Miller

BELOW Goedele Vanhille's paddled and cut thrown
earthenware pitcher has been raku-fired

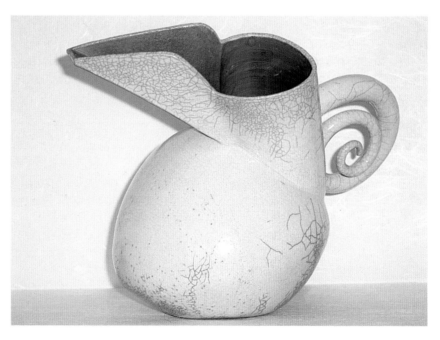

Make the flange for a lid by pushing straight down on a thickened cylindrical wall with the first finger of the right hand against the first finger of the left hand, which is underneath to support the flange

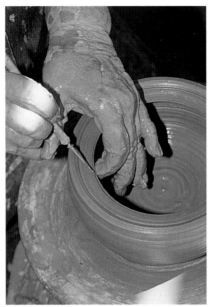

Cut the flange true with a needle at the 4 o'clock position

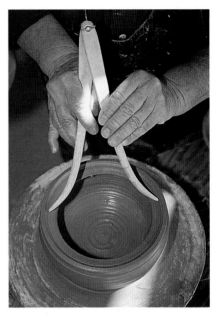

Measure with a wooden calliper the exact spot where the lid should sit, and throw the lid to fit

A casserole is a large half-sphere, with a horizontal flange where a lid will sit, or without a flange so that the lid must have a vertical flange that fits down inside the lip of the pot. Measure the opening the lid will fit into, or the casserole flange on which the lid will sit, very carefully because it is only a proper measurement that will make a lid fit. If it does not fit it is the potter's fault.

Lids for all pots are made in several ways:
1. Dome-shaped, upside down like a low, flat, open form, then turned right side up and trimmed. A hand-built knob is added, or a round fat coil attached and thrown true for a knob.
2. Right side up, flat against a bat: center a mound wide enough to fit into the pot; open the mound off-center, leaving clay in the middle from which to throw up a knob. A lid made right side up can also have a flange if you press into the clay at the base of the mound to achieve the proper diameter and height to fit in the pot.
3. Upside down with a flange: open a mound of clay as wide as the lid needs to be, pull the wall up once and fashion a flange at the edge, pressing in to achieve the required diameter, and pulling up a quarter-inch (6 mm) or more to fit inside the pot; then go back under the flange and belly out the dome-shaped lid, being careful not to ruin the flange. Or leave the lid flat instead of dome-shaped.

Lids should dry on their pots. Lid and pot should bisque-fire together, but askew so that air and moisture can escape from the pot. For the glaze firing, wipe the glaze from the edge of the lid and the rim of the pot so the two can be fired together. If you want the edge glazed, fire the lid separately. If lid and pot are nesting, glaze will seal the pot and lid together if there is the slightest drop on the contact edges of the two pieces.

Cups with handles are simple except for the handle-pulling. Handles for thrown pots should be pulled from a solid lump of clay, just as the cup is thrown from a solid lump. Hold the well-wedged lump in one hand, moisten the clay, and begin to pull downward with the thumb and finger, forming a circle around the clay; turn the pulling hand as you work to keep the handle shape even. When you have pulled a long enough, thick enough piece, pinch it off with your fingers, arch

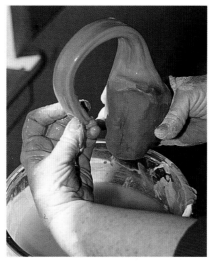

Pull a handle from a wedged chunk of clay 1
by holding the clay between thumb and
fingers, turning the other hand from left to
right, pulling from the top downward until
the desired shape is achieved

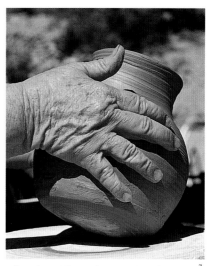

Curve the handle and set it aside to stiffen 2

When the pitcher is dry enough to handle, 3
roll the bottom against a flat surface to
achieve a rounded foot. Cut the handle from
its base, and fit it to the pitcher

it and put it on a board to stiffen
until you can attach it.

A tea- or coffee-pot shape is one
of the most difficult composite shapes
because of the complicated parts, the
assemblage, and the reference of the
parts to each other, but beverage pots
are among the most exciting forms
for the functional potter.

The body of the pot is made first;
then throw the spout (see p. 74) on
a separate bat. Make the lid with a
deep flange so it won't fall off the pot
when it is tilted for pouring. The spout
must be thrown so that, when it is
attached at an angle, it is long enough
for its narrow end to be as high up
as the lid of the pot – otherwise the
liquid will leak out.

Pull the handle when the body is
trimmed, then trim the lid if neces-
sary. Next, attach the spout, mak-
ing a full hole in the body, or punch
small holes at the point where the

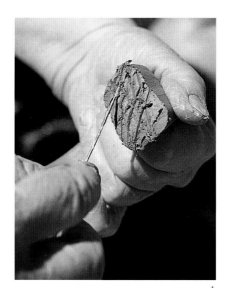

Score and moisten the ends that will be 4
attached

spout fits, to strain the liquid from the
leaves when pouring. The pulled
handle can be attached opposite the
spout or it can fit in an arc over the
top of the pot. If you prefer the Ori-
ental-style bamboo or reed handle,
make two small hand-built clay lugs
on either side of the top opening,
for the ready-made handle.

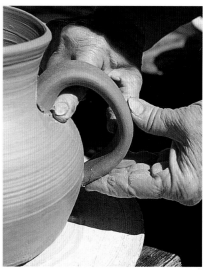

After scoring and moistening the 5
attachment points on the pitcher, fix the
moistened handle on and smooth it into the
body

Large thrown pots can be made
several ways (see pictures on pages
57–59):
1. Throw and coil: throw as tall as
 you can, then begin to add
 large fat coils one at a time,
 each luted well into the last,

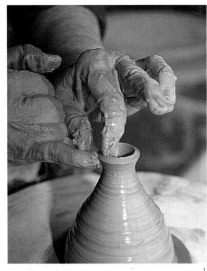

Throw the teapot spout by expanding it at the base and collaring in at the top, in much the same way as a narrow-necked bottle is formed

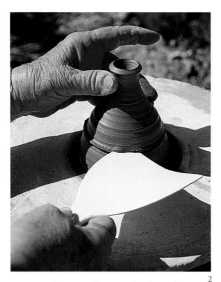

Wire-cut the spout base at the desired length, and lift it off when it is stiff

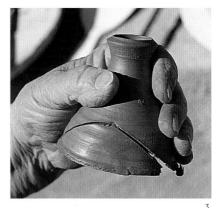

Arbitrarily cut away a triangular section to help fit the spout to the body

Thin the cross-section of the spout with a metal knife and score it in preparation for attaching

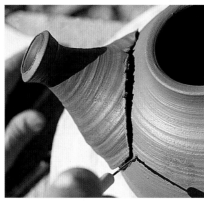
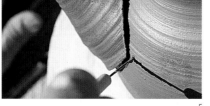

Hold the spout against the teapot body and trace around the base where it is to go. Use a drill bit or other rounded tool to punch holes to strain the tea-leaves. Score both the spout and the area to which it is to be attached, moisten, and meld the two

Three bisque teapot variations: left, a pulled clay handle, middle, a Japanese bamboo handle, to be fitted on after the glaze fire, and right, a thrown lug handle; the right-side-up thrown lid shows the correct depth of the flange

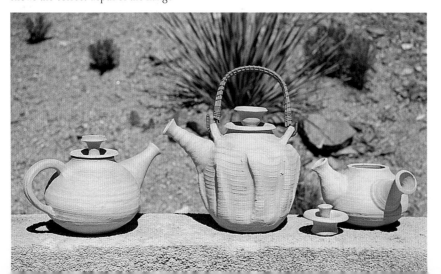

and throw each coil up true until you have your desired height.

2. Make a number of thrown sections, measuring with a calliper where they will fit together, and attach them in the leather-hard stage. Do not use a ruler: it is not accurate enough.

3. Make a number of thrown sections without measuring anything and put them together in a frenzy of creative passion, cutting, slashing, pushing the parts into a whole sculpture.

4. If you don't have a large enough kiln to fire the monolithic piece, fire the sections and attach them with a good glue or plumber's cement, or put them together by other means such as nuts and bolts, wire, wood or metal appendages, or even bandages.

Trimming thrown pots can be achieved in the classic fashion by turning the form upside down, re-centering it on the wheel, and trimming an indented, pedestal foot with a sharp tool; tool the profile on the right

side of the pot if the wheel goes counter-clockwise and on the left side of the pot if the wheel goes clockwise.

Alternatively, paddle the foot shape, carve it, add legs or other standing supports, roll the bottom against a flat surface – or think of other ways.

Making sets, all items alike or pro-portionally related, is difficult for begin-ners. Weighing balls of clay helps, as does taking proper measurements or making a template for the profile changes. Keep wall thickness, edges, and feet alike too.

Throwing off the hump: start with a large solid lump of clay and cen-ter the whole thing, or just the top for the first pot. Take a bite of clay the size you think you need by making a line at the base of the top centered chunk, open that ball, pull up and shape the pot from that line, cut with a wire and lift off. Start another piece the same way and continue until all the clay is used up.

Throwing teapot spouts uses the same method as making a tall thin bot-tle neck, except that you can begin from a hump of clay and cut the spouts off, or throw each spout directly on its own bat.

Throwing a closed form is simi-lar to throwing a spherical shape, except that you will pull the clay wall all the way over and close the vessel com-pletely; use a rib to press down at the closure to insure the seal. Prior to closing you may want to blow into the shape to fill out the form.

Throwing a do-nut shape is dif-ficult. Begin with a low wide mound of clay the diameter you wish the out-side to have. Make a hole, not in the center of the mound, but off-cen-ter; raise and shape the outside wall. Next, open the mound in the cen-ter and go directly down to the bat, clean up that hole with a tool, and

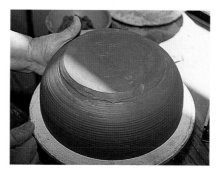

Trimming the bottom of a leather-hard pot on the wheel is only one of a number of ways to achieve a foot:
Recenter the thrown pot upside down on the wheelhead by leaning in with the base of the left-hand palm at the 8 o'clock position

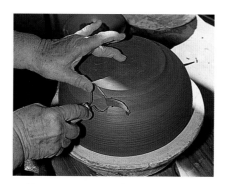

Hold the pot down with middle finger of left hand and tool the outside profile as desired

undercut it for shaping. Raise that wall also and pull the two walls up and over to each other, closing their edges together in the do-nut form; you now have a hollow do-nut shaped ring with a void in the center.

Remember that it seems to take forever to learn to throw. No mat-ter, a form of some sort will result each time you work at the potter's wheel. Use these uncertain shapes for glaze and decorative experimentation. For practice, please refer to my book *The Craft and Art of Clay*, for detailed step-by-step photographs of all the throwing processes. Often beginner's luck creates really interesting works.

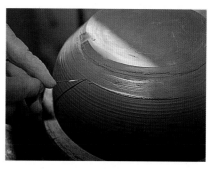

Alternatively, make a mark with any tool on the spot closest to you as the uncentered pot comes to you, mark each end of the line with the fingers, and bisect the line with the thumbs; push away from you a little at a time to move the pot on center. When it is on center your tool will make a mark all the way round

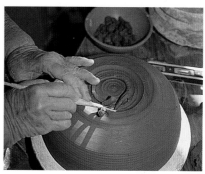

Carve a foot rim by pushing the tool first down in the center, then out toward the edge

Nothing is wasted; look carefully at everything you do, for inspiration, for self-tutoring.

Steps for easy progression in learn-ing to throw will be found at the back of this book, as well as suggestions for individual projects that can be fabri-cated in any of the methods we have discussed, once you have gained some experience. Collectors and friendly observers who are reading this book, but are perhaps not involved in clay construction, will find that the information and perceptions out-lined here are helpful in gaining a com-plete understanding of the ceramic medium.

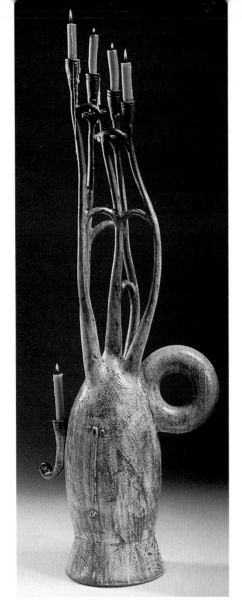

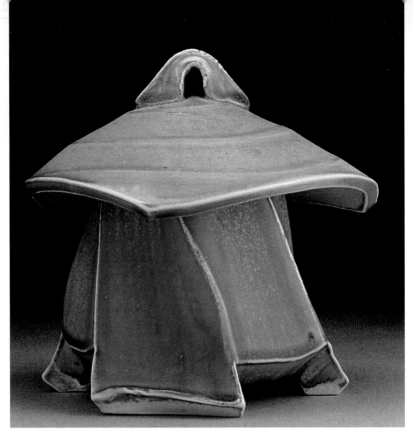

Gay Smith has cut and reshaped her porcelain lidded jar

Thrown pieces can be misshapen and changed into many other kinds of forms in the wet to leather-hard stage:

LEFT Curtis Hoard's thrown stoneware candelabra, nearly 5ft tall, is a tour-de-force of throwing and hand-building technique

Tim De Rose's thrown stoneware plate with articulated edge has been decorated with engobe and salt-glazed

Chris Staley's thrown porcelain teapot and cups were altered in the wet stage

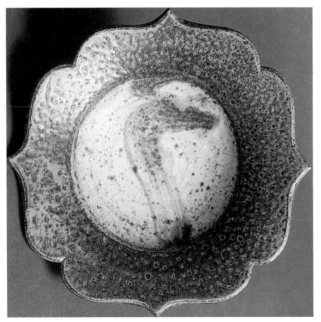

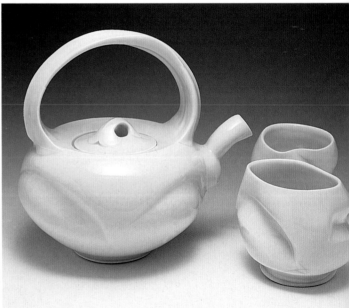

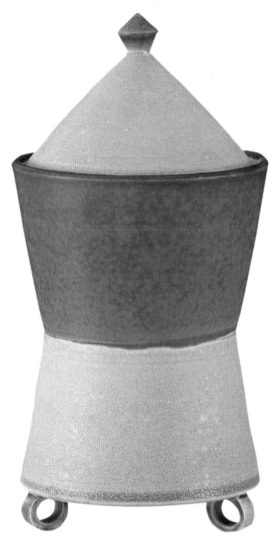

Oxidation fired stoneware lidded jar by Emily Myers, England

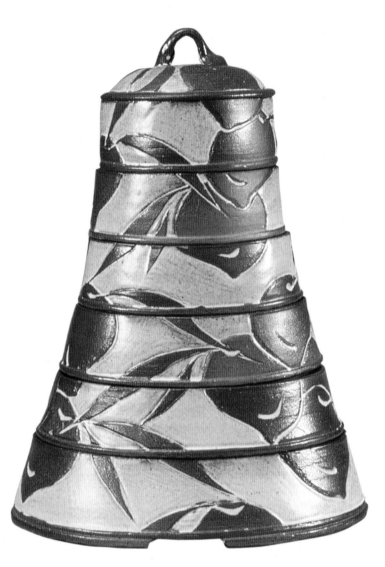

Ray Meeker's tiered and lidded set of serving dishes (India) is wax-resist and glaze decorated

Deborah Smith's lidded casserole (India) has an easily grasped knob and is decorated with brushed oxides over the glaze

Linda Christianson's woodfired porcelain cups and saucers are glazed inside only

The openwork sections of these thrown and pierced porcelain cups by Sandra Black (Australia) are covered by translucent glaze

Nick Joerling's thrown and altered stoneware cup and saucer is stain-decorated

Linda Arbuckle's earthenware cup is majolica-decorated with stain washes over a white glaze

Randy J. Johnston's thrown
teapot has been touched
with color in the woodfire

Sue Taylor's coffee-pot is
earthenware, glazed and
majolica-decorated

Sandy Simon's porcelain
teapot is brushed with black
and yellow glaze stains

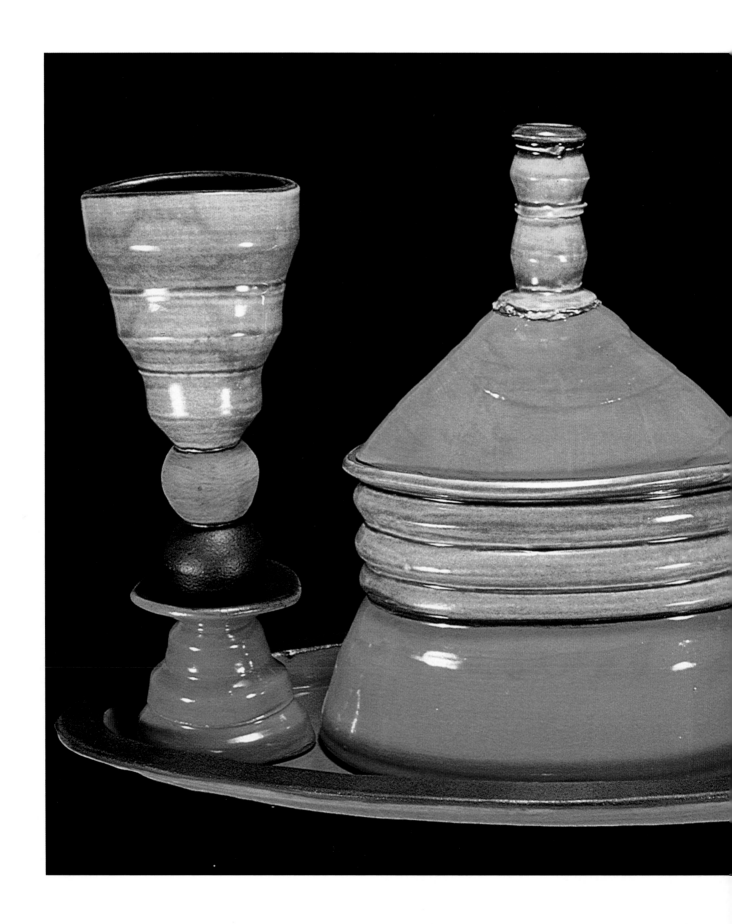

Sets are great fun for the potter, because relating the various components to one another presents a stimulating challenge:

Jane Dillon's set of a jar and two vases

Josh DeWeese's thrown and altered oil and vinegar set is soda-fired stoneware

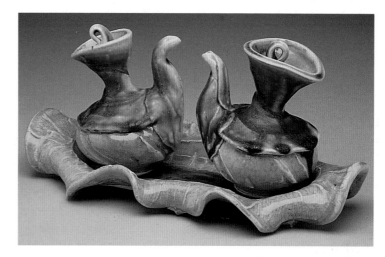

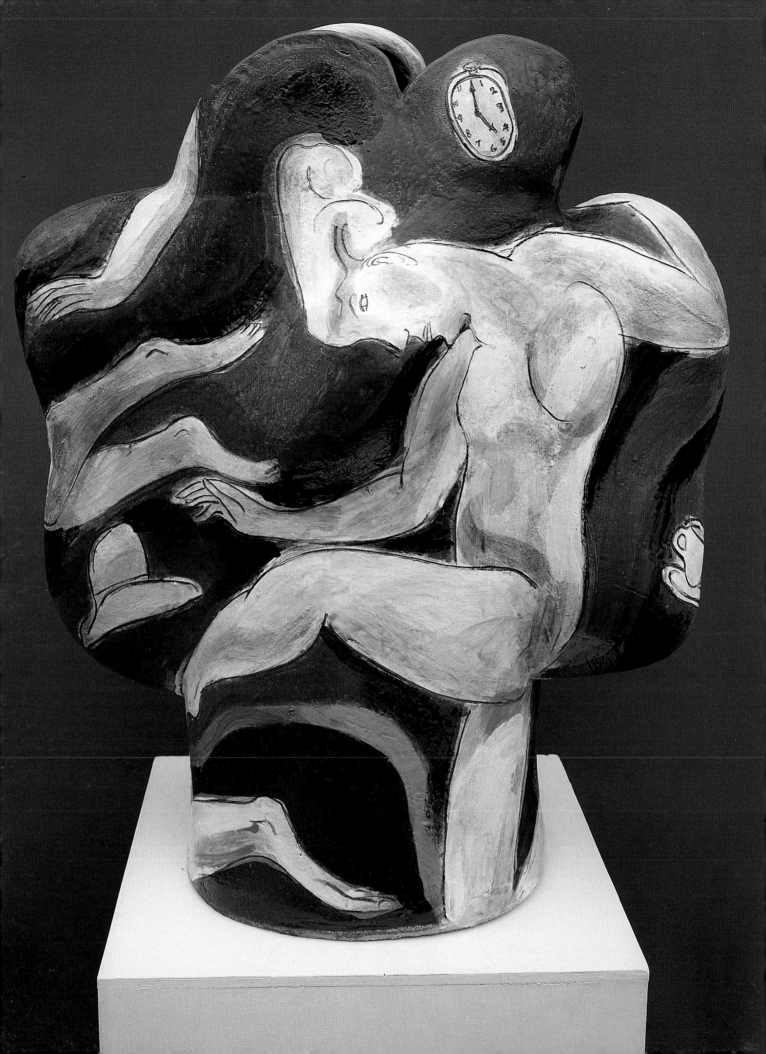

4

FINISHING

TOUCHES

ENHANCING THE CLAY FORM

Since the beginning of time, human beings have felt a desire to embellish their claywork. Early in history, coiled pots were made with the coils showing, and perhaps stick-marks or indentations were made on them while wet. Often clays of other colors were added to the surface of a vessel and drawings were scratched through the second color to the clay body. Sometimes clay cut-outs or decorative appendages serving no function were added to the surface. Many times, brush-strokes of a different-colored clay decorated the pot.

Thousands of years passed before glass and glaze were discovered, probably around 5000 B.C. With this achievement a variety of colors were possible and a shiny, easily cleaned surface was developed. More importantly, a transparent glaze could cover and protect the colored clays and textured surfaces with which primitive potters had been ornamenting their vessels.

Rudy Autio's large slab-built stoneware sculpture is decorated with vitreous engobes and stains and a thin coat of transparent glaze

The method of fabricating the clay does not matter: decoration of all kinds is possible on any clay shape. Industrial decorative processes do differ from hand processes, but some of those methods, such as the use of decals, can also be applied to handwork.

DECORATING WITH CLAY

Texture

The simplest method of decorating clay, found in all undeveloped societies, is to pattern it in the wet or leather-hard stage with any tool or object pressed into the clay to various depths. This includes use of the fingers in a number of ways; pressing imprints of objects from nature – seed pods, rocks, shells – or "found objects" – nails, screws, wires, and so on – into the clay; using stamps you make yourself from clay, textured, carved, and bisque-fired so they can be pushed into wet clay for decoration; pressing wooden paddles or rolling castors that you have carved yourself against your pots or sculptures. Anything can be used to make impressions on clay in random or organized patterns.

Ah Leon constructed his 60-ft long bridge in Taiwan over a period of several years; each segment was slab-built hollow, with interior buttressing, and different colored clays were used

1

The artist meticulously textured the clay to resemble wood and fired in high-temperature reduction

2

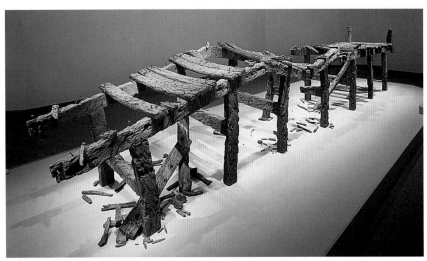

Section of Ah Leon's bridge; the entire piece was first shown at the Sackler Gallery, Smithsonian Institution, Washington D.C.

3

Texturing clay in the wet state gives a soft effect, as opposed to carving on the surface when it is leather-hard. After the piece is fired, colored metallic oxides can be rubbed into the indentations and wiped off, to highlight the patterns. Glaze will puddle in these indentations, which gives another quality to the texture.

Adding clay to clay

Clay forms of the same or different-colored clays can be appliquéd to the basic shape either wet or leather-hard; rolled, beaten, or torn slabs can be squeezed or pounded against moist clay forms; coils can be rolled into various shapes and added on, pressed flat or left to protrude; small balls of clay can be added in spots for emphasis; edges can be cut and folded to change the line. Experiment with many different additions to your forms – paddle, slash, and change the shape freely.

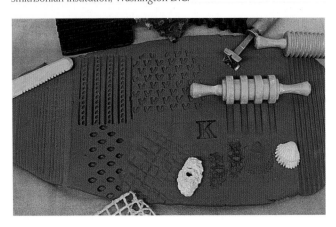

Clay is so susceptible to marking that the simplest method of decorating it is to push something into it. Any number of objects or tools will leave an interesting decorative pattern

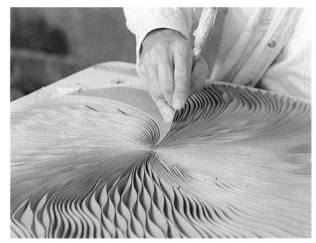

Marc Leuthold painstakingly carves a disk which will form the top surface of his sculpture

1

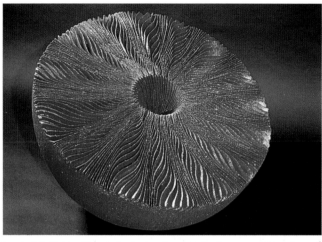

Leuthold's finished hemispherical sculpture is fired at cone 010 with a cadmium glaze

2

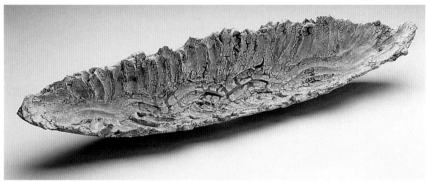

Gudrun Klix's textured earthenware sculpture (Australia) has been patinated with low-fire engobes and matt glaze to resemble bronze

Appliquéd heads and sgraffito carving embellish this vintage stoneware pot by Edwin and Mary Schirer

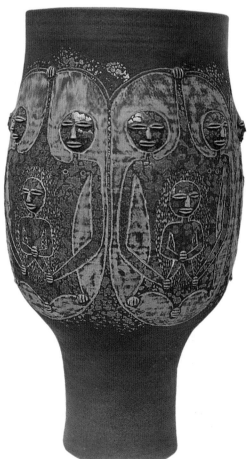

Detail of a Katie Kazan tray made with her millefiore technique. Sections of different colored clays are laid and pressed together to form patterns, then wire-cut across the grain into slabs

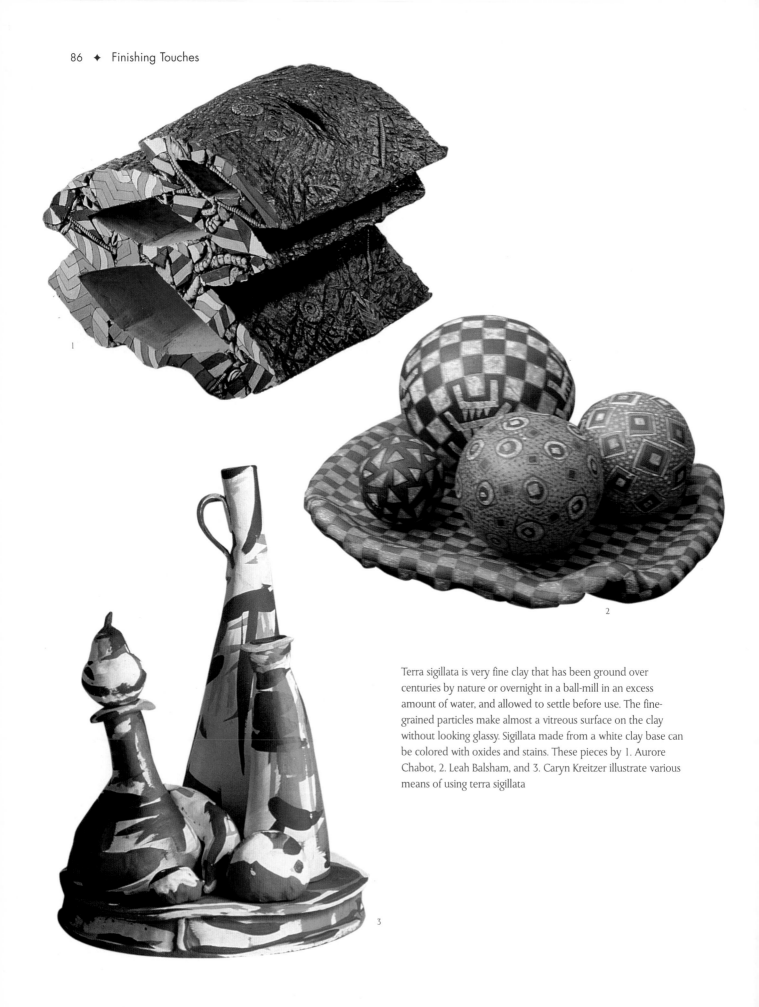

Terra sigillata is very fine clay that has been ground over centuries by nature or overnight in a ball-mill in an excess amount of water, and allowed to settle before use. The fine-grained particles make almost a vitreous surface on the clay without looking glassy. Sigillata made from a white clay base can be colored with oxides and stains. These pieces by 1. Aurore Chabot, 2. Leah Balsham, and 3. Caryn Kreitzer illustrate various means of using terra sigillata

Engobes (slips)

Engobes are liquid colored clays, sometimes called slips, that are applied in coats either in decorative patterns or all over a clay form in its wet or leather-hard state. Engobes bond only to these states unless they are specially formulated.

Engobes are made of clay and other materials that fire to the same temperature as the clay body and fit the body without cracking off. Sometimes the base clay of the engobe is the same as the clay body, or at least a similar composition. Engobes with a major proportion of clay content will be applied to moist clay; engobes made with 50% clay plus other inert materials can be applied to dry or bisque clay; engobe compositions can be made that will become dense and almost glaze-like, and are called **vitreous engobes**. White engobes can be colored with various metallic oxides. Engobes are only clay, and will not stick to the clay kiln shelf or any other pot during firing.

An all-purpose engobe batch for raw clay is:
 ball clay 80%
 feldspar 10%
 silica 10%

Add metallic coloring oxides or commercial stain colors to this batch in amounts of 20 to 50%; test the engobes on pots fired to your normal temperature with and without glaze until you reach the effect you want. This engobe is for use on wet to leather-hard clay.

An all-purpose engobe batch for bisque clay is:
 ball clay 50%
 talc 20%
 whiting 10%
 feldspar 10%
 silica 10%

An all-purpose vitreous engobe batch is:
 ball clay 40%
 whiting 10%
 feldspar 30%
 silica 20%

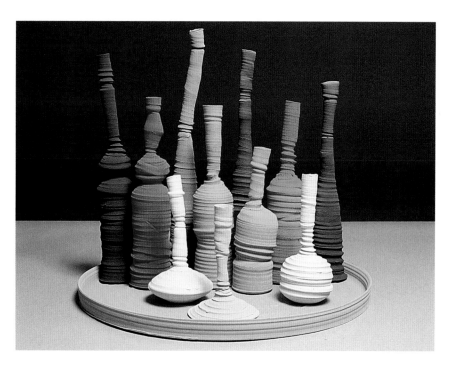

Engobes and glazes are colored with natural metallic oxides or with commercial blends of metallic oxides and other materials called stains, which achieve a wider palette:

TOP A porcelain sculpture by James Makins which was sprayed with stain-colored engobes and oxidation fired
BELOW Makins has added Mason stain 6005 to the base glaze, cone 10 oxidation

Add metallic oxides or commercially manufactured glaze stains in the amounts of 20 to 50% as mentioned above for the all-purpose engobe batch, to color these engobes.

Engobe techniques

1. Sgraffito Cover the clay body with one or more colored engobes and draw a design or carve away areas of the engobe through to the clay, to a suitable depth. Use a variety of tools to give different lines.

2. Slip trail Trail the liquid engobe with a syringe, a small bulb or a small ladle. Try this on the wheel too, allowing the clay to go around at different speeds.

3. Combing Draw a comb, a fork, or a quill through one wet engobe to another one, which can be either dry or wet. This is a simple method that looks complicated, especially if several colored engobes are used.

4. Marbleizing Pour two or more colored engobes in layers on the piece, pick it up, and rotate it so the colors mingle.

5. Brush, pour, dip, and spray engobes Engobe consistency determines the look of the stroke: the thicker the more like oil painting, the thinner the more like watercolor. Spraying with a hand or an electric gun may require the engobe to be thinned to go through the nozzle.

6. Resist Wax resist technique is most common, but liquid latex, paper or cardboard, commercial labels, masking tapes, and the like will restrict the application of engobe or glaze. To keep a crisp line, paper and latex should be removed after the design is completed, although they will burn out. Essentially, resist is a stencil.

Wax resist is accomplished with water-soluble waxes, available commercially, or with melted paraffin, to which benzine or turpentine is added to make the wax flow. (Great caution is needed when using these or any flammable solvents.)

Wax burns out at 300° F (150° C), leaving the blank spaces of the design. Water-soluble waxes do not resist as well as paraffin. Take care not to dissolve the wax with the liquid engobe or glaze. Paraffin cannot be removed from a brush; keep separate brushes for wax and utensils.

Engobe resist decoration can be left unglazed, which keeps its clay texture and is a handsome finish. Or, covered with a transparent glossy glaze, engobe will show the design exactly and will be shiny; covered with a thinly applied opaque white or lightly colored glaze, the engobe will show through dimly; covered with a translucent matt glaze, it will be diffused and dull in surface.

These techniques can also be used with glaze decoration.

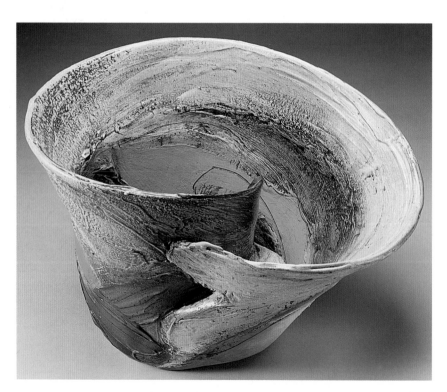

FACING PAGE Hakami is a traditional Japanese technique in which slip is applied with a huge brush, leaving the texture of the stroke or blob. This pot by Warren MacKenzie is reduction fired at high temperature and has an oatmeal glaze

INSET A floor piece by Lilo Schrammel is engobe-coated and high-fired

LEFT Heavy engobe, laid on thickly with a big brush, engraved through to the earthenware body and left unglazed; bowl by Susanne Stephenson

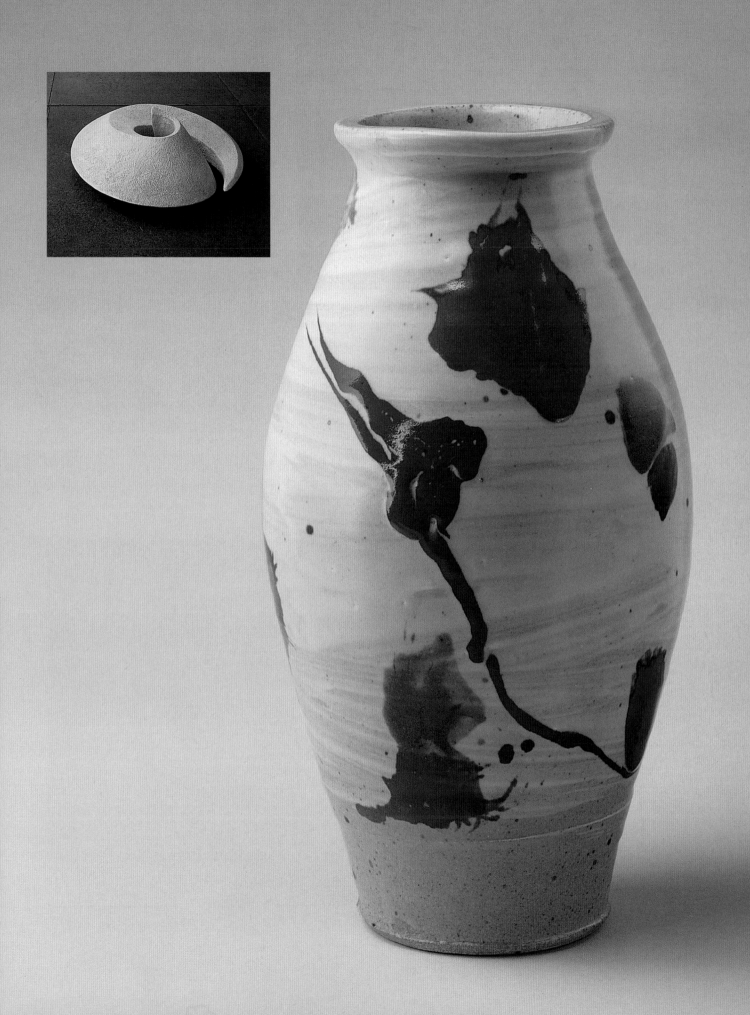

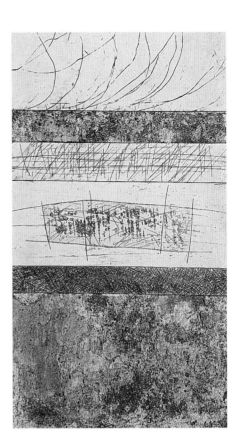

In the mishima technique, raw clay is carved, then brushed over with wet engobe; the surface is scraped clean, leaving the engobe decoration inlaid. This stoneware pot by Tzaro Shimaoka is high-fired in his hill kiln in Mashiko, Japan

This stoneware plaque by Cathy Fleckstein (Germany) illustrates the fine, crisp line that results from a sharp tool being drawn through engobe

Richard Zane Smith's carefully coiled and textured pot is painted with thin washes of colored engobes

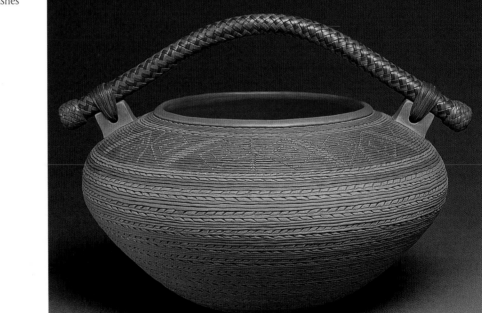

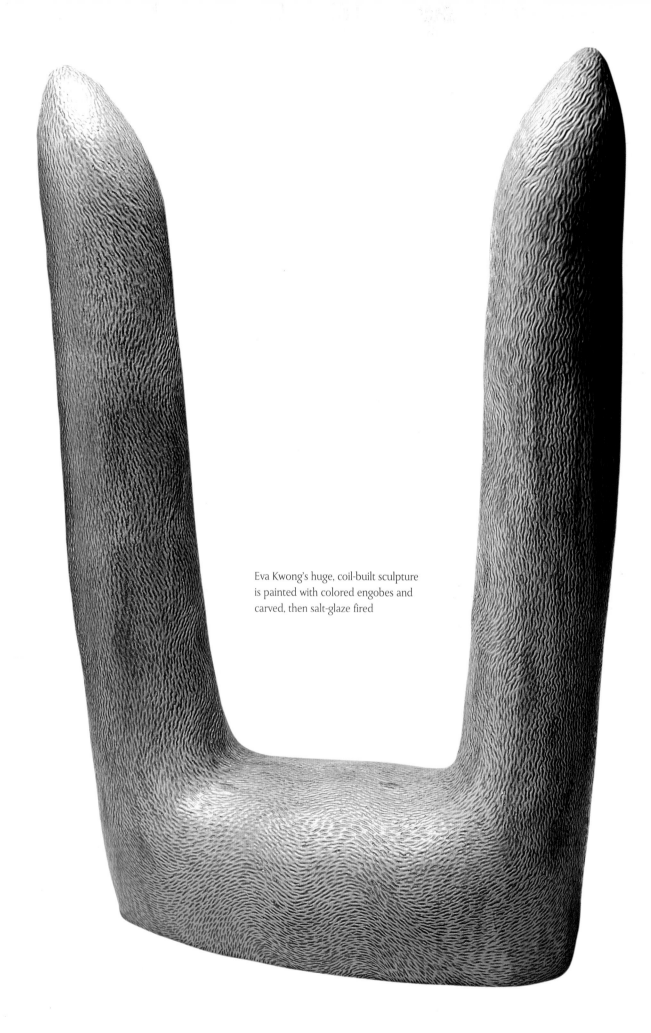

Eva Kwong's huge, coil-built sculpture
is painted with colored engobes and
carved, then salt-glaze fired

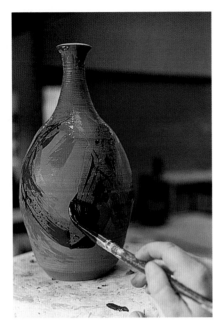

Susan Peterson brushes engobe to inlay a wax-resist pattern on leather-hard clay

TESTING AND USING GLAZES

Mixing glazes

Glazes are made from several basic ingredients added to silica, the essential glass-forming oxide. Because silica requires 3000° F (1650° C) heat before it melts by itself, fluxes must be added to lower the heat to regular glaze-firing temperatures for ceramics. Most glazes contain 50% silica, from various sources. The fluxes that lower the melting point of silica at low temperature – lead, boric oxide, soda, and potassium – and refractory fluxes – those that lower the melting point at higher temperatures, such as calcium, magnesium, barium, lithium, and zinc – are added to the silica in varying amounts according to the temperature to be fired. 10% clay is added for bonding.

The materials for glazes are dry powders, usually 200-mesh, mixed with water to a consistency measured by lifting your hand out of the glaze so that the liquid makes a long drool, then seven drops, and your skin is still visible through the liquid. As a very rough guide, 3,000 gm of dry material will make a gallon of liquid glaze.

Calculating glaze formulas

Formulas of glazes for specific surfaces and temperatures can be chemically and mathematically calculated from the molecular formulas of all glaze materials, then translated into parts-by-weight batches. However, most beginners do not want to learn glaze calculation. If you do, please refer to my book *The Craft and Art of Clay*.

Beginners will probably search books and magazines for glaze

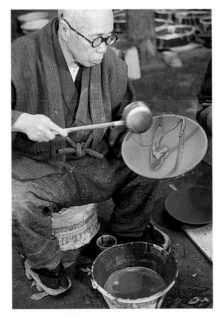

The late Shoji Hamada using a ladle to pour a pattern (which will come out black) on his famous kaki glaze

The kaki glaze of Mashiko, Japan, is ground from a local rock and mixed with water; it is very difficult to keep in suspension and must be stirred continuously

"recipes," or buy ready-prepared glazes for all temperatures, which can be purchased commercially in most areas of the world.

Lacking these aids and the will to learn glaze calculation, potters should know that all materials and minerals on the globe will melt at some temperature. Test what you think could make a glaze melt, add a 10% or so portion of white clay to each mixture for the bond, apply, and fire your tests. Weird and wonderful things may result!

Basic batches

Here are some basic batches for mixing your own transparent glossy, translucent matt, and opaque glazes, to be fired at the three median temperatures: 1900°, 2150°, and 2300° F (1040°, 1180°, and 1260° C), or approximately Orton cones (see p. 185) 04, 5, and 10.

Low-fire transparent glossy, the classic two-frit glaze, *cone 04:*

> lead frit 45%
> boric frit 45%
> ball clay 5%
> silica 5%

Alternatively, a raw glaze without the use of frits for low fire is:

> calcium borate (also called colemanite, Gerstley Borate) 50 %
> whiting 10%
> soda ash 20%
> clay 10%
> silica 10%

Low-fire translucent matt *cone 04:*

> lead frit 32%
> boric frit 32%
> whiting 26%
> ball clay 5%
> silica 5%

Low-fire opaque white *cone 04:*

Add 15% zircopax or other zirconia opacifier or 10% tin oxide to either of the two transparent clear glazes above

Median-fire transparent glossy *cone 5:*

> lead silicate 20%
> calcium borate 25%
> soda ash 15%
> ball clay 12%
> silica 28%

Median-fire translucent matt *cone 5:*

> lead silicate 14%
> calcium borate 16%
> soda ash 10%
> dolomite 30%
> ball clay 10%
> silica 20%

Median-fire opaque white *cone 5:*

Add 10% opax or 15% other zirconia opacifiers to the transparent glaze

High-fire transparent glossy *cone 10:*

> soda feldspar 44%
> whiting 18%
> china clay 10%
> silica 28%

High-fire translucent matt *cone 10:*

> soda feldspar 38%
> whiting 15%
> magnesium carbonate 15%
> china clay 10%
> silica 22%

High-fire opaque white *cone 10:*

Add 10% opax or 15% other zirconia opacifiers to the transparent glaze

As a starting point, color the above or any glazes with metallic oxides such as 2 to 4% copper for green in oxidation or pink-red in reduction (see Chapter 5); 1 to 2% cobalt for a strong blue; 1 to 4% chrome for forest green; 10 to 15% vanadium for yellow, best in oxidation; 10% rutile for burnt orange; 1 to 10% iron for amber to dark brown in oxidation, celadon to tenmoku in reduction; 2 to 8% manganese for tan to claret brown. For

a broader range of color, buy manufactured glaze stains from companies around the world such as Blythe, Drakenfeld, Ferro, Degussa, Pemco, Mason, and the like. Commercially prepared stains – basic natural coloring oxides combined with other ingredients to widen the palette, fired for stability, and ground again to powder – give the potter a complete selection of colors at most temperatures.

OTHER USES FOR GLAZE STAINS AND OXIDES

Glaze stains are manufactured from combinations of the basic metallic oxides – copper, cobalt, iron, vanadium, chrome, manganese, and a few others – plus added materials that stabilize them and widen the color palette. Stains or metallic oxides do not melt by themselves within the ceramic temperature range. They are the colorants for:

 clay bodies;
 engobes;
 decorative techniques such as under- and overglaze;
 glazes.

In addition, they are useful for:
1. serigraph printing on ceramics: mix stains with silk-screen medium and hand-roll a design through a silk screen onto a ceramic tile;
2. photo transfer or emulsion techniques;
3. glaze stain crayons, made by adding coloring oxides to wax;
4. decorating slumped glass at

very low fire (1300° F, 700° C, or lower); or you can add stains to ground glass and cast it into a bisque mold;
5. brushing or sponging over bisque to highlight a texture, with or without glaze;
6. sprinkling dry over sand or grog on a flat surface – you then roll a slab of clay over the sprinkles;
7. making your own decals.

Reds, yellows, and oranges

Why are there no bright reds, true lemons, and oranges above 1900° F (1040° C)? Uranium oxide, which gave us those colors prior to World War II, was withdrawn, and reserved for the atom bomb. It is no longer considered safe for use on ceramics, although it is, surprisingly, available again.

Because cadmium and selenium oxides, which become red, orange, and yellow in chemically-specific glazes at low temperatures, burn out above 1900° or so F (1040° C), they are therefore useful to potters at low-fire temperatures **only**.

Cadmium and selenium reds, yellows, and oranges have recently been stabilized in an astonishing patented process for use at all temperatures and in all atmospheres, by Degussa in

Marylyn Dintenfass's wall piece is a vibrant example of low-fire cadmium yellow, orange, and red glazes

Europe and Cerdec in America. These stains work well but are expensive.

Clay pieces can be bisqued and/or glazed at high enough temperatures to mature the clay body, then glazed with the usual cadmium low-fire reds, oranges, and yellows and fired a third time. There are other ways to achieve reds, such as with chrome and tin, and with copper in reduction atmosphere (see Chapter 5). The easiest way to get low-fire reds, oranges, and pure yellows is to buy these glazes ready mixed.

GLAZE APPLICATION

Stir glazes with the bare hand, or a stick, but only the hand can find lumps and feel the general consistency. It is a good idea to screen (strain) glaze before using it. Glazes tend to settle fast and need to be stirred often over prolonged use.

Glazes should be stored wet if they can be kept airtight. The best containers are oak barrels and stoneware jars. Most of us use plastic buckets, which tend to react chemically with glaze materials after a time. If you are using plastic containers it is best to let glazes dry out, and re-wet them with water for the next use.

Glazes are not generally hazardous, but if you have a cut, stir with a stick rather than your hand. It is sensible to wear a mask, particularly if you suffer from asthma or another respiratory disease.

Methods

1. Dipping If the pot is to be all one color, dip it into the glaze container until the pot is covered and remove it

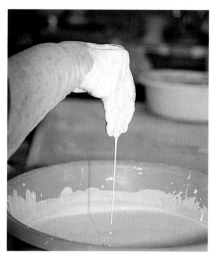

Stir glaze by hand; adjust the viscosity by adding water until the glaze is as thin as cream and gives a long drool and several drops from your hand

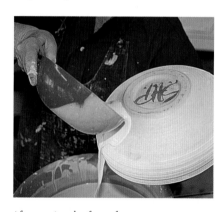

After waxing the foot of a stoneware pot, pour glaze on the outside, making a decision whether to keep the overlap pattern

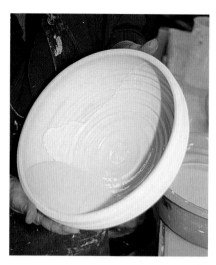

Pots are usually glazed inside first by pouring the glaze in, quickly rotating the vessel and pouring the rest out. Every overlap makes a mark; if you do not want it, scrape it down

Scrape off the excess glaze to clean the lip; spray, brush, or dip it

quickly. Properly dipped, the piece will be glazed inside and out. Glaze dries almost instantly to a chalky powder. Touch up spots with fingers or a brush. Pots can be dipped in patterns, or dipped in several glazes.

2. Pouring If the inside and outside of a vessel are to be glazed differently, pour the inside first. Fill a cup with glaze, pour it into the pot and roll it round up to the edge; pour the remainder out quickly. Turn the pot over and pour the other glaze over

the outside. If the outside pouring is done on a rotating wheel the glaze will coat all round evenly. If you pour in overlapping patterns, generally all variations in application show after the firing.

Clean excess glaze off the lip with a wood knife and dip the lip in glaze, or brush the glaze on.

3. Spraying Using an atomized spray gun is a satisfactory method of applying glaze, but only if the potter sprays evenly. Usually the inside

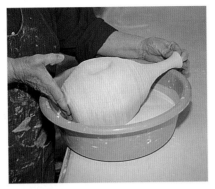

Patterns can be created by holding a vessel at different angles and dipping it into glaze

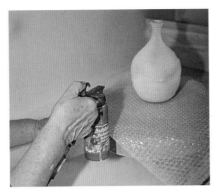

Spraying glaze adds variety of texture or color changes if you desire

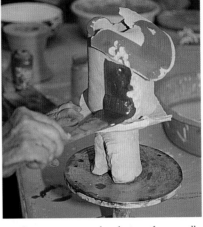

Brushing is not a good technique for overall glazing because all the strokes will show in the finished piece. It is better to brush glaze when you want the strokes to remain visible as a pattern

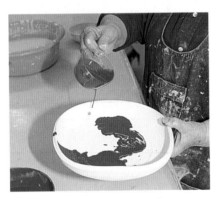

Ladle-pouring one glaze over another is an easy way of achieving decorative effects

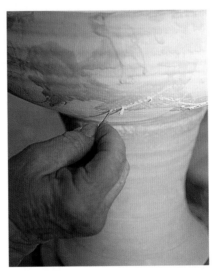

Water-soluble wax or melted paraffin can be used to make patterns over glaze or between glazes, or on the clay before glazing. Here a wax pattern over glaze is being scratched . . .

. . . and liquid cobalt oxide is being brushed majolica-fashion over and into the pattern

of the vessel is poured even if the outside is sprayed. Spraying different colors can result in highlights and shadows of color. Depending on how dry the glaze is when sprayed or how far the potter stands from the piece, speckles may develop.

Fill the spray gun with glaze made more liquid than the consistency for dipping or pouring. Standing too close to the vessel while spraying results in runny glaze application – you could like that! Some potters use an air-brush type of sprayer for very controlled application and complicated shadings.

4. Brushing Painting is a good idea only when you want brush-strokes to show, because they do. It takes years of practice to learn to apply glaze evenly

with a brush. Think of brushing as a means of getting variation and rhythm, according to the size of the brush and the manner of the stroke.

DECORATING WITH GLAZE

Usually pottery is bisque-fired at least to red heat (1300° F, 700° C) to make handling of the piece easier during the

glazing, and then fired again to the glaze temperature. Once-fired ware implies that the work is glazed leather-hard or bone dry and fired to top temperature once only. Depending on which process is used, the results will vary. Drawing through glaze on an unfired vessel offers carving advantages that would not be possible on a bisqued clay piece.

1. Dipping or pouring in pattern Surely this is one of the easiest means of achieving decoration. Try dipping or pouring several colors with or with-

John Mason's stoneware wall
relief shows great surface
variety, accomplished by
differing thicknesses of brush-
stroke and exploiting the fluid
quality of glazes that meld with
each other during the fire

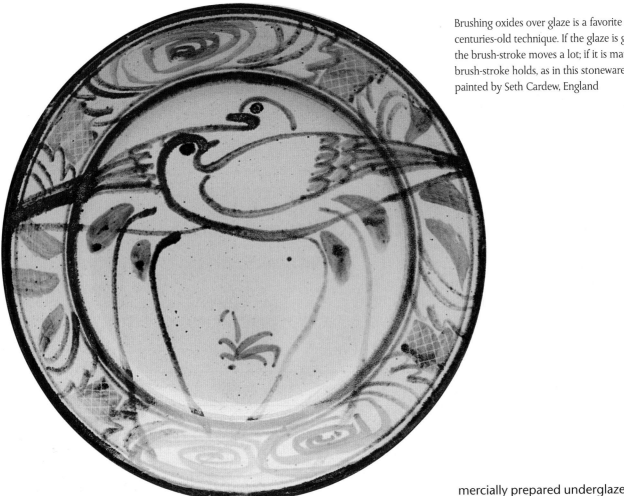

Brushing oxides over glaze is a favorite centuries-old technique. If the glaze is glossy, the brush-stroke moves a lot; if it is matt, the brush-stroke holds, as in this stoneware plate painted by Seth Cardew, England

out overlaps; try both matt and gloss surfaces; try leaving some of the clay body exposed. Pour from different containers to make different shapes and widths. Dip into glazes at different angles. If you don't like something you've done, scrape it off and start again. All variations of glaze thickness will show up in the finished fired piece, which is part of the beauty of this method.

2. Decorative brushing Stains or glazes can be brushed over or under each other. Brushing is a technique better known in the East and better practiced over and over by us in the West.

3. Spraying one color over another Colors will blend in this technique, but how depends on the firing, the thickness of application, and the consistency of the raw glaze. Keep records of what you do and analyze the results after the glaze firing.

4. Underglaze decoration Just as this implies, metallic oxides or commercial glaze stains can be mixed with water and applied to the bisqued surface, then glazed over. As in watercolor painting on paper, the more water the lighter the color will be, the less water the denser. Potters can learn to achieve great subtlety of brush-stroke and nuance with this method. A transparent or translucent glaze should be sprayed – not poured – over this decorative application. Com-

mercially prepared underglazes have moisture and a bonding medium added in the jar. These colors usually come as liquid in small 4 oz. jars and are very expensive. It is just as wise, in my view, cheaper, and more reliable to use the natural metallic oxides and stains.

Underglaze pencils, crayons, and chalks can be purchased or you can make your own. Even spray cans with commercially prepared underglazes are sold by ceramic suppliers.

5. Overglaze decoration Also called **majolica**, this technique is the opposite of underglaze decoration. Metallic oxides or stains mixed with water to watercolor consistency are applied over a dry glazed piece before it is fired. When the decoration is fired in the kiln it melts into the underneath glaze, causing a fuzzy or feathered line.

Verne Funk's delightful drawing is achieved with underglaze pencils on the bisqued clay, coated with a clear glaze

Liz Quackenbush's press-molded box has Italian-style majolica painting over the traditional white glaze on an iron-red clay body

The degree of fusion depends on the kind of glaze – some glazes are more fluid than others during the firing. If the glaze is very stiff, as a matt glaze is, the fusion will be slight. The characteristic melding of the design into the glaze is the trademark of majolica.

China paints and enamels are another form of overglaze decoration, but both are applied on top of a fired glaze and refired again at a low temperature, about 1300° F (700° C). Metals, such as gold and platinum, and lusters come in the same category. China paints, metals, and lusters require skill and experience in handling and patience in application. Brushes must be absolutely clean; painting must take place on an absolutely clean pot surface; firing is chancy.

6. Thickness of glaze Normal thickness of application of a raw glaze is 1/32 inch. Thinner than that is very thin, and heavier than that is a thick application. When placing one glaze on top of another, whether pouring, dipping, dropping, or whatever, you must keep in mind the total thickness of all the layers.

Too thick a glaze will crack as it dries and fall off the pot before it reaches the kiln. Sometimes glaze seems to adhere when it is dry, but falls to the shelf in the kiln because it was too thick. Test the thickness by placing the point of a needle or pin into the glaze; make a scratch, and estimate the depth. Your needle should feel as if it is going through a slim cushion of glaze; if the tool hits the pot right away the glaze is very thin.

Karen Koblitz's piece uses commercial underglaze heavily painted under clear glaze; the gold luster detailing is accomplished in a final, lower-temperature fire, 1300° F

BELOW A sculpture by Sandra Taylor, Australia, is painted with unglazed commercial stains

Helen Slater uses commercial underglazes on a white articulated wall piece which is covered with glaze and fired to cone 06

Stain painting on a white body under a clear glaze by Karen Massaro illustrates that, unlike majolica painting, stain or commercial "underglaze" stays put whether glazed or not

Kurt Weiser makes his own molds, casts his porcelain, glazes, china paints, and fires his work several times. This teapot is a fine example of virtuoso china painting

Lusters are usually purchased commercially to be painted on bisqued or glazed ware, and require a final firing from cone 022 to cone 013:

FACING PAGE Adrian Saxe's assembled sculpture includes a porcelain cup with gold luster on a base raku-fired with a cadmium red glaze

RIGHT Joan Takayama-Ogawa's sea urchin cup is thrown, hand-built, and fired to cone 08 for the copper glaze, china painted and fired to cone 013, and finally gold luster fired to cone 019

BELOW Regis Brodie's porcelain kaki glazed bottle is refired at low temperature with platinum luster

BELOW RIGHT Ralph Bacerra makes his own molds, casts porcelain, and fires in high-temperature reduction. In this piece the celadon glaze has crazed, perhaps due to the many subsequent low-temperature firings for the multicolored and gold lustered surfaces

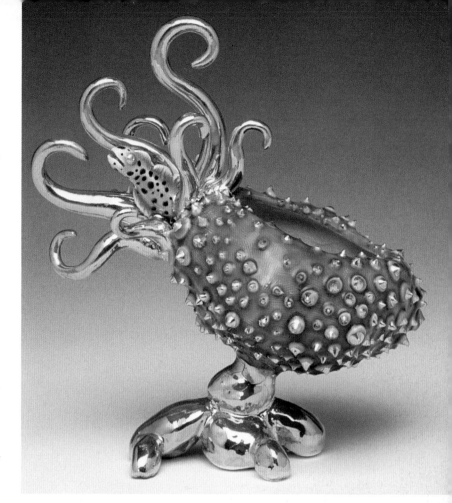

Sally Bowen Prange's hand-built porcelain
vase is high-temperature bisqued, and
refired at low temperatures with
overglaze colors and gold luster

Elena Karina's hand-built porcelain shell
form is refired with platinum luster

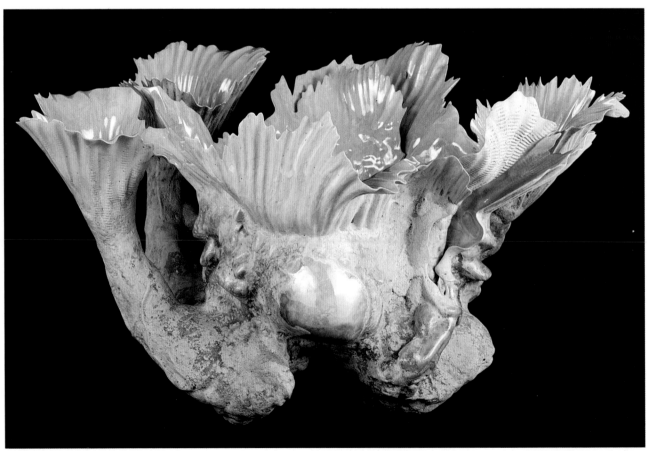

LEFT Nancy Selvin's sculpture is made by xeroxing images from her own journals onto transparent film. After reversing the film and copying the reversed image on regular xerox paper, she transfers it onto a finished ceramic piece with a non-toxic solvent; the reversed image now reads correctly

BELOW Two illustrations of decal overglaze technique (decal is a commercial process for applying the same decoration to hundreds of pieces):

To make a ceramic decal for his sculptures Les Lawrence uses a magnetic laser printer with iron oxide in the toner, printing onto decal paper and fixing with a clear lacquer spray. The decal design is soaked in water to loosen the image so that it and its coating can be slid onto the glazed piece. The third picture shows the color variation resulting from different firing temperatures: below cone 010 is insufficient for a secure image; at cone 04 the decal fuses into the glaze and at cone 1 the color bleaches out

Charles Krafft silkscreens ceramic pigments onto flexible decal paper and applies the design on earthenware, as in this plate

1

2

3

RIGHT Rick Malmgren uses tape against the stoneware pot to make a resist glaze pattern, fired to cone 6

BELOW Faith Banks Porter double-dips this stoneware vase in tenmoku glaze over her throwing marks, then ladle-pours a white glaze over. Note the color changes with thick and thin applications

Warren MacKenzie has made a pattern by pulling his fingers through the wet Shino-type glaze before it is high-fired

Detail of Jun Kaneko's large wall, white
earthenware and low-fire glazes

Glaze on glaze effects are usually mottled or striated, with generally pleasing variations in color resulting from one glaze "boiling up" through another in the molten state. If you really want several colors to "run" together in a fluid manner, apply the colored glazes and then apply a coat of clear glaze over all.

7. Putting texture in glaze Sand of varying sorts, dirt, tiny particles of grog (bits of ground, previously fired clay shards), or combustible materials such as coffee grounds can be added to glaze, or to engobe. In engobe the particles stay put, in glaze they move as the glaze moves during the firing. Glazes can be brewed chemically to have texture: these include crawled, crystalline, and lava glazes.

8. Wax resist Wax can be brushed on top of one glaze in a pattern and another glaze applied over. The wax burns out, leaving the second glaze in a design against the first.

Wax can be painted over all or part of the raw glazed vessel and scratched through to the first glaze, or scratched through all the way to the clay body, and stains or metallic oxides mixed with water can be brushed over the wax, inlaying the color.

9. Sgraffito through glaze Scratch through the raw glaze to the bisque pot (which may have been engobed). If the glaze is matt (matts do not run), it will hold your drawing during firing.

Crystalline glazes are not exactly for beginners, because of the precision required to grow the crystals and catch them at the proper moment in the fire. Simply stated, add 20% or more zinc oxide to any high-temperature glaze; hold the kiln for several hours at cone 5 on the cooling side of the firing, and tomorrow you may have crystals. Detail of Sally Resnik's crystalline glaze

Cryolite can be very reactive during firing, and sometimes continues activity after it has cooled. Sally Resnik experiments with a thick application of 50% cryolite and 50% talc, which, after salt-firing at cone 4, will continue to grow crystals

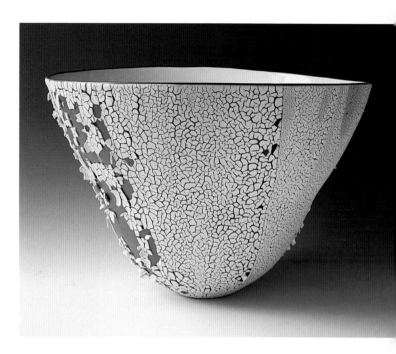

Jane Ford Aebersold's stoneware sculpture has been fumed with cobalt nitrate and bismuth, and multiple-fired with lusters

Crawl glazes can be made with excess magnesium carbonate (20% or more), which causes the glaze to mound up during firing, or they can be made by applying a clay slip over a glaze: examples are these pieces by Claude Champy, France (ABOVE) and Elisa Helland-Hansen, Norway (BELOW)

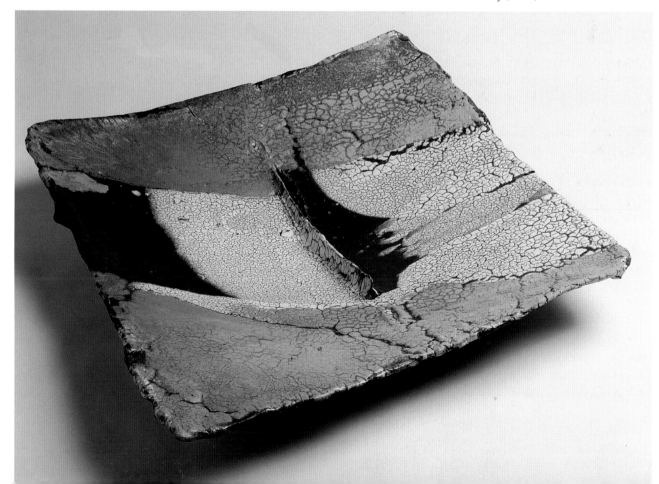

Keep records

Do your own thing, but keep a record of everything you do. You think you will remember but you won't. Every overlap, every thickness of application, every glaze layer, in short, every nuance should be recorded. After every firing analyze your records and make notes. What you called thin may not appear thin after the firing, or what you thought was thick may not show thick. Perhaps the glaze disappeared because it was very much too thin or it ran all over the kiln because it was too thick.

When you have a number of records and many kiln firings, take the time to make a general analysis of them all, and write this in a separate place to refer to from time to time before you begin to glaze another kiln load. This is the way to teach yourself and to put your experience into intelligent practice.

Experimentation

You can experiment with percentage or "part" additions to glazes with which you are already familiar, or you can run a line blend with five or more top members (see p. 183) and make 50–50 mixtures. Color is always a percentage addition to a given batch. Always use parts of 100, or parts of 10; your base should always add up to 100 or to 10. If you make changes within the batch, keep it adding up to 100 or to 10; if you make additions to the batch, add them in percentage amounts on top.

Fusion button tests can be made of various raw materials by placing a thimble or crucible full of the dry material upside down on a fired clay tile which has raised edges to catch the melt if it occurs. After you see the results

"Room-temperature glazes" refers to ceramic coatings that are not heat-treated in a kiln. Usually, this implies that the clay piece has been bisque fired:

LEFT Paul Berube's stoneware and underglazed bone china is painted with acrylics

BELOW Lisa Wolkow's sculpture is coated with colored wax crayons

of the fired buttons you can begin to think of combinations from the visual look of the melts – or non-melts. At the same time you can mix each material with water, paint it on a bisqued test tile, and fire it at the same temperature as the fusion buttons. The buttons work like large amounts of a given material, the painted tiles show the effect of a smaller amount. When you make 50–50 or 33–33–33 combinations, remember those facts.

Beginners especially need to make tests, but all potters experiment some of the time to add variety to their own work.

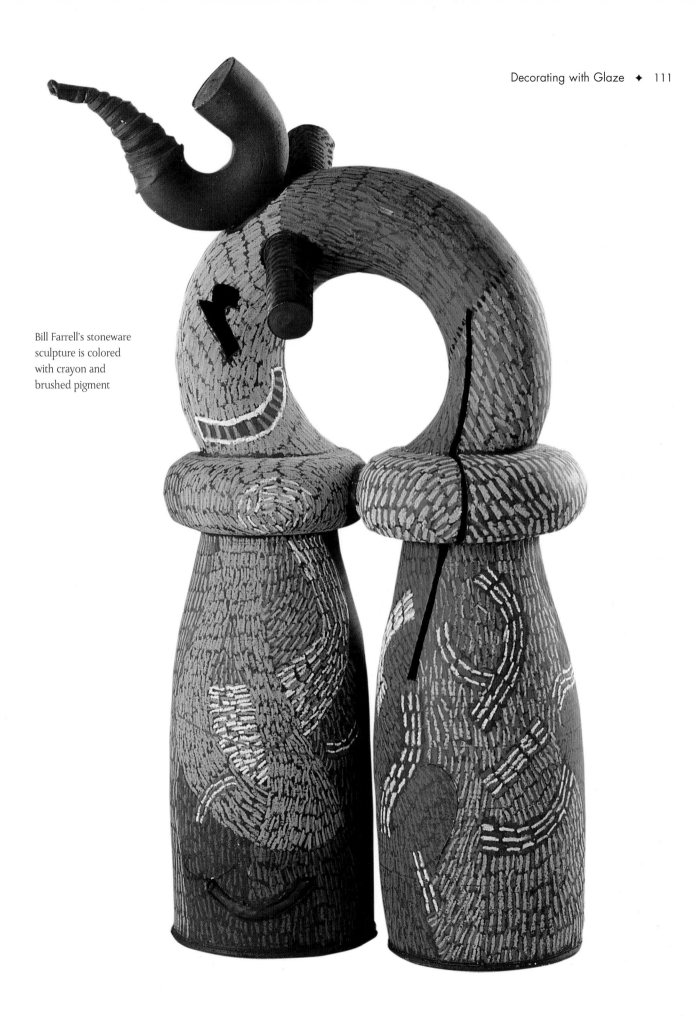

Bill Farrell's stoneware
sculpture is colored
with crayon and
brushed pigment

GLAZE IMPROVIZATIONS

Garbage glazes: every material on earth will have a residue when fired to 1300° F or above. Naturally, more melt will be achieved at higher temperatures. Among the most interesting materials are hardware and wire of all kinds, fruits and vegetables, broken glass, string, cord, fabric, and coins

ABOVE AND BELOW Garbage glazes, before and after firing

Fired broken glass

Try to think of everything that might melt at the temperature you fire. Or if the material didn't melt, would it be interesting to add it to a glaze or to a single material, such as ground glass, that will melt?

Crushed rocks such as granite, stones such as agate, broken glass bottles, pieces of metal such as copper, should be tested alone on dog-dish-shaped bisque tiles, and in combination with known glazes.

Various plant materials have always been glaze materials in the Orient. The most notable is wood ash; the ashes of some woods will melt at 2300° F (1260° C); most ashes will definitely melt when mixed 50–50 with clay, feldspar, soda ash, or borax. In addition other ashes such as those of seaweed or flowers, and volcanic ash will give appealing results.

Some flowers and plants will make their mark, if placed in or wrapped round a clay vessel, in a high-temperature firing for stoneware or porcelain. Plants contain at least soda, potassium, calcium, and silica – all glaze ingredients. Such things as seaweed, rice straw, wheat, ferns, and the like will volatilize during firing and will leave the imprint of their shape in a sheen on the clay below.

The metal wire found in copper, stainless steel, and brass kitchen scrub pads can be pulled apart and wound round a clay piece, then glazed over or left bare. Glaze will melt the wire more and will bring out its true color. If left unglazed, the wire will probably melt into a feathered line on the vessel and will have a metallic black color. Alternatively, the wire can be placed over an unfired piece that has been glazed, and in the firing it will melt down into the glaze.

Low-fire common surface clays will usually become glazes when fired at

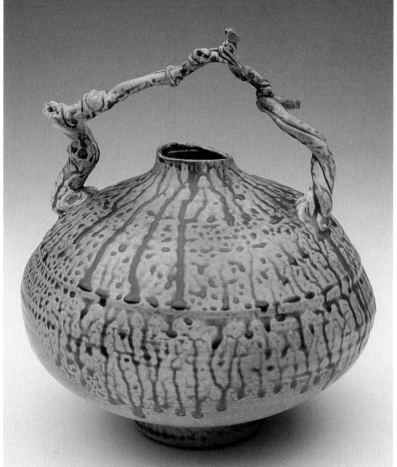

Ash from any plant, vegetable or tree material, can make a glaze, or ashes can be added to known glazes to change the effect. Ash patina can also be created inside a kiln over a period of days in a wood-fire. Tom Coleman's pot is glazed with applewood ash and fired to cone 10

Most low-temperature red clays and certain shales will form glazes when melted at temperatures from cone 5 to cone 10. One of the most famous glazes from crushed rock is the so-called kaki, showing brown here among the overglaze enamels on this bottle by Shoji Hamada, Japan

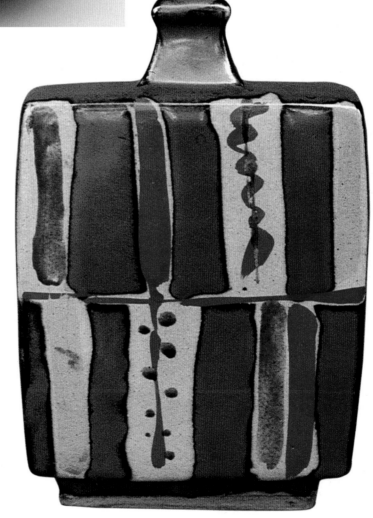

2100° F (1150° C); we call these slip glazes. In the United States the most famous clay for this purpose was named Albany Slip and was mined near that city in New York State. The supply has run out, but other similar clays are being mined that give the same result. It is easy to prospect your own surface clay from a creek bed or near a lake, or in the desert in a dry lake or riverbed. You could try clay from a brickyard or from a sewer-pipe plant.

Shoji Hamada, the famous potter and National Treasure of Japan, used a crushed shale from Mashiko, his pottery village, which when melted at 2300° F (1260° C) was, as he said, the same color as ripe persimmons on the 24th day of October. Hamada's name for the glaze was Kaki, the Japanese word for persimmon, and he dubbed it the "specialty of the house" from his studio because the color quality and surface luster were so popular.

It is important to test and keep testing. Artists continue to grow by trying new things.

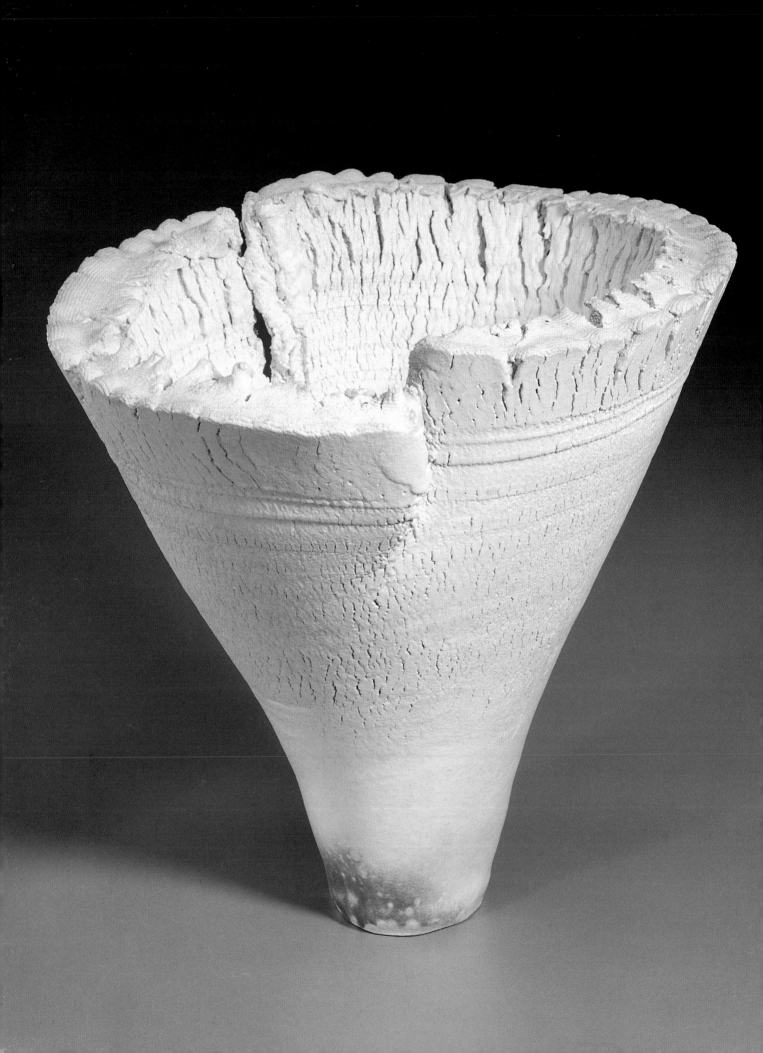

5

FIRING

CERAMICS

HEAT PRINCIPLES

Ancient peoples fired pottery on the ground, with twigs and other combustible materials between and over the work. In some societies the mound of pots was covered with earth to give some insulation. In China, where huge figures have been excavated in recent years at Xian, archaeologists surmise that they were probably bonfired lying horizontally in a pit, or possibly handmade bricks were piled over the sculptures to retain heat; the bricks would have been removed from round the figure when the firing was over.

Native Americans fire one or a few pots at a time, in an open bonfire fueled with wood, or with organic material such as cow, sheep, squirrel, or deer dung.

Altered wheel-thrown porcelain vessel by Fritz Rossmann, Germany, engobed with china clay, turns partially orange in a salt fire

In Nepal, pots are stacked amidst heaps of combustible straw for fuel. This huge mound will be covered with clay and ash, lit, and allowed to smolder several days

A bonfire reaches red heat, 1300° F (700° C), the lowest temperature at which clay will become chemically hard enough to be somewhat durable. Common surface clays, found everywhere in the world, become more dense at low temperatures than other clays and are the most widely used by tribal peoples.

In most parts of the ancient world, firing was accomplished in caves, or pits in the ground, or in bricked-up cylinders with fire underneath and a lid of some sort on top. In India and Nepal, many "kilns" are piles of bricks or pots interlaced with combustible material

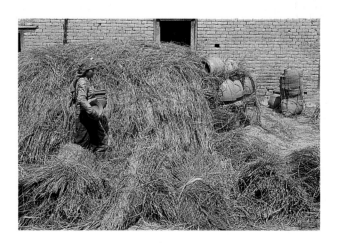

such as twigs and brush, then an over-lay of insulating sand is added, with more brush. This is lit to become a large and fast-burning fire, then allowed to smolder for a few days. Astonishingly, such methods of firing are still the norm in many parts of the world. Many contemporary potters enjoy experimenting with these primitive techniques in a quest for unusual effects.

The important point is that clay needs at least red heat to become durable enough to use. Anything that burns can be used as fuel. Various woods are preferable for ceramic firing in countries where trees are plentiful, or where they are planted in a sustainable program. Engineering charts will give you the BTU (British Thermal Unit) rating of different woods, dungs, petroleum fuels, and kinds of electricity; but red heat is the highest temperature that open-fire wood and dungs can yield.

Fossil fuels such as gas, oil, kerosene, and coal, produce higher temperatures. Historically, as soon as these fuels were discovered they were used to fire claywork in pits in the ground, a method that can still be witnessed, particularly in the Middle East.

Kilns

When the first "kilns" or enclosures around the ceramic bier were developed, perhaps in about 5000 B.C. in China, heat could be contained, reflected, and refracted, making possible the attainment of still higher temperatures. Eventually the Chinese became the first to learn to fire at a high enough temperature to turn a china clay body into fine porcelain. Porcelain-making temperatures could not have been attained without the development of kilns – or enclosures – to retain the heat.

Throwing salt into a downdraft outdoor kiln

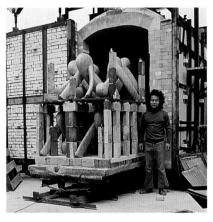

A downdraft car kiln built by Jun Kaneko around 1965

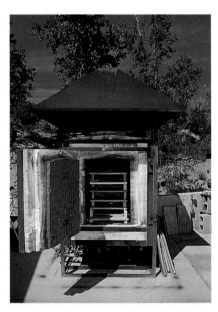

RIGHT AND BELOW Susan Peterson's 1955 updraft kiln, still in use today. The center four and the eight outside burners are on separate gauges; the pilot has a separate valve; excess gas jets to aid reduction are adjacent to the inside burners and are also controlled by a gauge

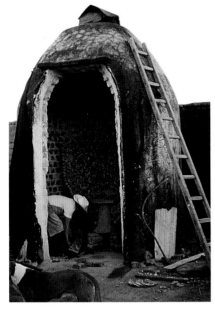

A very tall kiln in Metopec, Mexico, for firing large "trees of life"

Electric kilns can be composed of many rings, each with an individual switch, so that they can be assembled to any height

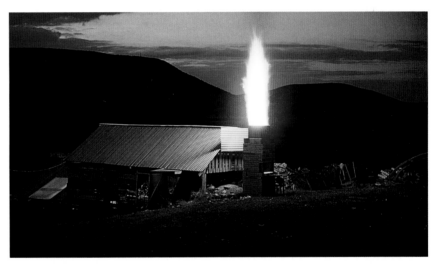

In a six-day firing, Paul Chaleff's anagama kiln belches flame

Rick Hirsch has constructed a tall ceramic-fiber kiln for his raku ware

RIGHT Robert Turner's downdraft wood kiln; the wood goes into the large hole at the front, while the smaller holes control the draft

LEFT The five-chamber noborigama kiln that Shoji Hamada used to fire; bricks for closing each chamber are piled in front

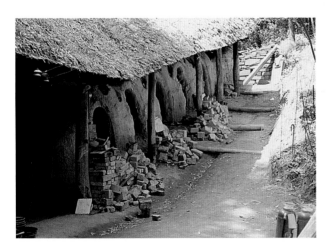

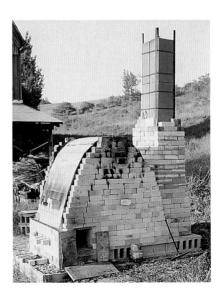

Kilns can be built of refractory brick or any other insulating high-temperature material, such as the space materials "kaowool" or "fiberfax," or they can be natural caves or holes in the ground. Kiln design is ancient but has hardly changed today: there is the single chamber hill-kiln called an anagama, the multi-chamber hill-kiln called a norborigama, and variations; the box or round structure with a side or top-loading door that can have fire under, around, or above the ware; the "car" kiln, through which pottery moves on a firing and cooling temperature curve; the "envelope" kiln that moves over the stationary ware; and many other shapes and types.

Most furnaces that potters use today are fueled with natural gas or propane, or oil. Electricity is also used to fire kilns, although it does not offer the possibility of different atmospheres, as do petroleum fuels. And firing with wood has become very popular for the fun of it – camaraderie builds up in a team that must almost continuously stoke the kiln to top temperature over a period of several days and nights. Such a lengthy period is needed in order to achieve the fascinating colorations and flashings that develop from the build-up of wood ash and the play of the fire.

The kind of fuel and the way a kiln is designed make quite a difference in the firing. Certain glazes are more affected than others. Oil and coal are "dirtier" fuels than gas or propane; electricity gives only a neutral atmosphere – neither oxidizing nor reducing (see page 121) – which makes certain metallic oxide glaze colorants problematic. Some potters build and use several different types of kilns to exploit the different effects obtainable.

FIRING PRINCIPLES

1. Clay bodies shrink as they dry, and in the early stages of firing; they become more dense as the fire gets hotter, and finally warp or melt if the heat is too great for that particular clay.
2. The rate of heating and cooling is determined by the volume of the load in the kiln: the more ware, the longer it will take to fire and cool.
3. How the ware is distributed in the chamber, evenly or not, makes a great difference to the atmosphere and reaction to heat in a kiln. Most potters endure a long series of mistakes before coming to an understanding of the importance of how the kiln is packed.
4. Ceramics fire by heat radiation from the walls of the kiln and from the other surrounding pots. **It is important in stacking a kiln to leave enough spaces everywhere for even heat distribution during the firing.**
5. Clay pieces must be properly structured in the first place, to withstand the weight and shrinkage movement that takes place during firing. Every

different clay body will react differently.
6. A kiln should be fired slowly up to top temperature and allowed to cool down slowly. How a kiln is fired has many variations and the right degree of control can be discovered only through many trials and much practice. In general, let the kiln cool before opening it at least as many hours as it took to fire it.

For firing curves see page 122. More detailed information will be found in my book *The Craft and Art of Clay*.

TEMPERATURE INDICATORS

The color of the heat changes in a kiln as the temperature goes up. Most of us are familiar with the orange flame of a bonfire, which reaches a maximum of about 1300° F (700° C). As the temperature rises above that, the color becomes cherry red, then lighter red, until finally at 2300° F (1260° F) the color in the enclosed kiln

Cones should be properly set in a pack of clay with the faces forward, so that they will fall without touching each other

Wrong setting on the left: cones fall over each other. Correct setting on the right: cones fall free

chamber is nearly white, hence the term white-hot. In China and Japan, where the first stoneware and porcelain products were made, "reading the fire," that is, reading the color of the fire to gauge the corresponding temperatures, became a special profession. Fire readers were hired by potters when it was time to run a kiln.

About one hundred years ago Seger in Germany and Orton in America, more or less simultaneously, devised a system of temperature measurement based on the slumping of certain clay body compositions at certain temperatures. Both men used **cone** shapes, narrow triangular forms of clay-glaze mixtures, to indicate their temperature scales.

These cones are now commercially manufactured, numbered according to the melting temperatures on the Orton or the Seger scale (see page 185). 2000° F (1095° C) is the mean heat, the melting point of cast iron. Cone 1 and cone 01 are designated immediately on either side of the mean temperature. So above 2000° F the cone numbers have no zero in front; below 2000° there is a zero in front of each number. Below 2000° the numbers run downwards, from 01 (hotter) to 022 (cooler); above 2000° they run up in ascending order. So 022 is cooler than 010; 010 is cooler than 1; 1 is cooler than 10.

Because each cone is made of ingredients similar to the ware and glazes in the kiln, it is the best direct measurement of the heat treatment of the ware during the fire. At least one cone should always be used in every firing – take a new one out of the box each time. Generally potters use three cones, one lower and one higher than the middle cone indicating the desired firing temperature, which act as a warn-

ing as well as a check to see if over-firing took place.

Cones should be set in a very small amount of groggy clay and placed opposite the vantage hole inside the kiln, so they can be watched. When a cone has bent to the 3 o'clock position, it has reached its temperature. Cones must not touch each other and must be placed in the cone-pack so that they can fall free as one after the other they slump at the end of the firing.

There are approximately 32° F (18° C) of difference between cones, and about twenty minutes of firing time between cones at the end of a normal cycle; this helps you to know when to keep a constant vigil. If the atmosphere is to be controlled at specific points during the firing, cones for many temperatures can be placed in the kiln. If your kiln has a mechanical thermocouple and pyrometric measuring device – which in my view all potters should own and use for efficient firing – **always** include and watch cones inside the kiln.

It is useful to remember some guideposts for temperatures and cone numbers for special bodies, glazes, or effects, as follows (Orton scale):

cone 10
2350° F (1290° C)
stoneware and porcelain

cone 5
2150° F (1175° C)
stoneware

cone 1/01
2000° F (1095° C)
melting-point of cast iron

cone 04
1922° F (1055° C)
earthenware

cone 010
1700° F (930° C)
normal bisque

cone 022
1300° F (700° C)
lusters, gold

PYROMETRIC TEMPERATURE DEVICES

As I have just stated, I believe that the intelligent kiln firer always uses a pyrometer-thermocouple, records a temperature curve during the firing cycle, and analyzes each kiln load's firing curve; this enables the potter to duplicate a good firing or change the curve to improve a bad one. With energy conservation an issue, as well as the price of fuel per firing, it is important to know exactly at what temperature the kiln is at all times, the length of time it has taken to get wherever it is, and what the settings on the kiln were. Some commercial electric kilns have only numbers of hours that can be set, some have just one or two

Pyrometers gauge temperature during the firing of a kiln. Heat is registered on a two-wire thermocouple in the kiln and is transferred to the pyrometer. Inexpensive thermocouples for low temperature can be used at high temperature if covered with a nickel alloy protection tube as shown here

switches that allow little control; commercial gas kilns usually have no instrumentation, but it should be added.

Inexpensive pyrometers can be purchased, with inexpensive chrome-alumel thermocouples, ordinarily usable only for low temperatures. High fire requires a more costly thermocouple, made of platinel or platinum-rhodium. However, the cheap low-temperature chrome-alumel thermocouple can be covered with an 8-gauge, 1-inch diameter protection tube made of the nickel alloy inconel, which will protect the couple for many years' use at high fire. Any pyrometer must be calibrated to match the type of thermocouple to which it is attached. Instrument companies or ceramic suppliers may help you make a proper purchase. At any rate, you should definitely use a pyrometric measuring device each time you fire, as well as cones inside the kiln.

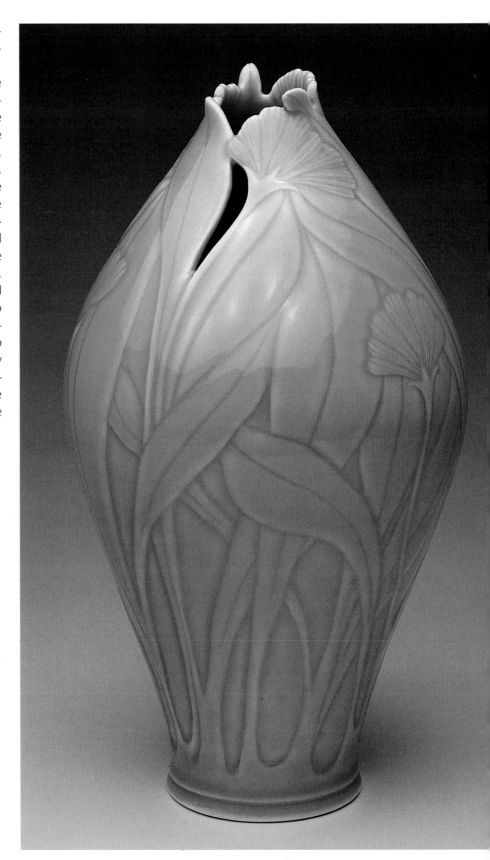

Elaine Coleman carves a porcelain vase: her transparent reduction-fired celadon glaze puddles in the indentations and breaks over the smooth surface

OXIDATION AND REDUCTION ATMOSPHERES

An oxidizing atmosphere is one in which all the molecules in the clay and the glaze have an opportunity to pick up as many oxygen molecules as they need to complete the chemical reaction. Some potters call this a "complete burn." Simply stated, in an organically fueled firing this means a blue rather than an orange flame. Each metallic earth oxide we use for ceramic pigments has an oxidized hue after firing, which can vary according to the oxidized temperature.

Reduction firing means that the amount of oxygen in the atmosphere is reduced. The oxygen supply to the firing chamber must be cut down by:

1. inserting more fuel to increase the carbon ratio;
2. cutting down the air supply;
3. literally smothering the fire.

In a gas or petroleum-fueled furnace, or in a wood fire, reduction is usually accomplished by cutting down the air supply through means of partially closing a damper on the flue. Increasing the amount of fuel to the chamber will increase the proportion of carbon to oxygen. Primitive potters often smother an open fire with wood ash or cow dung to create a black instead of an oxidized red clay color.

The Chinese discovered that a small amount of copper oxide in a glaze, which customarily yields a grassy green

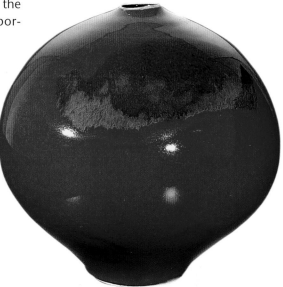

Greg Daly's porcelain vase (Australia) with a brush-stroke of copper over the glaze has been post-reduced at 1300° F to achieve this color

BELOW A group of porcelain bottles by Susan Peterson illustrates tiny variations of percentage amounts of copper carbonate in the high-fire reduction base glaze

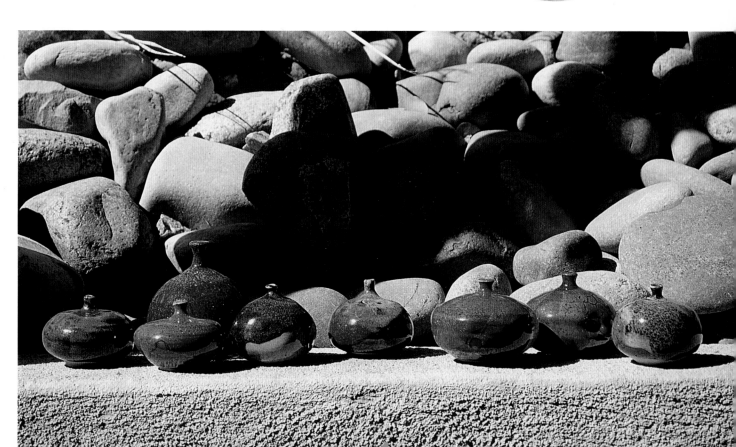

or turquoise color in oxidation, would produce an "ox-blood" red in reduction. They also discovered that a small amount of iron oxide in a glaze, which usually results in an amber color in oxidation fire, would become jade green in reduction; this color is called celadon. A larger amount of iron in a glaze yielded the well-known tenmoku black-brown colors, famous from the stoneware and porcelain of the Tang and Sung dynasties. Most other coloring oxides are not affected by a change in atmosphere.

Electric kilns have a neutral atmosphere; no air circulates, causing a not quite oxidizing situation. Reduction is not easily feasible unless a reducing agent is present (such as oil of lavender in commercially manufactured luster glazes), or if the potter adds silicon carbide to the glaze. However, combustible organic materials such as oil-soaked rags, new-mown grass, rubber tires, asphaltum, and the like, can be injected into the electric kiln at red heat and above, to burn and therefore reduce what little oxygen is present in the chamber. It isn't easy, but low-fire Persian-style lusters and high-fire Chinese reds and celadons can be produced this way.

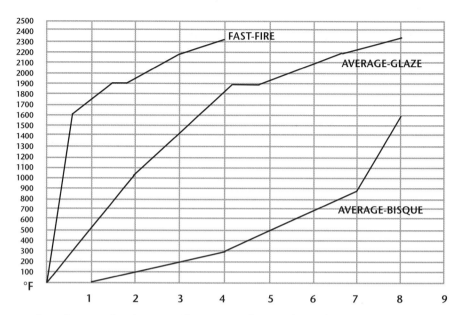

Fast fire and average glaze firing curve for cone 10 and average bisque firing curve for cone 010 in a gas kiln. Damper, burner settings, and other information such as weather conditions can be written in. Plot your own curve each time you fire with any fuel

higher temperature to make the body more durable. Commercial porcelain manufacturers bisque high to support each piece to density, and glaze much lower. Some artists fire high for the body and low for the brighter-colored glazes.

In any case, in a bisque kiln wares can be stacked together, touching, sideways or upside down; yet the weight, volume, and design of the pieces must be thought about for support as well as even distribution of heat.

Bisque firing in six to eight hours
Fire carefully, so as not to blow up the ware from the evaporation of the physical and chemically combined moisture content. Go up to a pyrometer reading of 1100° F (600° C), making a gradual temperature rise over

STACKING AND FIRING KILNS

Bisque firing

Bisque or biscuit is the term given to a clay body fired without glaze. It can imply either low or high temperature. Most potters bisque-fire at low temperature – red heat or a bit higher to cone 010 – to facilitate handling, and glaze at a considerably

Supports for kiln shelves should be as broad and sturdy as possible; three-point stilts or bar stilts are used for stacking greenware in a fast bisque firing or for stacking low-temperature glazed pots (stilts do not withstand high firing)

about six hours. At this point the clay will have passed through the "water smoking" period, when the water that made the clay plastic is driven off, and through the "dehydration" period, when the hygroscopic water combined in the clay molecule is driven off. If the ware is large it is a good idea to leave the door or the lid of the kiln open a crack, so that the moisture can escape, and to slow down the heat.

After 1200° F (650° C) close the door if it is still open, and go as fast as the kiln will go to the desired bisque temperature; well-built kilns – electric, gas, oil, or wood – should reach cone 010 in another hour or two. Really large kilns holding hundreds of pieces will take at least twice as long to fire. Huge hill-style wood kilns can take days and nights of stoking.

When the firing is finished, the kiln should be closed and left untouched until it is cool, for at least as long as it took to fire, but usually for 24 hours. If you have a pyrometer, it should register at or below 400° F (210° C) before the kiln lid or door is opened a crack. Wait until the temperature shows 100° F (38° C), or even room temperature, before removing the ware.

Bisque firing for large wares

If the pots are excessively large or heavy, the bisque firing will take much longer. For instance, for sculpture that may be as tall as the kiln chamber, it is wise to move the firing up a maximum of 50° F (29° C) per hour until past 1200° F (650° C) – this takes at least 24 hours. The pyrometer is measuring the heat at the point the thermocouple reaches into the kiln, not the heat that the pots have actually absorbed, which always lags behind the instrument reading. When the pyrometer registers a certain number

of degrees on a kiln full of large pots, you need to allow a bit more time for the interior of the work to become as hot as the pyrometer says.

Glaze firing

Glazed wares fire at the temperature necessary to mature the clay body, or at the temperature necessary for the glaze itself. I have explained the definition of earthenware, stoneware, and porcelain (pages 20–24), the making of which may determine your firing temperature. The body can be bisqued low or high and glazed at some other temperature. Think of maturing the clay body and firing the glaze as two different things, not necessarily linked.

Stacking the kiln for a glaze firing is perhaps the most important single act of the firing process. How the kiln is stacked determines the color and surface quality of the glazes as well as how comfortably the kiln will fire.

Glazed wares must be placed at least an inch apart. Glaze bubbles like boiling water during the firing and can attach itself to nearby wares, or to the kiln wall or the shelf. Large and small pieces should be placed randomly but evenly. Even heat distribution during firing is actually the result of even kiln stacking.

In a gas kiln keep at least a 4-inch open space – called flue space, or combustion space, between the wall and the work – all around the group of wares. In an electric kiln stack at least two inches from the elements. Electric atmospheres produce no movement like the turbulence that transpires during firing with wood or gas; leave several inches more room between each piece and each shelf for air circulation in an electric kiln. Only petro-

leum or organically fired kilns can be fired easily in reduction atmosphere, remember – electric kilns are basically limited to very slight oxidation.

The glaze firing starts fast, just the opposite of the bisque firing, and slows as the temperature goes higher. The last 100° F (60° C) of any glaze fire should take one hour to mature and soften the glazes, no matter what the temperature. This is an important point often ignored, which produces immature glaze surfaces and undeveloped colors.

A reduction firing requires a proper balance between the fuel and the air to provide the required atmosphere for the desired glazes. You will find more about this in my book *The Craft and Art of Clay*, and in other books listed in the bibliography at the end of this book.

Most glaze firings to stoneware or porcelain temperatures take eight to ten hours, although I fire to cone 10 in four to five hours. During this time a complete record should be kept of burner and damper settings in a gas-fired kiln, and of time and temperature. An electric kiln offers fewer options, but keep a record of the switches, time, and temperature. Records should be compared with results every time you fire, and analyses made.

All kilns are individual. Even kilns made by the same manufacturer to the same specifications will not be the same. Kilns built alike sitting next to each other will not fire the same. No matter what, your results will not be the same as mine or anyone else's. Therefore potters can work and learn best with their own kiln. Firing is an extremely personal matter; if it is recorded and analyzed over and over, doing it satisfactorily will become second nature to the artist.

Pit firing

Pit firing has many connotations: an actual pit in the ground, a built-up pit made of brick, a metal garbage can, paper-clay formed like a pit, a sand pit, or a saggar. The wares in the pit are usually laced with combustible material such as twigs, brush, straw, paper, rags, or sawdust, which will fire and smolder; more fuel can be added to achieve more heat and a longer time, or the firing can be consummated in a few hours.

Low-fire glazes or frits can be applied to the raw or bisque pieces for coloration, or chemicals can be inserted in the mixture: for example, silver nitrate for silvery luster, potassium bicarbonate for yellows, potassium dichromate for yellow-greens, bismuth subnitrate for goldish color. Experiment with the chlorides and nitrates of all the metallic oxide ceramic coloring agents.

Raku firing

Raku is a special kind of ware, with a good deal of Japanese folklore attached, developed by Zen monks in the sixteenth century and made famous by a family dynasty named Raku. The firing is akin to the Native American or any primitive bonfire technique, but not the same. The theoretical idea is to pull a burning glazed pot from the hot fire, at about 1800° F (980° C), and smoke it to develop black lines in the crackles that open up in the thermal-shocked glazed surface. Artists have elaborated on this idea, as have the Japanese tea ceremony bowl-makers. Some potters use cold water to quench the piece, some thrust the hot pot into combustible materials such as leaves and straw that burn again, some add salt or the chemical

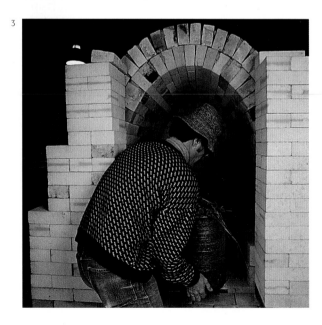

1

2

Chuck Hindes's combustibles for saggar firing include corn cobs, straw, woodchips, and leaves, which will be placed in the container and around the pots. Some saggars can be fired by themselves for low-temperature smoldering, but Hindes is placing the saggar in a kiln for high-temperature firing. The finished look of saggared claywork is very different at low and high fire

3

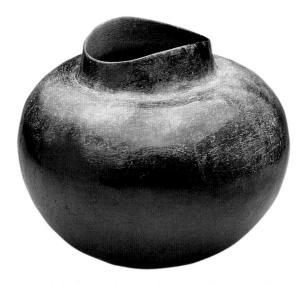

Jimmy Clark's hand-built, pit-fired jar shows the markings from the organic matter he used to fuel the pit

Maria Martinez and her daughter-in-law Santana stack their burnished red pots on a grate over juniper wood, which will be covered by old metal trays and dried cow dung to insulate the bonfire; the fire is smothered with fresh horse manure and ash to turn the red clay black

This pot decorated with a polished *avanyu* (rain god) by Maria and Julian Martinez is an example from a black firing, c.1920

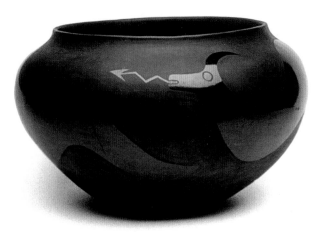

Detail of Paula Rice's pinched and slab-built pit-fired figure; the smoking enhances the iron, rutile and cobalt engobe decoration

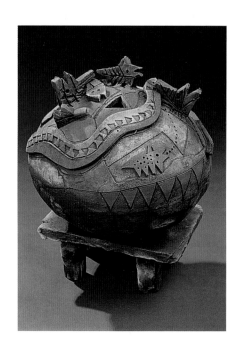

RIGHT The lustrous sheen on the surface of Maurice Grossman's appliquéd vessel, hand-built from multicolored clays, can be achieved from burnishing or from low-fire glaze washes in the smoky atmosphere of a pit or a raku-style firing

Lucy Lewis and her daughters Emma and Dolores set their pots among protective shards surrounded by a mound of dried cow dung, which provides the fuel for the fire

salts of metallic coloring oxides to the post-firing for a lustrously fumed surface, some just use smothering of the hot unglazed piece in the combustibles to totally reduce and therefore blacken the work.

Raku is only a decorative technique; the temperature is so low that pots will not hold water, and fear of bacteria in the porous clay body should keep food out of raku containers. The "happening" quality of the firing makes it experimental and joyful, which is a possible meaning of the word *raku* in Japanese.

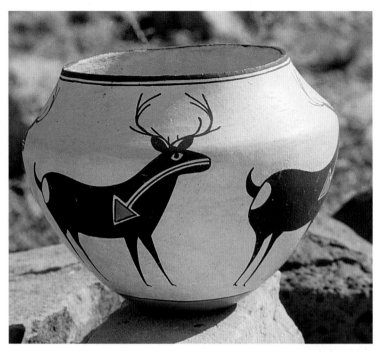

Dung-fired burnished vessel decorated with hematite and red iron oxides by Lucy Lewis, 1980

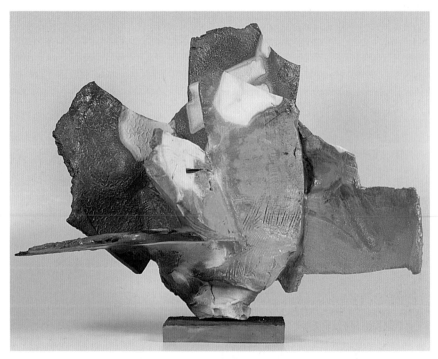

LEFT Paul Soldner, probably the most famous exponent of raku technique in the West, pulls a pot out of the fire with a raku tong

A Paul Soldner raku sculpture

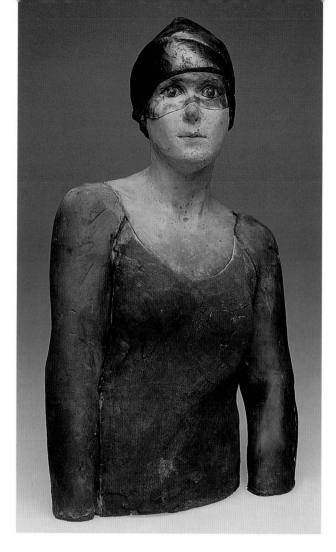

This haunting figure by Margaret Keelan has a smoked unglazed engobe patina from the raku fire

A group of mounted disks by Peter Hayes, England: black and white clay bodies smoked in a raku fire

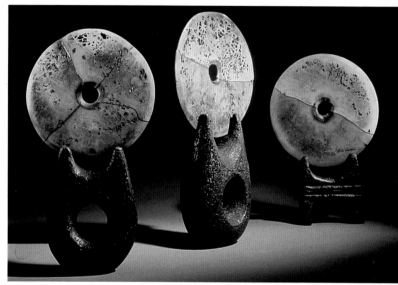

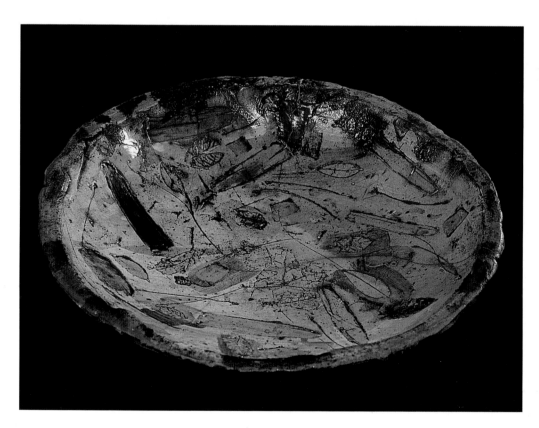

Grete Nash's hand-built platter (Norway) has sgraffito decoration through engobes, and a lustrous glaze surface resulting from the raku fire

Salt, soda, and wood firing

Potters experiment with many different types of firings, but usually decide on just one or two for their own work. Adding chemicals to the fire has been practiced for ages to change colors and surface effects. Salt glaze, one of the most important additions to fire, which causes glaze on unglazed ware, developed in Europe, notably Britain and Germany, during the sixteenth century. Throwing rock salt (sodium chloride) into the fire *at the maturing temperature of the clay body* results in an orange-peel, glossy texture, that takes on the color of the clay or engobe decoration underneath. In Europe and later in America this became a relatively inexpensive method of

Sodium bicarbonate or soda ash can be substituted for the usual rock salt (sodium chloride) used in a salt firing. Soda vapor enhances the color of stains and oxides but usually does not develop the orange-peel glaze texture characteristic of salt firing:

ABOVE Marie Woo's wall piece was covered with straw and placed in a soda fire, leaving markings from the grasses and color from the sodium

Rick Berman has coined the word "salku" for his wood-firing with salt using the raku technique

BELOW In recent years Don Reitz has explored low-fire salt glaze over vitreous engobes, as in this platter

RIGHT A typical example of Don Reitz's large vessels, glazed by high-temperature salt firing. Don Reitz has for many years been one of the foremost exponents of the salt-glazing technique

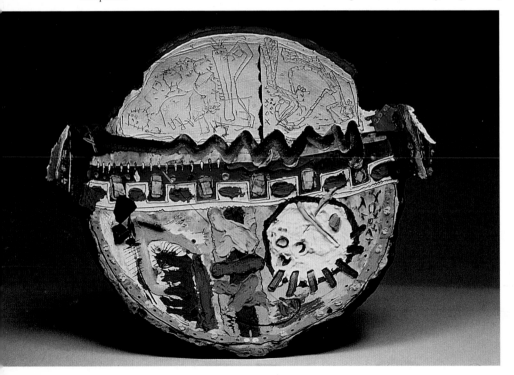

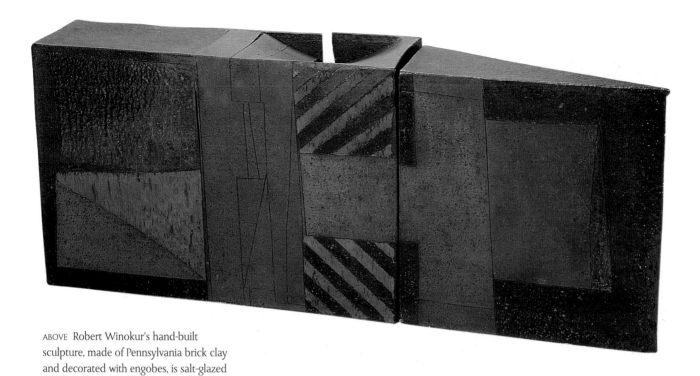

ABOVE Robert Winokur's hand-built
sculpture, made of Pennsylvania brick clay
and decorated with engobes, is salt-glazed

LEFT Dan Anderson's
covered jar is a
combination of wood
and salt firing

RIGHT Jay LaCouture
has improvised a
blower system to
augment the deposit
of sodium vapor,
which increases the
amount of sodium
bicarbonate for the
alkaline glaze on his
porcelain teapot

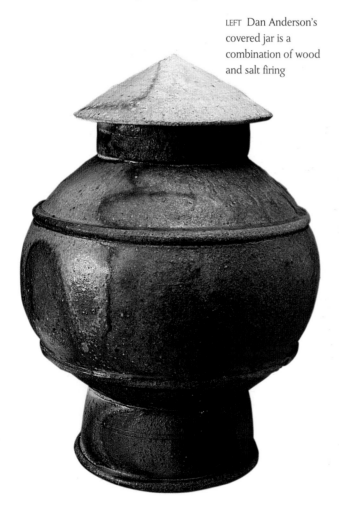

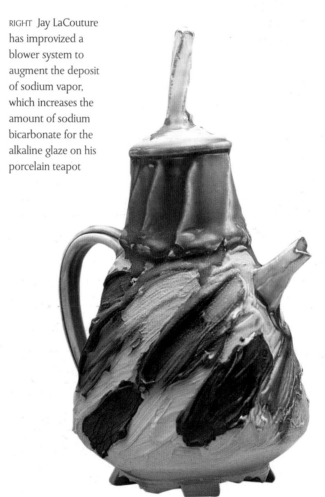

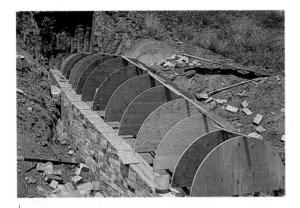

1

John Balistreri building an anagama kiln:

1. Plywood ribs make an arch support for the plywood form of the kiln

2. Brick is laid over the form, which can be burned out in the first firing or can be pulled out after the bricks are mortared

3. John, Ken Ferguson, and a group of students fire the kiln

4. Looking through the door of the kiln while a log is inserted during firing

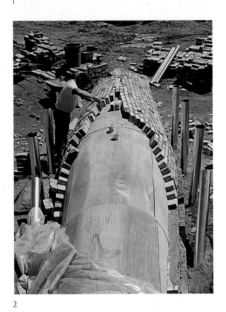

2

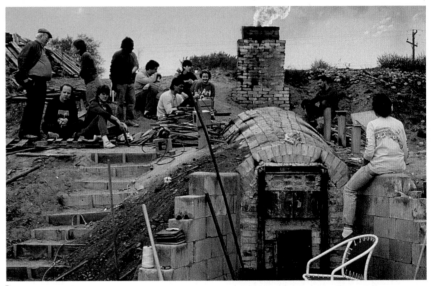

3

4

achieving a durable glazed surface on utilitarian wares such as crocks and mugs, and also for roof tiles and water pipes.

Adding soda ash (sodium carbonate) to the fire at any temperature, not necessarily the maturing temperature of the clay body, is a similar treatment to salt glazing, but mainly enhances engobe and clay colors and does not yield the heavily pock-marked glaze quality of salt. Soda ash may be less hazardous than salt to the environment. However, most chemists will state that sodium is not dangerous when volatilized above red heat; potters use soda and salt at much higher temperatures.

A kiln can be fired with wood purely as a fuel for bisquing and glazing clay-wares. In contrast, wood and its ashes can become the principal means of coloring and partially glazing the work inside the kiln as it is stoked over long duration – several days and nights – according to the desired build-up of patina on the ware. Wood ashes from firing can be used as actual glaze fluxing ingredients, similar to the mineral feldspar, but with quite different effects. Japanese potters have long been addicted to the look of wood-ash firing, mainly in folk-pottery villages such as Shigaraki. A number of other clay artists have adopted wood firing as a principal aesthetic of their work.

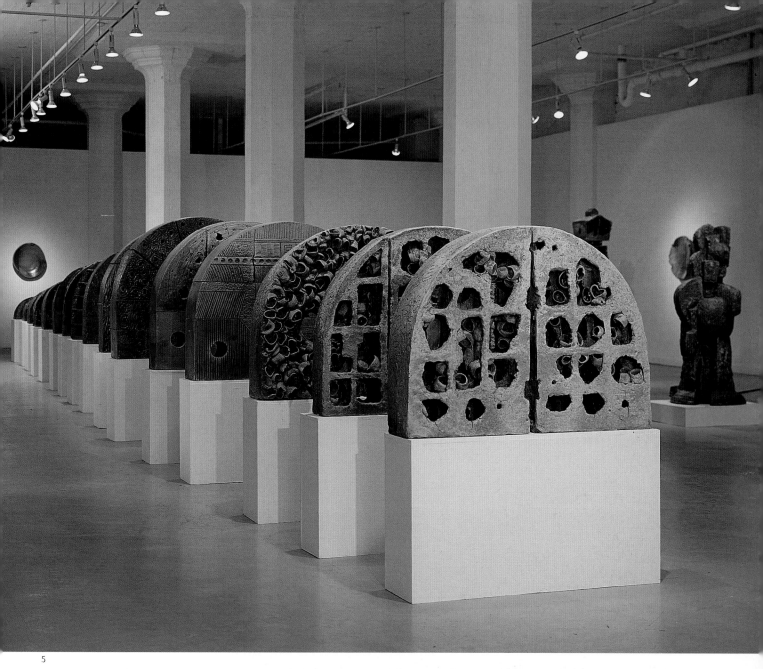

5

5. This exhibition piece documents with slabs and pots an entire firing in the 60 ft long anagama kiln

The flue end, made of field stone, of Kirk Mangus and Eva Kwong's handmade brick anagama wood kiln; the bricks are half fire clay and half sand

Four long-necked vase forms by Paul Chaleff show the colorations of the ash deposits from a six-day wood firing

Sometimes wood ash reacts on porcelain to give vibrant colors, as in this wood-fired pot by Don Reitz

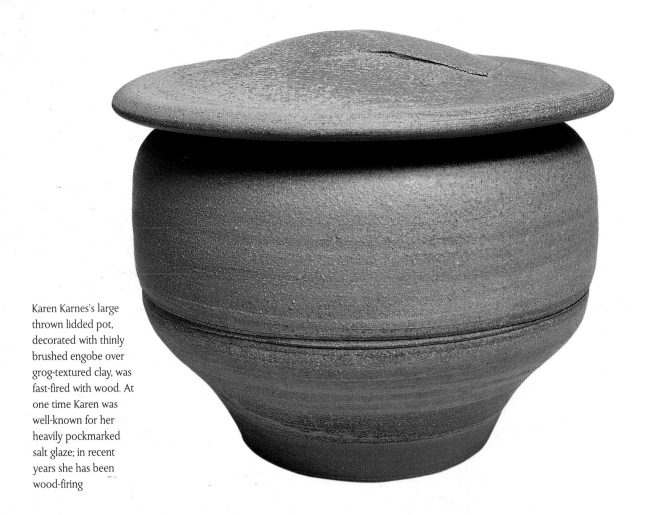

Karen Karnes's large thrown lidded pot, decorated with thinly brushed engobe over grog-textured clay, was fast-fired with wood. At one time Karen was well-known for her heavily pockmarked salt glaze; in recent years she has been wood-firing

Unglazed wares are fired with wood especially for the ash patina, but many potters use wood as the most readily available fuel for glaze firing. Goro Suzuki (Japan) uses a traditional green oribe glaze for his wood-fired chair sculpture

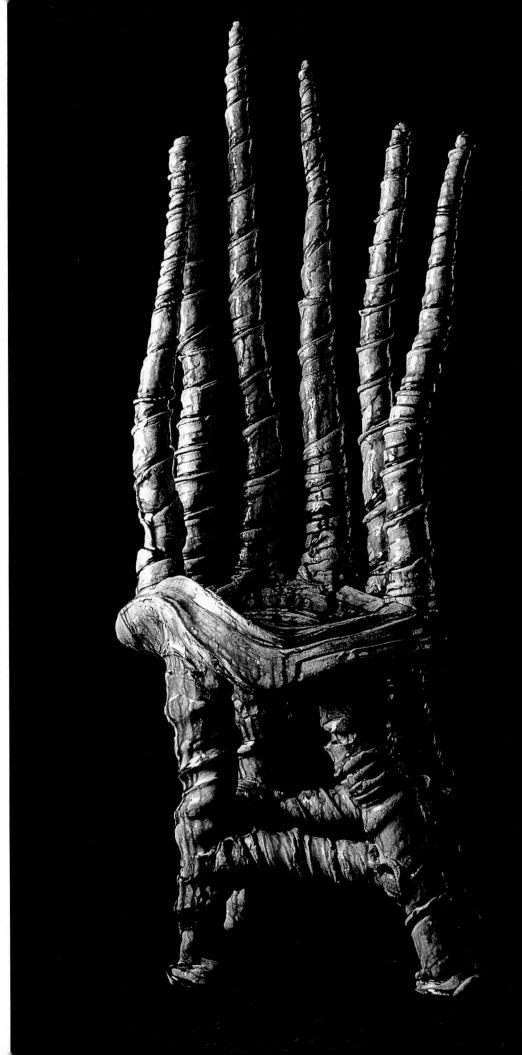

Patty Wouters in Belgium has developed a simple method of constructing a kiln made of paperclay. Such a kiln could fire clay bodies of any type, but paperclay bodies have the advantage that they do not burst from thermal shock or fast firing:

1. Blunging paper and clay with an electric mixer to make a paste

2. A sculpture is constructed of paperclay; units are assembled

3. The seams of the sculpture are patched with paperclay

4. The sculptures to be fired are covered with wood and cardboard for fuel, then with a layer of paperclay for the kiln

5. Three fire holes are fashioned of brick at the base of the kiln

6. The fire holes are ignited with charcoal to make an initial warming and drying fire; the wood inside the paperclay cover is catching fire

7. The sculpture burns in a hot fire for several hours

8. The finished sculpture is installed

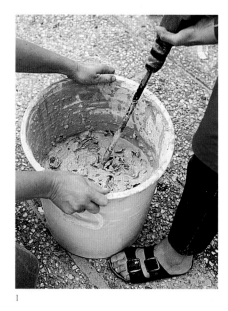

1

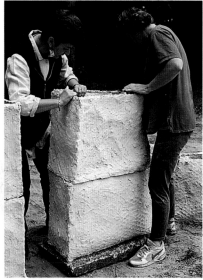

2

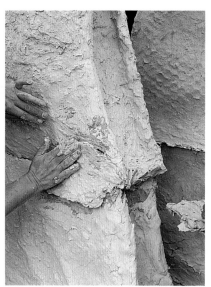

3

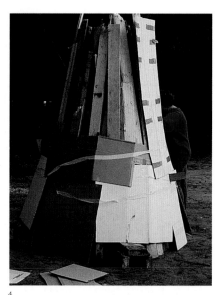

4

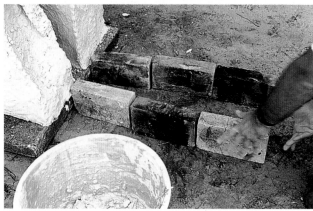

5

6

7

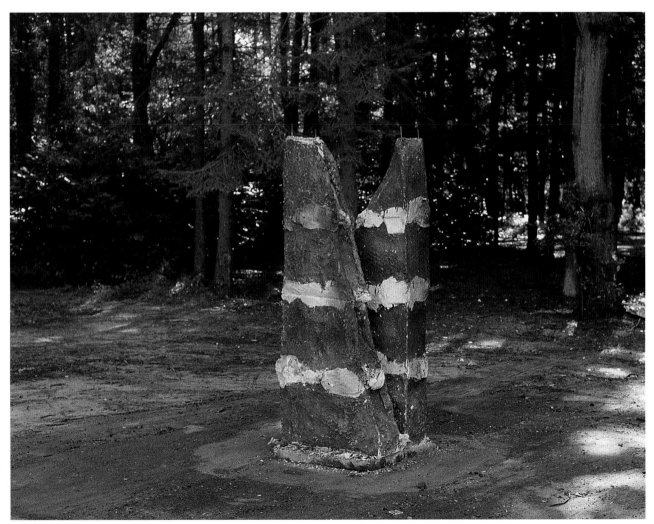

8

Paper-clay for making ware and for kilns

The idea of adding inert material to clay to lessen its propensity for thermal-shock destruction is probably as old as time, but has been recently resurrected. Using papier-mâché-like strips or particles of water-soaked paper added in a proportion of about 50–50 to a clay body is popular now for very thin large slabs, from which sculptures can be built, or for the actual construction of kiln chambers for any kind of fuel except electricity. This clay body will create a paper-like look when fired, and is particularly favorable to print or painting techniques.

Adobe, natural mud-earth that has some clay chemistry, is another age-old material that can serve well for certain sculptural and installation uses. Adobe will set in air, or can be fired. Concrete, another member of the ceramic family, is a possible addition to the sculpture vocabulary. Try adding concrete in varying percentages to your clay body for airset or fired sculpture, or the concrete/clay mixture can become a kiln construction material for very low-fire work only.

GLAZE AND FIRING PROBLEMS

These are problems that can be easily corrected.

1. Glaze runs off the pot onto the kiln shelf Too much glaze was applied. Remember that the recommended thickness of any glaze application is 1/32 inch. Glaze should be the consistency of milk or thin cream in the container; usually studio potters need to add water to thin glazes that have been standing between uses. If several layers have been applied, scrape the dry underlayers thinner toward the foot.

Earthenware vessels fired at low temperature can be glazed all over and supported on three-pointed ceramic "stilts" that can be knocked off when the piece is removed from the kiln. Stoneware and porcelain should have no glaze on the foot and for at least ¼ inch above it – we call this "dry footing." These wares become so dense in the firing that stilts would warp the piece.

2. Glaze appears bubbled or blistered after firing Air was trapped during the glazing application. You can learn to note these bubbles as you work. Glaze dries instantly, so you can rub bubbles down with your fingers before putting the pot in the kiln.

3. Glaze drops off the pot and fuses to the kiln shelf during firing, leaving unglazed areas on the piece Probably the glaze application was so thick that bonding could not ensue, hence in the initial stages of firing some glaze fell off.

4. Glaze "crawls" away in spots, revealing unglazed clay in some areas The answer can be the same as above, too thick an application. Or the potter may have used hand lotion before glazing and touched the pot – lotion or oil prevents the glaze bonding properly.

5. A glazed piece that has been bisque-fired blows up during the glaze fire The kiln was stacked and fired immediately after the pots were glazed. Always let the pieces dry a day after glazing before packing the kiln.

6. Several pieces have stuck to each other during the fire Ware was placed too close; allow the space of at least two fingers between each work.

7. Pieces fell over during the glaze firing Wrong construction, bad support, or improper loading.

8. The fired glaze is harsh and dry to the touch The glaze can be immature for various reasons: the glaze batch could have been improperly mixed; the firing temperature was wrong or no cone was in the kiln; the kiln fired too fast during the last 100° F instead of approaching the peak slowly. Each glaze requires different handling, which is one reason potters limit themselves to a few types of glaze in order to learn and appreciate all the nuances.

READY-MADE KILNS

Manufactured kilns are available in most parts of the world. In general the differences are few: gas, wood, or electric; side loading or top loading; round, oval, square, or rectangular; size varying from one to 60 cubic feet or more; refractory brick or ceramic fiber; in sections or one-piece; with pyrometric instrumentation or without; with computer controllers or without; with "kiln sitter" turn-offs (never to be trusted) or without.

For gas and wood kilns choose up-draft, cross-draft or down-draft – I like up-draft.

Kilns do not exactly wear out, but they mellow, and firings may change with age. Bricks do erode after many years of use, or after salt or soda firings, and may need to be repaired or replaced; soft-brick kilns are more fragile than hard-brick. The choice

of fiber as opposed to brick is controversial. Some potters like a fiber lining over one course of brick; some potters are addicted to ceramic fiber bricks; some potters drape a blanket of fiber over a load of pots and put a burner into the interior. Paper-clay kilns provide an experimental toy for some artists.

Electric kilns are more problematic. Europeans, especially Scandinavians, probably have the most experience with them because electricity has been their basic fuel for such a long time. Electric elements give out quickly and deteriorate over successive firings.

Globar and other esoteric elements have a better survival rate, but are costly. In most areas where both electricity and natural gas or propane are available, electricity is more expensive.

For certain kinds of glaze firings – such as colored lusters, gold and platinum, low-temperature bright reds, yellows, oranges, and china paints – electric kilns may produce a cleaner fire. Any fuel will work, but the results may vary.

You certainly can build your own kiln, in which case you need Fred Olsen's *Kiln Book* (see bibliography). Fred (205

Pinon Crest, Mt. Center, California, USA, phone/fax [001] (619) 349 3291) is the only potter I know who makes and sells kiln kits all over the world, together with complete instructions. Cone and firing charts are at the back of this book (page 185).

Firing is the proof of the pudding. After all the work that has been involved in preparing the claywork for the firing, this is the test. Losses occur during the fire from improper handling of the kiln and its fuel. The potter should concentrate on the firing during the whole sequence and not do any other tasks.

1

Ray Meeker has been building fired houses for the past ten years in the area of Pondicherry, South India. This staggering feat is accomplished by building the vaults with handmade brick and firing with wood inside and outside the structure for many days. The house-kiln needs to be full of claywork to hold the heat, so bricks and other clay products are stacked inside. After firing, the house is plastered. Meeker originally conceived the idea as a solution to the low-cost housing problem in India, but unfortunately wood is too rare and costly to make it practicable

2

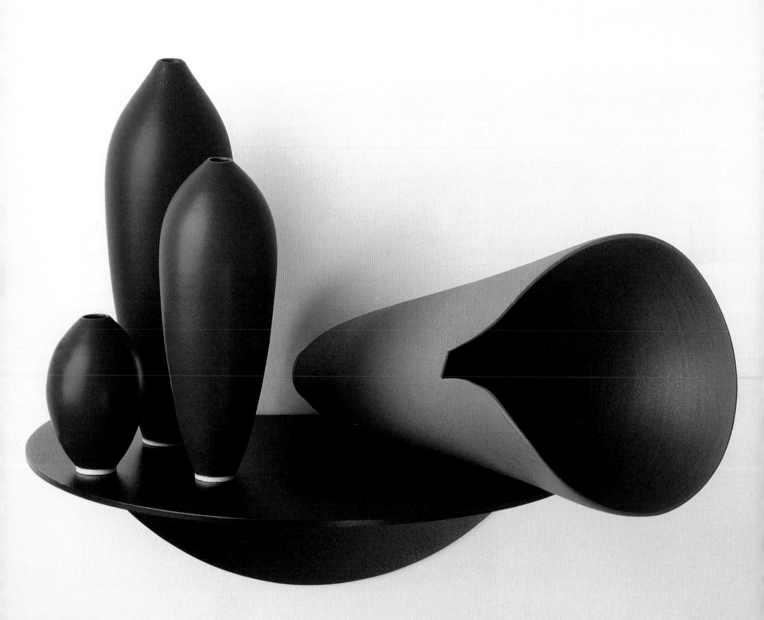

6

THE ART OF
CERAMICS

FROM IDEA TO ART

Having an idea in mind and being able to execute it in clay are two different things until you gain a certain amount of expertise. Knowing what is or isn't art, or if art is craft or craft is art, may not occupy your thinking in the beginning, but later on these questions are of some concern to the clayworker. Philosophically such questions always spark heavy discussions among collectors and purchasers of ceramics. The trick is to know when a piece is good, no matter what it is or how it was made. The artist or the collector tries to develop an eye for what the sense of passion brings.

Learn to see line and space everywhere, in nature and natural settings, in architecture, in city streets. Practice making decisions intuitively about what you like and don't like. Eventually, when working in clay or when buying clay objects, you will see line directions and define shapes and planes automatically. Always be aware of our colorful world; color often supersedes line and even space.

Make judgments alone, so that they are personal and meaningful to you. Today no one emits adamant statements about what design is or what art is; no one can tell you that. You tell yourself through constant observation and silent pro and con discussions with yourself.

The remarkable assets clay has – surface, color, scale, unlimited shape – have been incredibly exploited in the last fifty years. Clayworks overlap with sculpture in all media, with shaped canvas and off the wall painting, and functional ceramics in many cases become objects of art. As well, we are looking at historical ceramic objects with a new realization of the remarkable contributions of all cultures to the art of today.

I show you the stunning portfolio that follows so that you will have a small understanding of the larger ceramic picture, from all areas of representation to installation and conceptual art. Use the work of these clay artists as a springboard for your own discoveries.

Elsa Rady, Still Life 1

MASKS

From time immemorial potters have created masks and heads for spiritual as well as aesthetic purposes. Often large heads must be built upside-down.

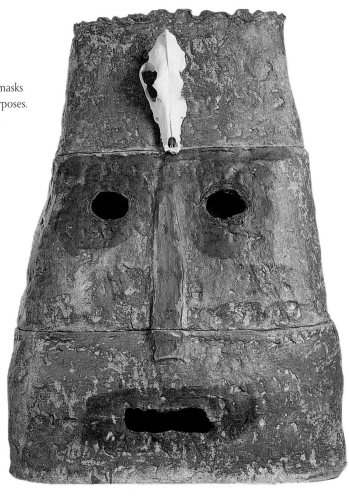

Gillian Hodge, Shaman

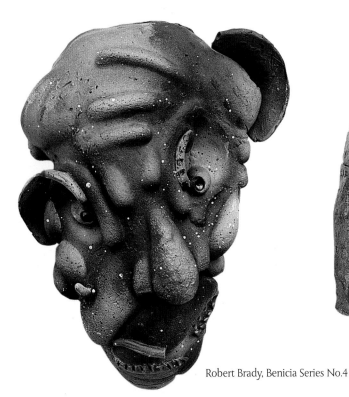

Robert Brady, Benicia Series No.4

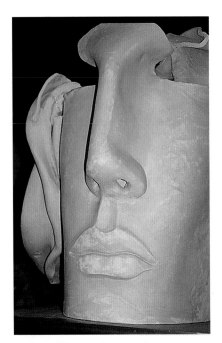

Hertha Hillfon (Sweden), Head

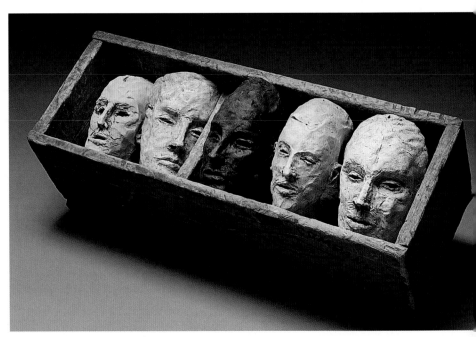

Judy Moonelis, Heads in a Box

POTS AND PLATES

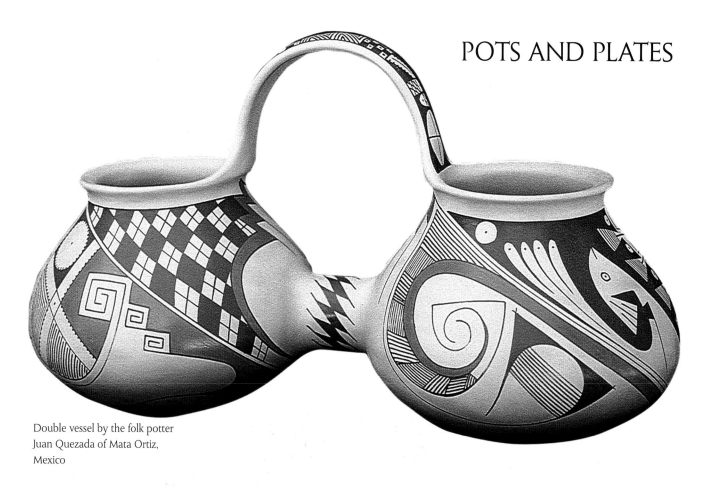

Double vessel by the folk potter
Juan Quezada of Mata Ortiz,
Mexico

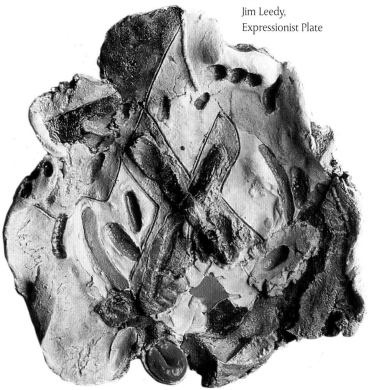

Jim Leedy,
Expressionist Plate

Ron Nagle, cup metaphor

BIRDS AND ANIMALS

Hollow-building ceramic sculpture with reference to birds and animals is currently very popular.

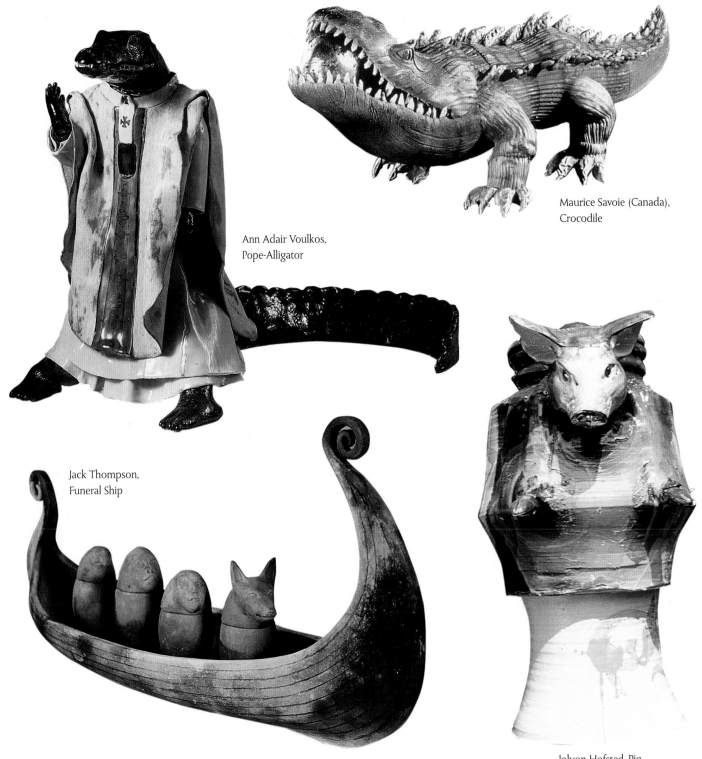

Maurice Savoie (Canada),
Crocodile

Ann Adair Voulkos,
Pope-Alligator

Jack Thompson,
Funeral Ship

Jolyon Hofsted, Pig

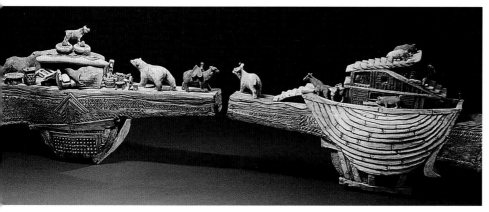

Nancy LaPointe, Unencumbered Leap

James Shrosbree, Yeast

ABOVE Tom Supensky, Where is the Water?

RIGHT Richard White, Birds and Figure

David Smith, Waiting

FIGURES

Large-scale sculpture is hollow-built in a similar
manner to coil, pinched or slab vessels. Some of
the most exciting work being done in ceramics
today is figurative.

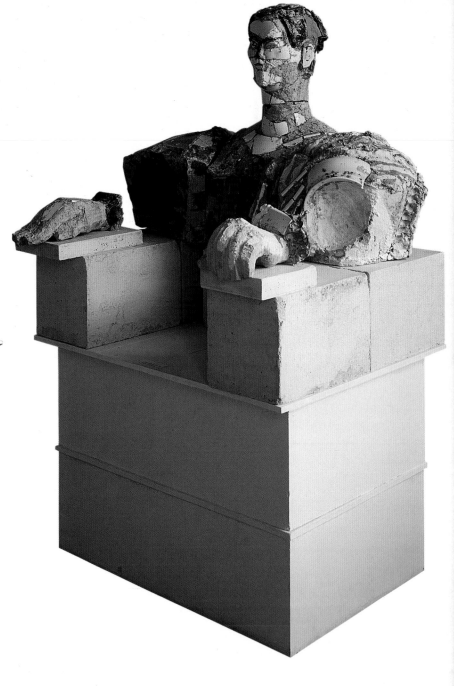

Cara Moczygemba,
Princess

Gertraud Mohwald (Germany),
Large Figure in Five Parts

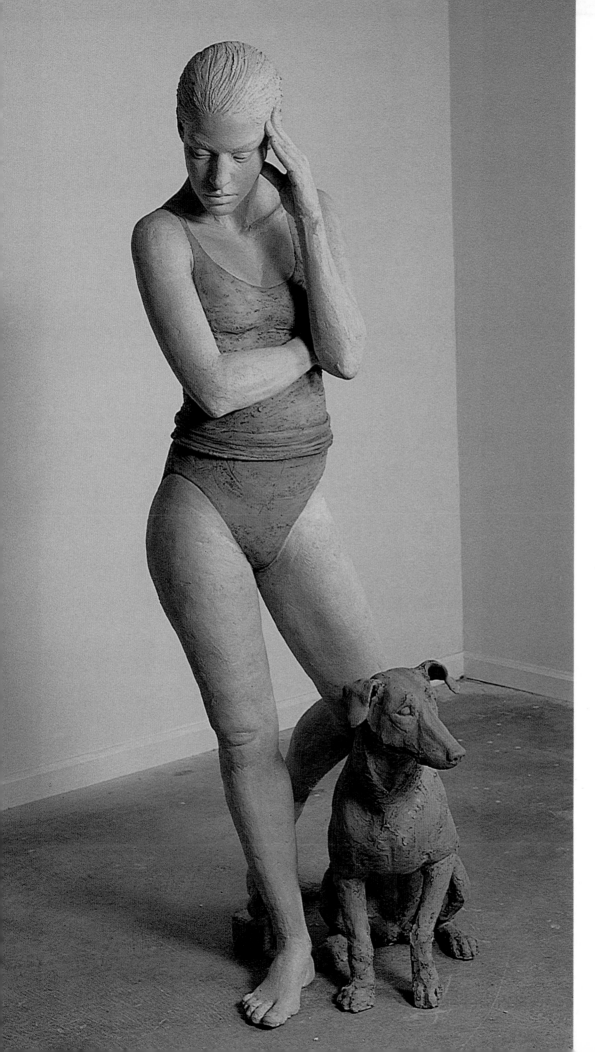

Lisa Reinertson,
Noi Siamo

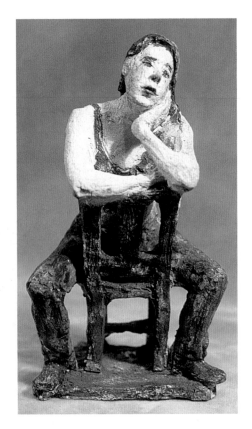

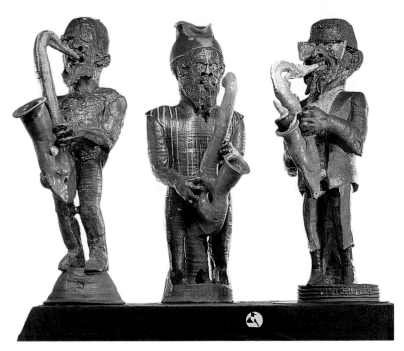

ABOVE Jeff Schlanger, Three Tenors

LEFT Claire Clark, Lila Sitting

BELOW Akio Takamori, Path

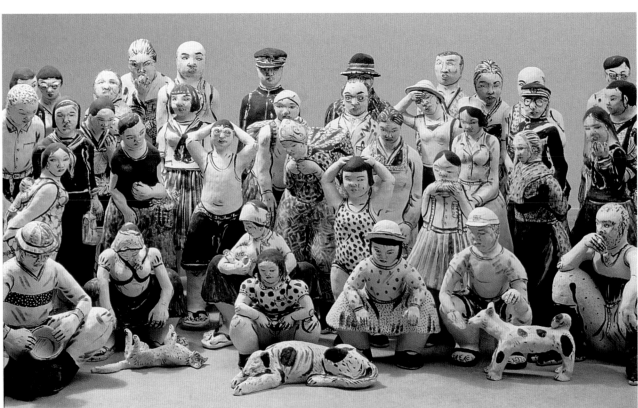

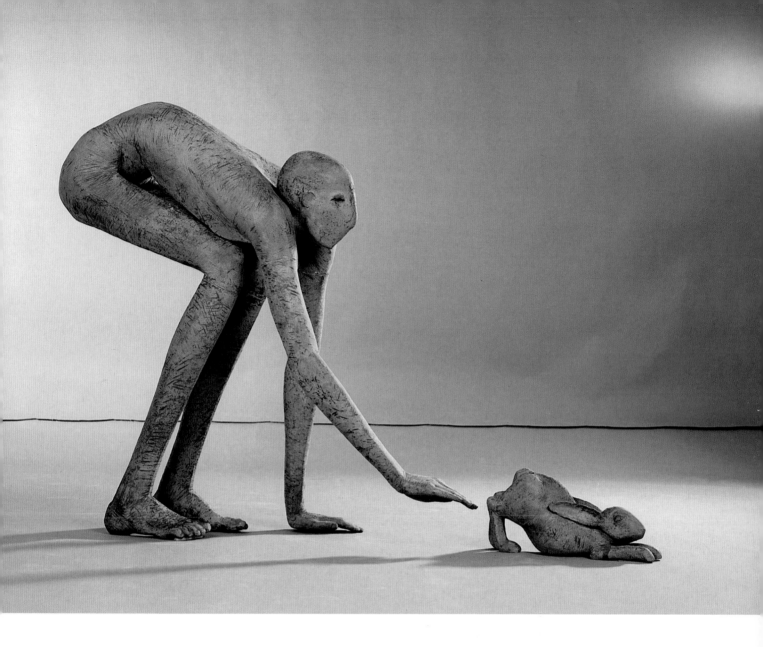

ABOVE Ingrid Jacobsen (Germany),
Ein Mann sucht was

Clayton Bailey, The Predator

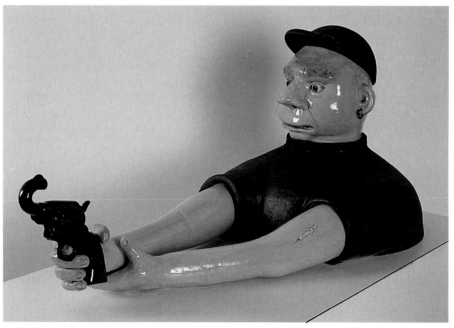

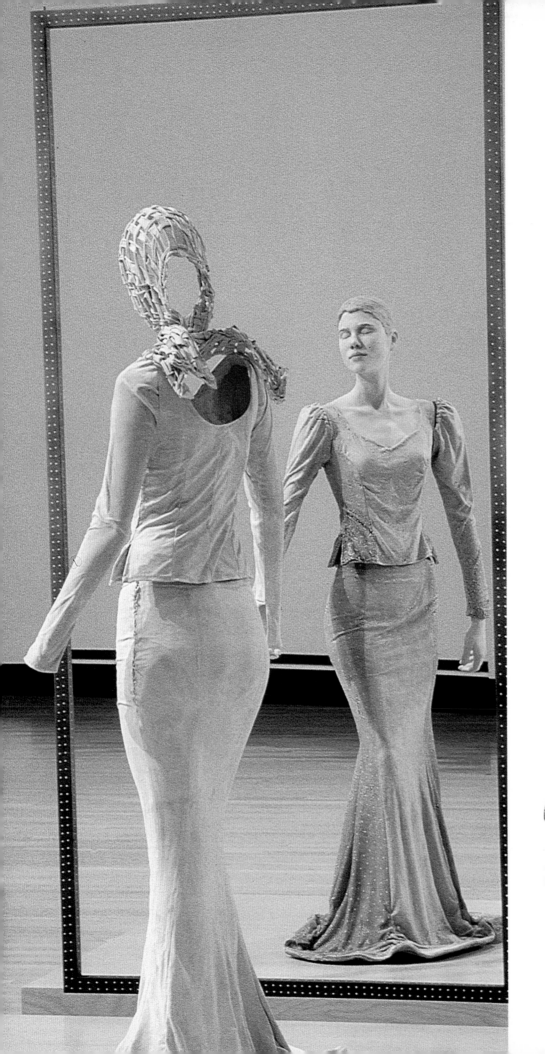

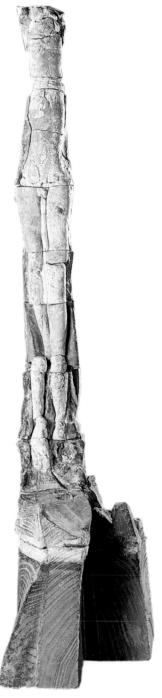

ABOVE Stephen DeStaebler,
Standing Woman with Flared Base

LEFT Nan Smith, Visionary

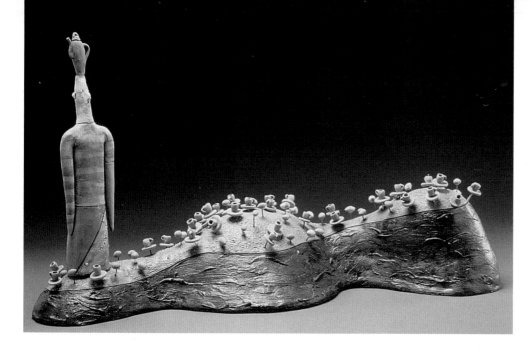

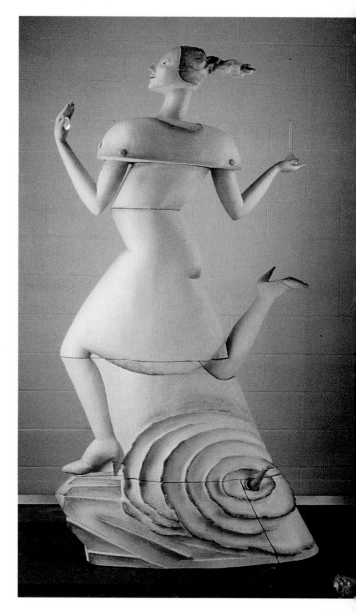

LEFT Don McCance, Sterility

BELOW Patti Warashina, White Lighting

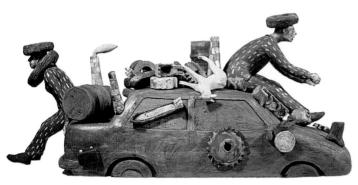

ABOVE Stephen Braun, Out of Gas

LEFT Richard Slee (England), Young Toby

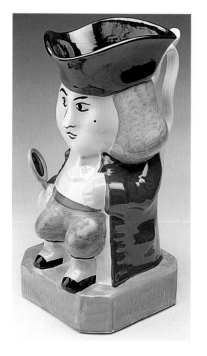

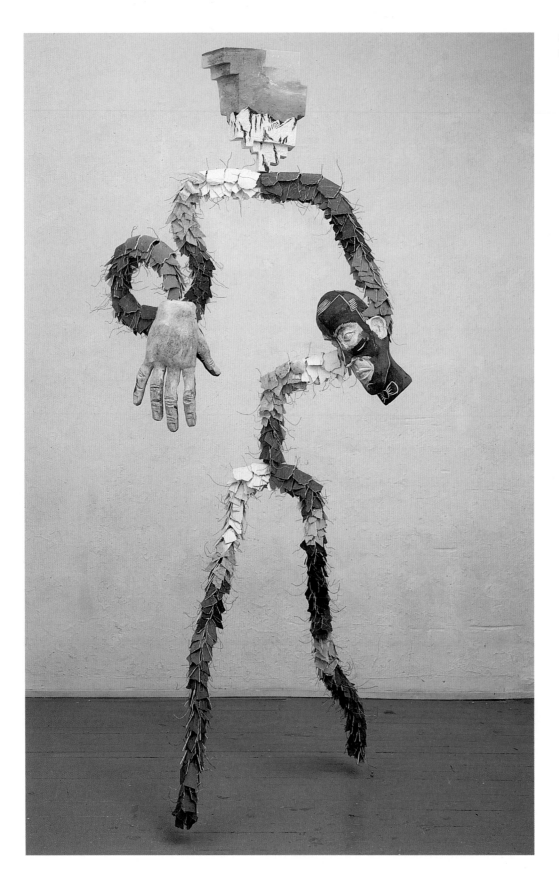

Michael Lucero, Snow-
Capped Mountain

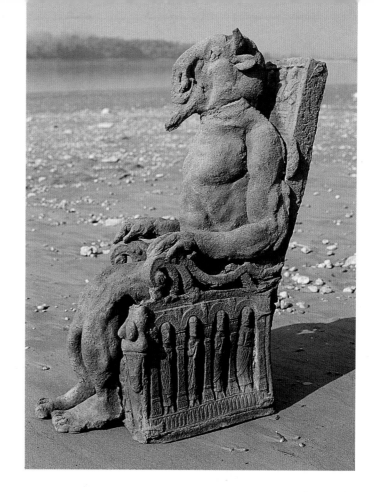

RIGHT Imre Schrammel (Hungary), lifesize figure

BELOW RIGHT E. Jane Pleak, Fine Art of Conversation

BELOW Beatrice Wood, Priscilla

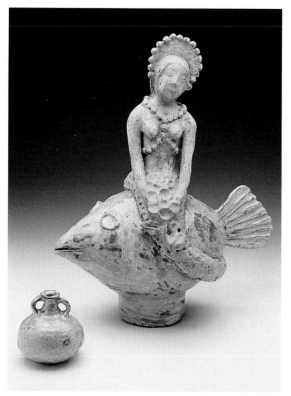

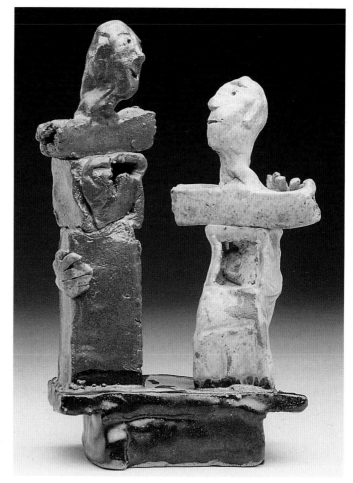

SCULPTURE

Sculpture is a nebulous term that can apply to anything. Often the term applies to abstract work that has no realistic meaning. Sometimes sculptural work is allegorical or metaphorical, or even humorous. Recognizing that all three-dimensional pieces that exist in space can be called sculpture, I have chosen a few representative images here.

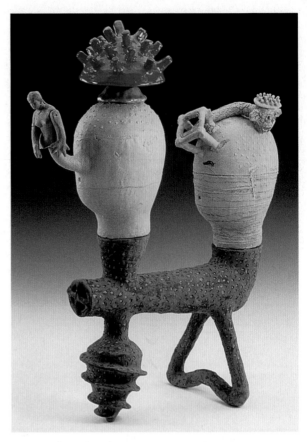

ABOVE Bill Stewart, Doodad

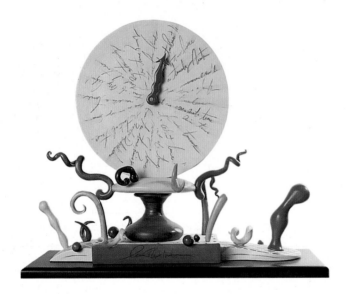

LEFT Tom Rippon, Time Machine

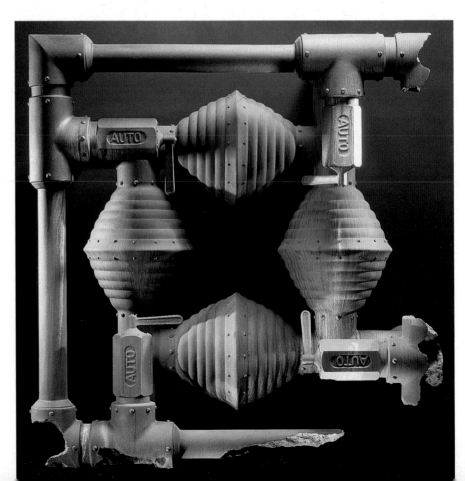

Steven Montgomery, Quadrus

Peter Voulkos, untitled

ABOVE Angel Garraza (Spain), Sitios y Lugares (detail)

LEFT Kukuli Velardé, Queen

ABOVE Richard Shaw,
Dark Temple

RIGHT David Gilhooly,
Coffee Break Selections

FACING PAGE Øyvind Suul (Norway), Dive

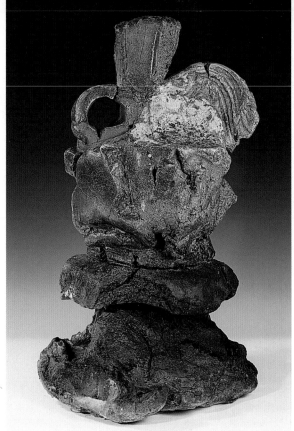

ABOVE Peter Callas (Australia), Sculpture

LEFT Paula Rice, Heart of Stone

FACING PAGE Xavier Toubes (Netherlands), 'Namorados da Lua

BELOW Keisuke Mizuno, Miniature Sculpture

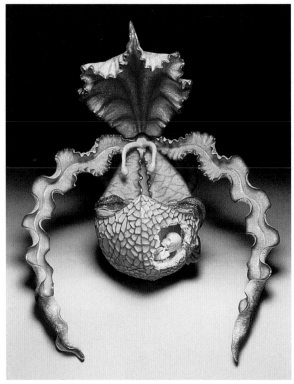

MIXED MEDIA

Ceramic materials are often combined with one or a variety of other materials, for aesthetic or structural reasons.

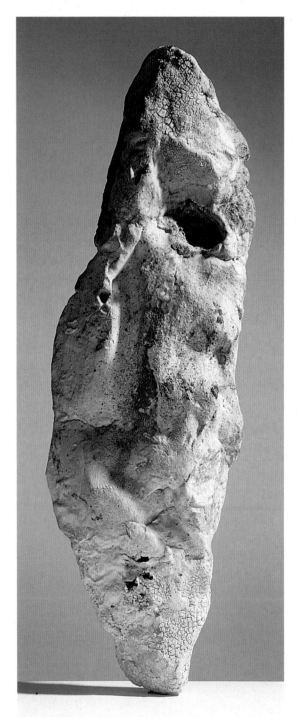

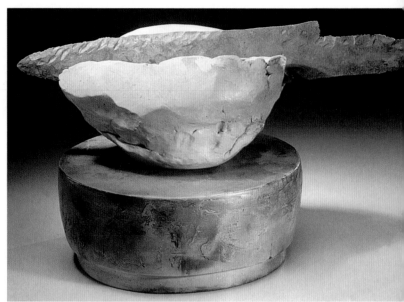

ABOVE Rick Hirsch, Altar Bowl with Weapon (forged steel and clay)

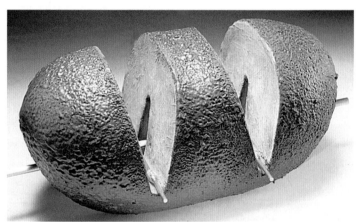

ABOVE John Stephenson, Isolator (wooden dowels and clay)

RIGHT Cynthia Chuang and Erh-Ping Tsai, Lady-Bug Pin (clay, gold, and stones)

LEFT Ewen Henderson (England), Standing Fish Form (paper and clay)

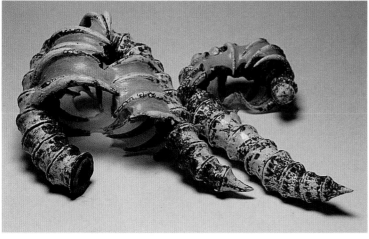

ABOVE Elisabeth Langsch
(Switzerland), Garden
Balls (concrete and clay)

Nori Pao, Two
Generations (fired clay
and latex)

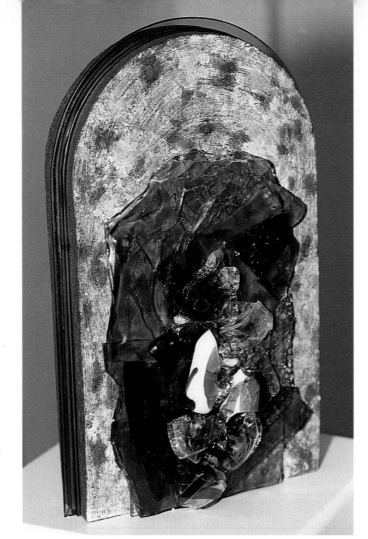

Bingül Başarir (Turkey), plaque (ceramic and glass)

BELOW Marilyn Lysohir, The Alligator's Wife (rice, lights and clay)

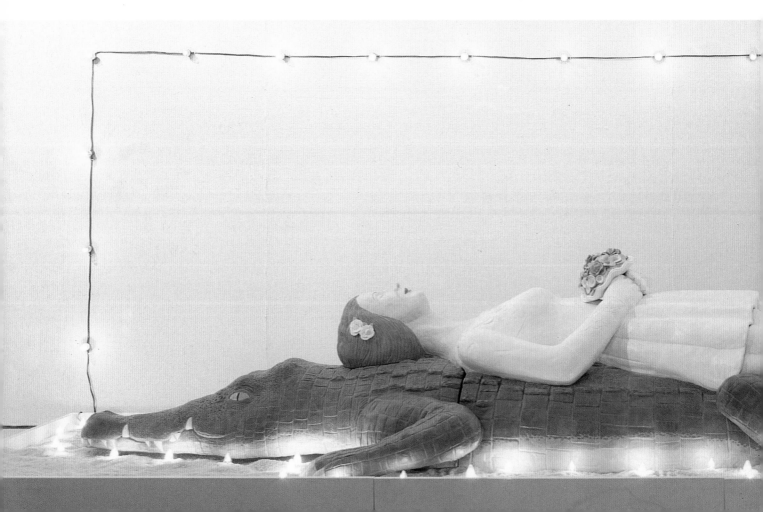

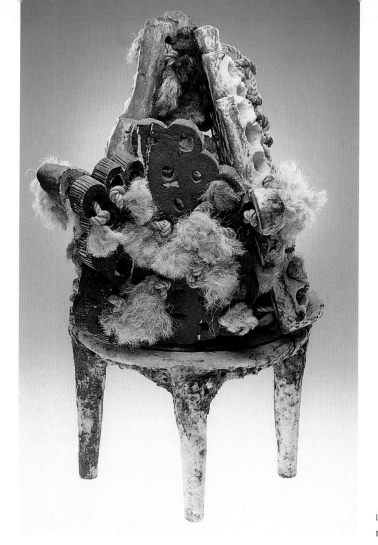

LEFT Bill Parry, Per Se (wood, rope, feathers, metal, and clay)

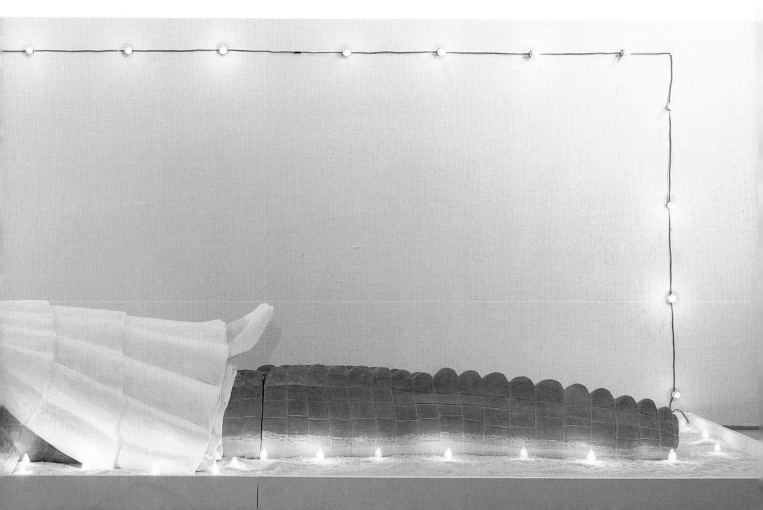

WALLS

Carol Aoki, Pod Collage
No.1

John Mason was one of the
few ceramic artists in the
1950s to fabricate and install
large wall constructions. The
21 ft Blue Wall is one of his
best known.

Vaslav Serak (Czech Republic), wall piece

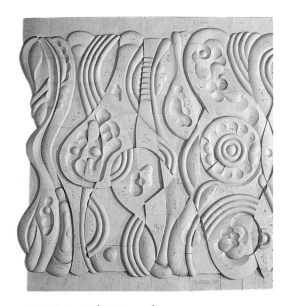

Ivana Eneva (Bulgaria), mural

Marit Tingleff (Norway), wall

Mai Järmut (Estonia), Hopeful

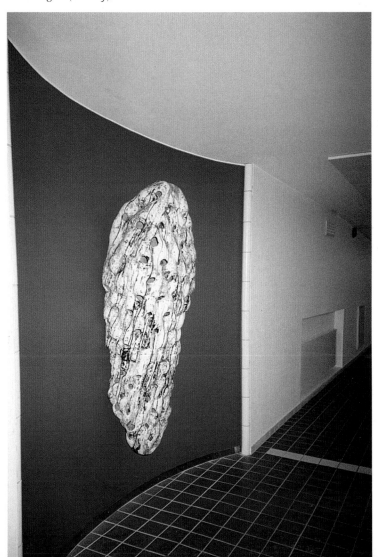

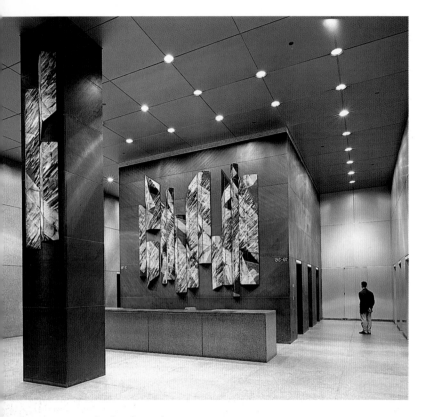

Dale Zheutlin, Archisites

Jale Yilmabaşar (Turkey), Eyes

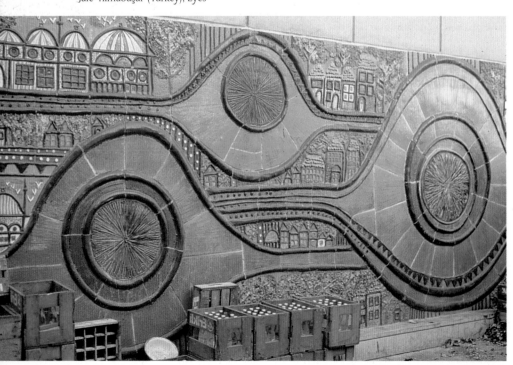

Peter Kuentzel,
Raindog

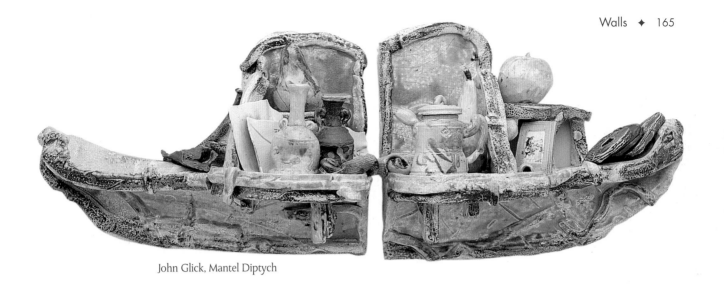

John Glick, Mantel Diptych

Paula Winokur, Entry III: Boulder Field Wayne Higby, Intangible Notch

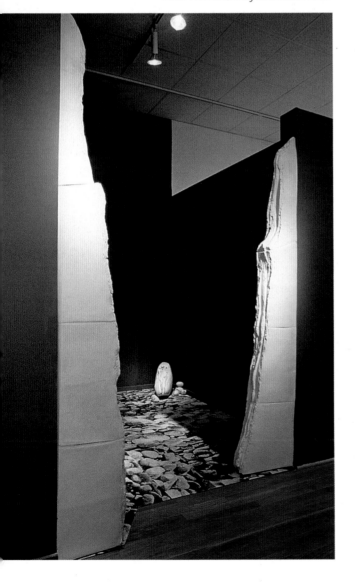

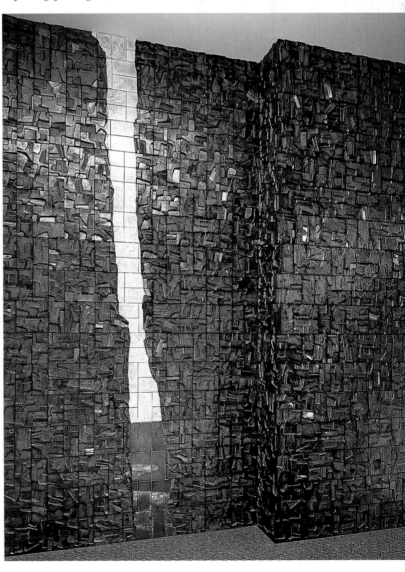

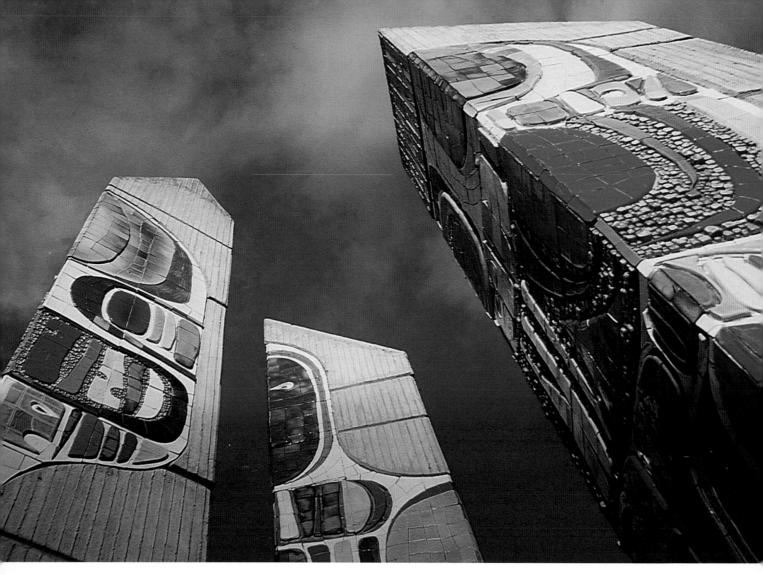

Edoardo Vega (Spain), Los Totems (detail)

Jim Melchert, section of 220 ft mural

ABOVE Jeanne Otis, Crocus Glow

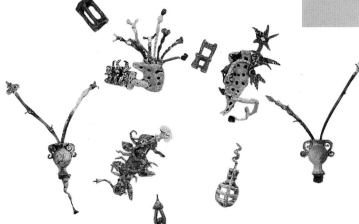

LEFT Bruce Dehnert (Malaysia), My Song for Kelly

Anthony Rubino, Ovid's Threshold

BELOW Jun Kaneko, Nagoya Wall

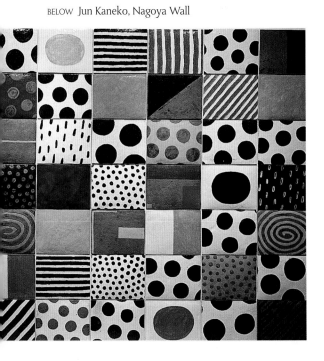

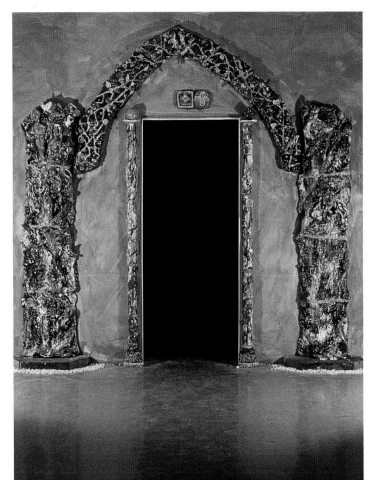

INSTALLATIONS

Ceramic installations are increasingly important as outdoor public art
statements, as accessories to architecture, and in large public spaces such
as lobbies, subways, hospitals, stations, and so on.

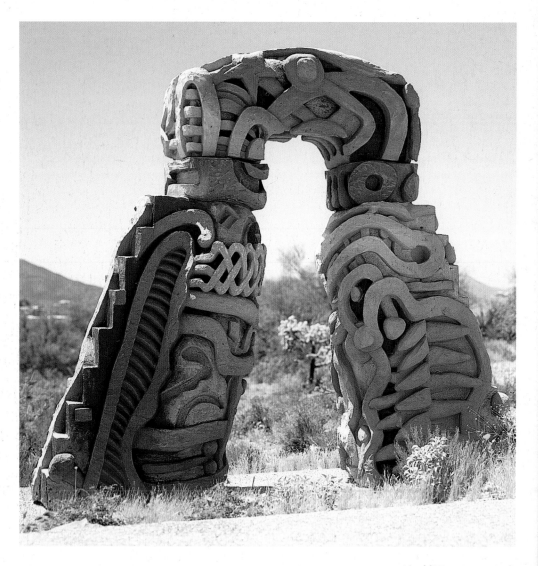

ABOVE Arnold Zimmerman, Arch

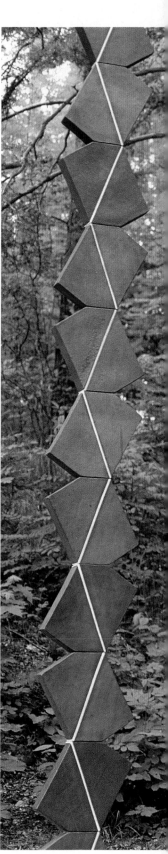

Patricia Lay, Mythoi

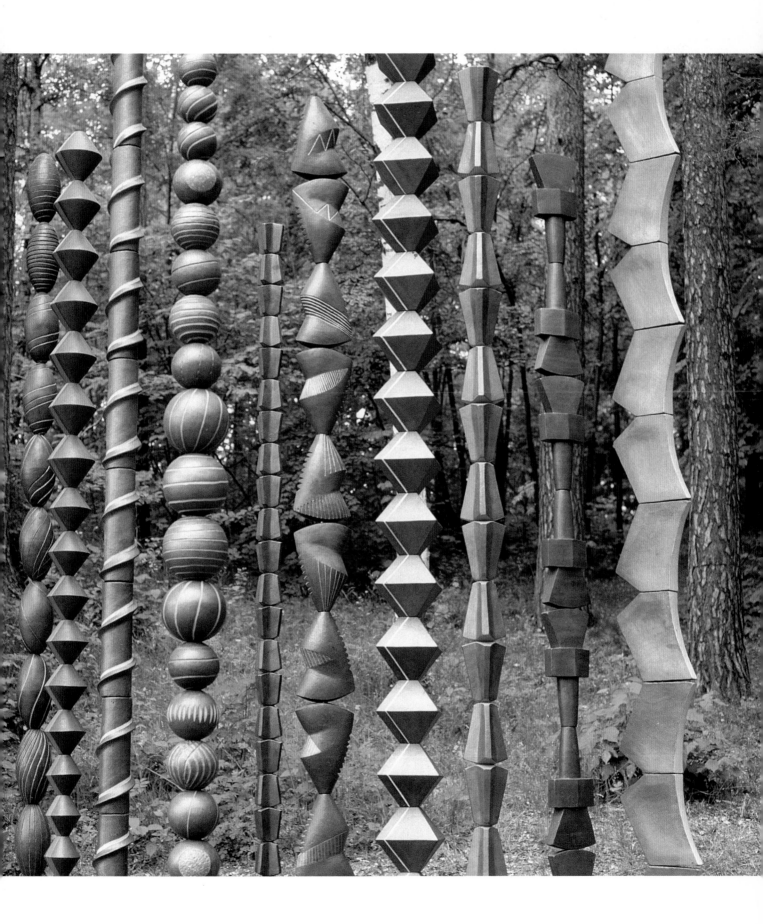

Deborah Horrell, Hell and In Between

George Geyer, Tidal Erosion

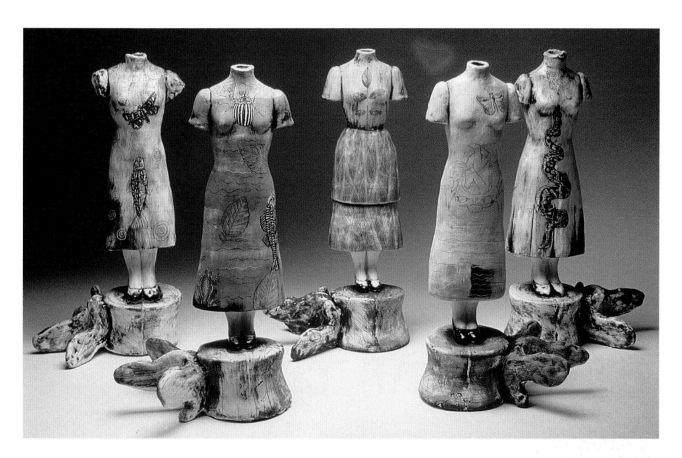

ABOVE Marilyn Lysohir, Tattooed Ladies

RIGHT Berry Matthews, White Space

BELOW Neddo Guioli (Italy), Limerick

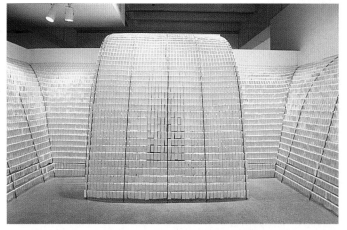

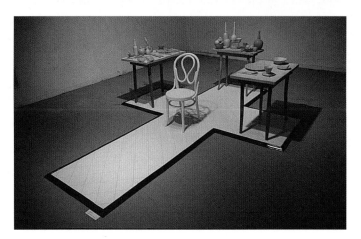

Bernard Kerr (Australia), Throne

7

THE TIMELESS
WORLD HISTORY OF
CERAMIC ART

Jomon ("cord pattern") large jar, coil built, with characteristic impressed surface decoration, from prehistoric Japan; 10,000 B.C.

Prehistoric Chinese pot, one of the earliest examples from the long tradition of Chinese pottery unbroken until this century; c. 5000 B.C.

What seem to be the earliest glazes were discovered in Egypt, dating from about 5000 B.C. At the same time, the Egyptians mixed clay and glaze into "Egyptian paste", a self-glazing clay body, to make small *ushabti* figures to be buried with the dead.

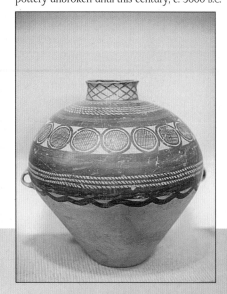

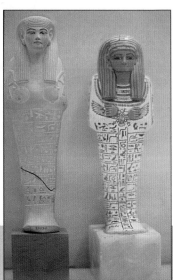

Fragments of clay vessels and objects have been the chief and sometimes the only remnants left from pre-historic human activities. Ancient peoples are studied mainly through the clay artifacts that remain in tombs and excavations all over the world. From the ceramic fragments that survive we draw inferences about cross-cultural borrowing, trade, migration, lifestyles, and the degree of sophistication of various societies according to their art forms. Clay was such a universal, easily obtained and moldable material that – more than rock art or marble sculpture – its remains supply countless ways to determine an intimate picture of ancient life, albeit without language.

Decorative motifs often seem to be similar and timeless. Perhaps the motifs that we see repeated time and again, simultaneously in different cultures or progressively through the ages, occur because processes are parallel and because the universal forms demand certain kinds of graphics. Or perhaps, as some leaders of surviving tribal groups maintain, there were long-term, long-distance migrations, exchanges, and communications of all sorts among distant peoples.

Tradition prevails in ceramics more than in other arts, because there are so many variables to be controlled in the materials and firing. Potters tend not to change anything for fear of having to change everything. Families and dynasties continued secret processes for generations and knowledge was refused to outsiders. All the same, new ways developed and some traditions were lost.

It is interesting to speculate why certain cultures were ceramic pioneers and others were not. For instance, why did only the Chinese develop porcelain, when the natural china clay plus flux and filler combination existed in the ground in Japan and Korea as well? Why did it take several thousand years for Europeans to develop porcelain, when they had the same ingredients but deposited separately? Why did North and South American societies burnish clay and never discover glaze? Why was the wheel used historically by potters only in the Orient, Middle East, and Europe, never in the so-called West? The answer probably lies in the fact that, if the societies did not invent or pick up from each other, their attention was focused elsewhere – on warfare, for instance.

The art of ceramics has the longest and most varied history of any of the arts. Neanderthal hunting and gathering groups roamed across Eurasia 70,000 to 35,000 years ago at least. Those early people had fire and probably made clay pots.

The first evidence of carving and the artistic employment of clay for ritual and functional use occurs about

The early Minoan culture on the island of Crete made very sophisticated pottery, thrown on the wheel, unglazed and decorated with various clays; 2500 B.C.

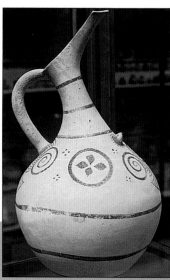

Yokes of Egyptian paste ornaments, as depicted in hieroglyphs, were used to hold up women's garments; c.2000 B.C.

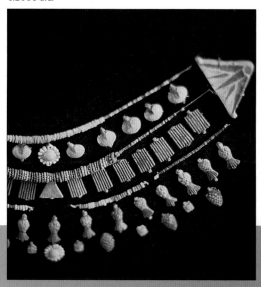

Amlash stylized animal, burnished and bonfired, from Luristan, Persia; 1500 B.C.

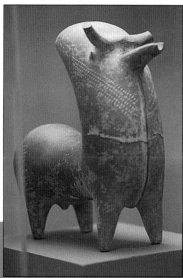

The Etruscans, ancient pre-Roman people of Italy, buried their dead in clay sarcophagi of vast scale topped with representational life-sized figures; 700 B.C.

A black on red terra sigillata jar from Attica, mainland Greece, produced during the so-called Golden Age of ceramics, 500 B.C.

Xian soldier, one of 6,000 life-size figures buried with the Chinese Emperor Ch'in Shih Huang Ti; 200 B.C.

35,000 years ago, during the Ice Age; clay animals and figures emerge, modeled in the round as well as carved in clay floors and walls. Ruins of prehistoric kilns have also been found dating from this period. Native American Indians were burning clay pots in bonfires 25,000 years ago; to this day they do not use kilns. This long and varied history of ceramic art changed directions many times, dropped out of sight, moved forward or stood still, then cropped up again in other pockets of time and space as civilization progressed; it is still continuing.

Although new ways have been adopted by whole cultures, evolutionary stages of clay art have more often originated with individuals. In contrast to the large body of anonymous folk artists, these innovative individuals have often been known by name. Some even reached a stage

Wonderful, spirited engobe decoration characterized Chinese Tz'u-chou dynasty pots; 600–1100.

The mysterious Mimbres American Indians (900–1300) disappeared inexplicably, but left us with exquisite stylized designs on ceremonial pots. The hole allowed the dead person's spirit to be released.

Pottery in the Chinese Tang dynasty was noted for its lead-based polychrome glazes – grass-green, amber yellow, and cobalt blue – and for its exquisitely executed hollow-built horses, camels, and warriors; 600–900 A.D.

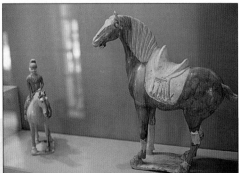

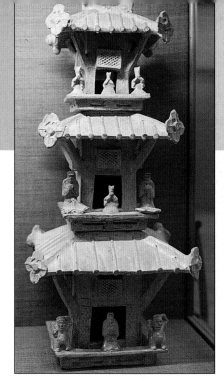

During the Han dynasty in China, seemingly thousands of figures and dwellings were created, depicting with wonderful movement and grace the daily life of the people; 200 B.C.–200 A.D.

The slick sheen characteristic of Roman pots was accomplished by the use of iron colored clay sigillata, often over relief designs; 100–200 A.D.

Stylized hollow-built Haniwa figures of warriors and animals were set into the ground around Japanese tombs; 400 A.D.

where they created economic gain for their societies.

In modern culture the break with tradition initiated by contemporary clay artists in their search for new ways has liberated claywork, sending it storming into the art world, and allowing not only space-age applications but also such non-traditional uses of clay as unfired clay art and site-specific installations.

In the pictorial time-line that comprises this chapter I indicate some of the highlights in the lengthy devel-

opment of ceramics. The dates given are approximate. This overview is based on my own observations in museums and at archaeological digs in various parts of the world. In the 19th and 20th centuries some of the greatest painters and sculptors of our time have been enamored of the plastic qualities of clay and have chosen to experiment seriously with the medium. We all need to be aware of the magnetism that history holds for our own involvement with clay.

The Chinese Sung dynasty is thought of as the greatest age in ceramics. It combined the highest technical ability with simplicity of form. The outstanding contribution was the discovery of reduction atmosphere, which produced celadons and oxblood red glazes. Porcelain, celadon-glazed ewer, 900–1200.

The Persians developed a scintillating luster technique, achieved by painting copper sulfate over a glaze and reducing it on the cooling cycle of a firing at 1300° F; 900–1300.

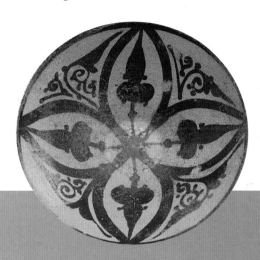

Pre-Columbian pottery in the USA is represented by this Zapotec stoneware figure of a god, 900 A.D.

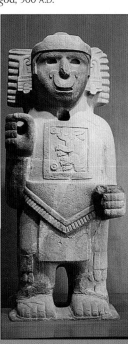

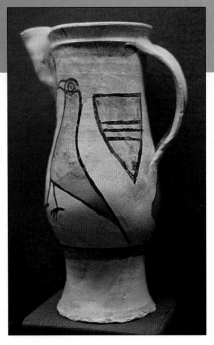

This medieval French jug is an example of the exuberant functional wares that were being produced all over Europe; 1100.

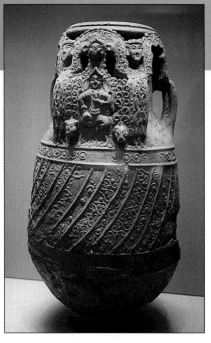

An unglazed Persian burial pot with an effigy; c.1150.

Early Italian majolica overglaze decoration on a tin opacified glazed pitcher; c.1400.

The famous Persian blue was produced by copper in a high-alkaline glaze. This ewer is decorated with engobe under the transparent glaze; c.1600.

The long history of Turkish ceramics culminated in the 15th and 16th centuries in the beautifully overglazed Iznik vessels and tiles.

The famous Imari porcelain factory in Arita, Japan, produced spectacular overglaze enameled and gold lustered wares such as this platter; c.1600.

The luster technique that the Persians developed spread across Europe, but was perfected in Valencia, Spain, which was a center of lusterware production in the 1500s.

For several generations the Della Robbia family in Italy produced architectural ceramics for interiors and exteriors, usually in carved white clay body with colorful majolica brushings; c.1500.

In China, potters of the Ming dynasty imported cobalt from Persia for blue-painted decorations on their clear-glazed white porcelain bodies. The dynasty also gave us the Ming colors of yellow, apple-green, and lavender that have never been duplicated; c.1500.

In France, King Louis XV instituted a state porcelain factory at Sèvres, where unusually fine overglaze painting was practiced on rather extravagant forms. Floor vase, c.1750.

Early in the 18th century, a porcelain body was developed at Meissen, Germany; porcelain centerpiece, c.1750.

The Dutch settlers, originally from German-speaking Switzerland, who came to Pennsylvania in the 1700s brought the peasant style of engobes on redware under clear glaze.

Besides functional porcelain dinnerware, large portrait sculptures were produced all over Europe, such as this one from the 18th-century St-Cloud factory in France.

In Switzerland and northern Europe, clay was used exuberantly to fashion sculptural stoves as room-warmers; c.1800.

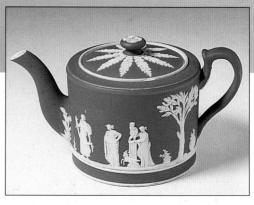

Josiah Wedgwood developed a porcelain clay body at Stoke-on-Trent, England, in 1760. The porcelain body was colored with cobalt blue, chrome green or basalt black, with white relief carvings superimposed; teapot, c.1800.

Adelaide Robineau made elaborate porcelain carvings early in the 20th century and founded the Ceramic Museum in Syracuse, New York.

Maija Grotell was a Finn who worked in the U.S.A. at about the same time as Adelaide Robineau; both women were influential. The work Grotell did in the 40s and 50s initiated an early modern style in ceramics.

Platter by Joan Miró (1893–1983)

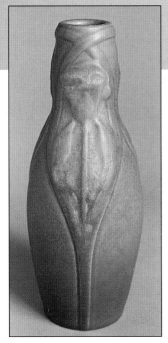

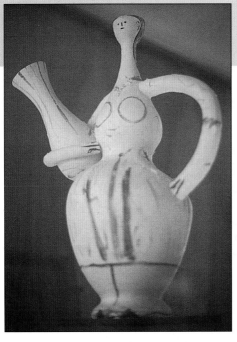

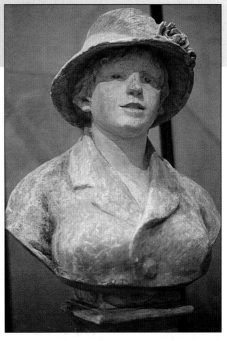

European ceramists who had worked in the state-subsidized porcelain factories settled in Ohio where there were good clay deposits, and founded the Rookwood factory, which closed in 1900. This subtly colored vase was one of this firm's many individually produced designs.

European painters who were inspired by the vigor of folk pottery began to use ceramics as an art medium; most notably, Pablo Picasso (1881–1973) carried clay into museum sophistication, as exemplified in this vase. The contribution of many of these artists – Braque, Giacometti, Chagall, Léger, Rouault, Matisse, Gauguin, among others – elevated the stature of clay as an art form.

Bust by Pierre-Auguste Renoir (1841–1919)

Fine French china from the Limoges factory, overglaze hand-painted in contemporary designs, 1990s

COMPENDIUM

1. SUGGESTED PROJECTS FOR INDIVIDUAL WORK

General procedure

1. Determine method of production to be used: hand-building; throwing; coil or slab or both; casting in a mold, or other.
2. Always consider size, proportion, shape, and color in relation to function.
3. Design in terms of the characteristics of your production method.
4. Remember shrinkage and limitations of your clay.
5. Structure of the shape is implicit in the design.
6. Color, textures, type of glaze or clay surface, must relate to the shape and function.

I. OVEN OR SERVING CONTAINER FOR HOT FOODS:

a. *Casserole* – design container for particular foods. What shape? What type lid? Handles necessary? Slant of sides? Easy to clean? Can it be used at table? What volume? Is color pleasing? Easy to store?
b. *Individual casseroles* – same as above.
c. *Soup tureen* – How big? How carried? Does ladle rest in tureen? Designed to keep soup hot? Color?
d. *Chafing dish* – Size? Handle? Where and how does it get heat?

II. BEVERAGE CONTAINER OR DISPENSER:

a. *Pitcher* – Do size and shape correspond to contents? Hot or cold liquid? Easy to grasp or hold? Pleasant and easily cleaned surfaces? Is handle attached near maximum weight? Is handle close to pot for leverage? Does spout provide guide to the liquid? Will spout drip? Does the pitcher have a substantial base?
b. *Mugs* – Large enough? Hot or cold liquids? Easy to grasp or hold, especially if hot? Pleasant lip to drink from?

If members of a set, do they hold correct amount in proportion to size of pitcher?
c. *Teapot* – Size? Spout pours well? Balance of handle? Is lid secure when teapot is tilted? Lid easy to grasp? Relationship of teapot body, handle, spout, and lid? Is there means of straining tea? Spout placed high enough so pot can be filled up?
d. *Cups and saucers* – Cup easy to hold and drink from? Does shape retain heat? Does saucer need a "well"? Relation of cup to saucer?
e. *Wine or liqueur bottle* – Size? Shape? How picked up? Will it pour? Visual appeal for this type of liquid?
f. *Coffee pot* – Large enough? Pouring facility? Lift? Will it keep coffee hot?
g. *Creamer and sugar* – Size? Pouring facility? Pouring lip? Handles or not? Lid for sugar?
h. *Punch bowl* – Size? Room for ice? Ladle? Cups?
i. *Water cooler or party keg* – Size and shape? How is liquid dispensed?

III. KITCHEN AND TABLEWARE

a. *Mixing bowls* – Different sizes? Can they be measuring bowls? Are they substantial? Reinforced lip? Really designed for *mixing*?
b. *Canisters* – Sized for contents? Shaped for storage? Type of lid? Rugged construction?
c. *Butter dish* – For both serving and storage? Size and shape?
d. *Salt and pepper* – Easy to load? What shape and size? Difference between salt and pepper? Easily cleaned?
e. *Salad bowl* – Shape? Color? Size?
f. *Jello/jelly molds* – Shaped for easy release of contents?
g. *Soufflé dish* – Size? Straight sides?
h. *Fruit bowl* – To hold what kind of fruit? What shape best? Can it have a tall foot?
i. *Cookie/biscuit jar* – How much does it hold? Will it keep contents dry/moist? Large enough opening for hand to go in easily?
j. *Miscellaneous* – Condiment trays, snack servers, cruets, tile hot-pads or trivets, batter bowl, jam pot, garlic pot, herb jars, colanders, etc.

IV. LAMP BASE

Size? Shape? For what purpose – reading, decoration, or light? Type of shade? Fixture? What happens to cord? Proportion of base to size of shade to light fixture? Simplicity, good substantial form, important.

V. PLANT AND FLOWER CONTAINERS

a. What type plant, as to size, color, culture? Should pot be porous? Must it provide drainage? Does it need a stand? Is there enough root area?

b. Cut flowers, what kind? Short or long stems, graceful or stiff? Design container for maximum water at base of stem.

c. Florist-type flower container, possible for mass production, low cost.

VI. OUTDOOR ACCESSORIES

a. *Brazier* – Size? Depth? Stand? Type and placement of grill? Porous clay body essential.

b. *Planter or decorative garden pot* – Glazed or not? Textured? Root room? Drainage?

c. *Space divider* – Such as could be made from ovals cut from thrown cylinder shapes, or slab constructions, etc.; or from many assembled clay shapes.

d. *Garden sculpture* – Withstand the elements? Where will it be used – among plants, on brick, free-standing? Interesting clay body important asset.

e. *Barbecue cooking accessories* – Large salt and pepper, basting pot, oversized salad container, condiment jars, etc.

VII. INTERIOR ACCESSORIES

a. *Wall decoration* – Flat tiles, relief sculpture, etc. How will it hang? Does it retain clay quality? Movable or permanent?

b. *Tobacco humidor* – Size? Shape? Lid? Means of retaining moisture?

c. *Tile table-top or tile trays* – How are tiles mounted? Spaces between? Continuity? Decorative or functional?

d. *Miscellaneous* – Door knobs, bells, tree or patio decorations, table centerpiece, clock, candle-holders, boxes, mirror frames, branch vases, hanging lights, porch lights, thrown or hand-built sculptures for interior or exterior spaces.

2. SUGGESTED PROJECTS FOR BEGINNING HAND-BUILDING

TEXTURE Experiment with objects pushed into clay to make patterns: tools, nails, bolts, buttons, seed pods, bark, etc. Glaze or stain to emphasize the texture.

COIL Round form with coils exposed and textured, or round form with coil building method concealed by smoothing the clay inside and out.

SLAB Build box or rectangular form with slab bottoms and sides, or cut *two* patterns and put them together in an asymmetrical shape. Glaze to enhance the main directional line.

HUMP OR SLING

Hump: rock or clay form.

Sling: hammock, draped in box or between four table legs, made of cloth. This is a good method for making simple, flat, low, open forms. You can add a foot or feet, or a top, or spouts, or put two humps or slings together, etc.

HISTORICAL POT OR FIGURE

Not copy, but grasp the same "flavor" as something from ceramic history. Suggestions: Tang, Sung, Haniwa, Jomon, Harappa, Syrian, medieval English, pre-Columbian, Native American, Egyptian, early Greek, Pennsylvania Dutch, etc. (See bibliography for help in finding historical illustrations.)

POT OR CONTAINER FOR DRIED BRANCHES

Find the grasses, stalks, or branches, then design the pot. This can be designed to hang free, hang against, stand alone, or be a group. Glaze only partially so the vegetation will relate to some "natural" clay surface.

PATIO LAMP

Light, lantern, or candle container, for outdoor use. Most important: light pattern, cut holes designed for shadows.

3. PROGRESSION OF INDIVIDUAL STEPS IN THROWING

1. Learn to *center* ball of clay. Try progressively larger balls, up to 10 or 15 lb.
2. *Pull cylinder* with even cross-section. Get clay *up* from bat. Cylinder walls should be heavier at base, gradually thinner toward the top.
3. Throw *bowl* shape, low and wide.
4. Pull *tall* cylinder, work up to 13 inches high, even wall-thickness.
5. *Collar* in small neck of cylinder, for bottle.
6. Throw *pitcher* and pull lip. Sharpen pitcher lip-edge so it will not drip. Pull and attach handle.
7. Throw *mug* and add handle.
8. *Pot with lid* to fit. Practice making flange on either pot or lid.
9. *Teapot*, watch size, proportion, balance, height of spout, type of handle.
10. Set of four or six *all alike*.
11. *Set*, one large container and several small ones, according to size and volume. Make enough small ones to hold the contents of large pot, no more, no less.

- *Watch structure*, learn to prevent warping, slumping. Engineer cross-section and profile for greatest support.
- *Watch foot shape* and size: should relate appropriately to profile-line of pot, and be similar thickness to the lip of the pot.
- *Signature of potter* should finish design, not hurt it.
- *Lip of pot* should end the shape. Try different ways of making and finishing feet and lips – bevels, sharp edges, soft rolls, beads, etc.

If you master the steps above, try these:

1. Try larger lumps of clay, perhaps twice larger at each stage, and do again the beginner projects.
2. Combine wheel-thrown shapes into larger pots or sculptural forms, putting them together wet, squashing or paddling the thrown pieces, adding texture, etc.
3. Large decorative plates
4. Planters
5. Lamps or lights
6. Hanging units: bells, mobiles, planters
7. Tea- and coffee-pots
8. Sets, alike or not, of anything
9. Closed forms
10. Footed compote

4. SUGGESTED PROJECTS FOR CLAY, GLAZE, AND DECORATION EXPERIMENTS

Body and glaze development

1. Learn properties of raw materials by experimental testing.
2. Set up standards for a particular type of clay body, color, firing properties, working qualities. Fit composition together, mix a batch, and run tests.
3. Set up standards for developing glazes to fit this clay body. Determine composition of raw materials, mix a batch, test, make necessary correction, try colorants.
4. Set up standards for any specific type of glaze – surface texture, temperature, color, viscosity. Mix and test.
5. Develop casting slip for specific temperature, type, color.

This can go on indefinitely!

Decoration

1. **Engobe:** brush, trail, dip, sgraffito; add flux to make engobe more vitreous; add more color to make it bleed through glaze.
2. **Underglaze:** decoration with stains or oxides on bisque.

Practice varieties of brush-strokes. Vary shading by spraying.
3. **Majolica:** decoration with stains or oxides over an unfired opaque glaze. Lines will fuse and feather. Freer than underglaze technique; use "washes" and other watercolor techniques.
4. **Glaze on glaze:** learn characteristics of various types of glazes. Watch color combinations. Spray, dip, over-dip, brush.
5. **Sgraffito:** draw lines through engobe or glaze or scrape away areas. Glaze should be non-fluid so lines will remain clear-cut in firing.
6. **Wax resist:** brush decoration with paraffin or wax emulsion on bisque, engobe or glaze over, or wax between two glazes.
7. **Stencil:** spray colored areas through stencil with underglaze, majolica, or over-spray techniques; or brush or sponge color using stencil pattern.

Exploit characteristic effects by analyzing your results, and making more tests.

Design standards to keep in mind

1. Proportion, size relationship, weight, balance, volume.
2. Placement of appendages.
3. Function and utility of shape.
4. Definite changes of plane make more vital form.
5. Keep character and freedom of the clay and its production process.

5. EXPERIMENTING WITH MATERIAL ADDITIONS TO A BASE GLAZE

Bisque a number of tiles for making tests: (a) test individual glaze materials mixed with water and applied to tiles; fire at cone 04, 5, and 10 to see the separate melts.

(b) Batch glaze for testing – one you already know or want to try. Mix it dry, well. Divide it into 100-gram amounts and add the proper material additions (see below). Mix each one wet and apply to tile with spatula, or by pouring or dipping. Fire.

Note: It is interesting to try the test at each of the above temperatures to see how it varies, but if you can't do that, just use the one temperature (cone) at which you usually fire.

Code back of each test-tile with cobalt, or black stain, and water, or use a commercial ceramic pencil.

TEST TILES: BASE GLAZE PLUS ADDITIONS. Take a known glaze and test it with additions:

☐	☐	☐	☐	☐
Flint 10%	Flint 20%	Kaolin 10%	Kaolin 20%	Talc 10%
☐	☐	☐	☐	☐
Dolomite 10%	Nephelene syenite 10%	Barium carbonate 10%	Zinc oxide 10%	Whiting 10%
☐	☐	☐	☐	☐
Magnesium carbonate 10%	Calcium borate 10%	Rutile 10%	Wood ash 10%	Base glaze 100%

Make a second test, replacing the 10% and 20% with 20% and 30% additions respectively, to see the limits. Make a test with color additions.

6. GLAZE IMPROVIZATIONS

Everybody, even children of elementary school-age, enjoys doing individual raw material experiments. Always use parts of 100, or parts of 10, that is, keep the "base" adding up to 100 or to 10. Add test materials to the base in percentage amounts to make changes. For example:

MAKE
- 10%–20% additions of all the raw materials on your shelves to base glazes (your own batches or taken from a book);
- or additions of natural raw organic plant materials (wood ash, flowers, volcanic ash, seaweed, etc.) to a base glaze;
- or additions of low-temperature common surface clay (found in the desert or near creek beds);
- or organic ash 50–50 with a glaze, or to glaze batches starting with 10%;
- or crushed, pulverized, ground rock used by itself, or added to other base glazes.

Test these sample experimental glazes on tiles or pots and fire at the temperature you normally use.

Seeing the results of standard glaze materials or of additions such as wood ash, etc., *as they melt by themselves (or don't melt) at various temperatures* can be a fascinating experience for students, and an absolute necessity for the potter; then, make more compositions from these results.

7. GLAZE "LINE-BLEND" TEST

This involves making all possible 50–50 combinations of some basic colors on your favorite glaze, at your favorite temperature.

1. Make 15 tiles for one test. (If you want more tests, add more top-members to the test.)
2. Mix 100 grams glaze for every top-member – in this case there are five, so measure 500 dry grams of glaze, mix well, and divide equally into five sandwich bags.
3. Add appropriate colorant to each sack and mix well: For instance: sack #1 = 2% cobalt carbonate; sack #2 = 4% copper carbonate; sack #3 = 10% rutile; sack #4 = 5% iron oxide; sack #5 = 10% zircopax – or make your own top-member list.

4. The line blend looks like this:

1	2	3	4	5	or more
	1 + 2	1 + 3	1 + 4	1 + 5	
		2 + 3	2 + 4	2 + 5	
			3 + 4	3 + 5	
				4 + 5	

Take a measuring spoon of dry glaze from each of the five sacks, mix it with water and apply each color to the first

five tiles. Then each successive tile is a 50–50 blend of the top-members. Take a measuring spoon of dry glaze from each of two sacks, mix together with water and apply to tiles (e.g., ½ #1 & ½ #2; ½ #1 & ½ #3, etc.). Mark back of tile with code number and fire.

8. SPECIAL LOW-FIRE INFORMATION

Egyptian paste

White Batch Formula (Self-glazing clay/glaze composition similar to that used several thousand years ago by the Egyptians)

Fire cone 010 to cone 04
(1800° to 1900° F, 980° to 1040° C)

Nepheline syenite	342 grams
Silica	342 grams
Ball clay	133 grams
Soda ash	53 grams
Baking soda	<u>53 grams</u>
Total	923 grams

(makes about 2 lb.)

Keep wet batch wrapped in damp cloth and stored in airtight container.

Colors

(Try adding one of these to the base batch above)

Turquoise – copper carbonate		3 % (light)
	or	4 % (darker)
	or	6 % (black)
Dark blue – cobalt oxide		1–2 %
Yellow-green – yellow-green stain		5 %
Purple – manganese dioxide		2 %
Yellow – yellow stain		8 %
Dark green – chrome oxide		5 %

Experiment with other metallic oxides and stains for color; 12 % color addition is maximum.

Use Egyptian paste for beads, pins, buttons, jewelry. Fire on nichrome (nickel-chrome) wire in regular bisque firing.

Mosaic cement

(Use for setting ceramic or glass mosaic pieces)
Mix: magnasite and magnesium chloride together into paste form.

Low-fire engobe

For cone 04: Use dry talc-type low-fire clay body for base white batch for firing at cone 04 or lower.

Add colors:

Blue – cobalt blue	20 %
Orange – rutile	40 %
Green – chrome oxide	40 %
Violet brown – manganese dioxide	12 %
Black – black stain	10 %, plus
iron oxide	10 %, plus
manganese dioxide	10 %

(start with red clay, if possible)

or mix your own low-fire base white engobe as follows:

Talc	70 %
Ball clay	30 %

(See "Engobes", page 87, for example of a high-fire engobe.)

9. EXAMPLE OF A POTTERY STUDIO

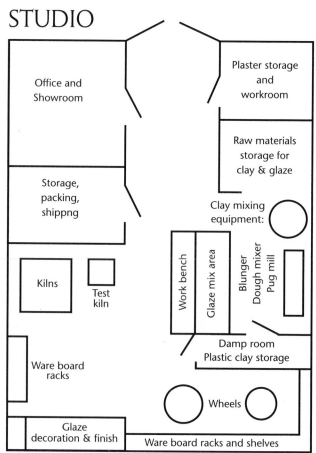

10. TEMPERATURE EQUIVALENTS OF ORTON CONES

Remember that cone temperatures are approximate – it is always best to watch the cones.

CONE NO.	68°F	20°C	CONE NO.	212°F	100°C	CONE NO.	1112°F	600°C
022	1085	585	23	2876	1580	39	3389	1865
021	1103	595	26	2903	1595	40	3425	1885
020	1157	625	27	2921	1605	41	3578	1970
019	1166	630	28	2939	1615	42	3659	2015
018	1238	670	29	2984	1640			
017	1328	720	30	3002	1650			
016	1355	735	31	3056	1680			
015	1418	770	32	3092	1700			
014	1463	795	32½	3137	1725			
013	1517	825	33	3173	1745			
012	1544	840	34	3200	1760			
011	1607	875	35	3245	1785			
010	1634	890	36	3290	1810			
09	1706	930	37	3308	1820			
08	1733	945	38	3335	1835			
07	1787	975						
06	1841	1005						
05	1886	1030						
04	1922	1050						
03	1976	1080						
02	2003	1095						
01	2030	1110						
1	2057	1125						
2	2075	1135						
3	2093	1145						
4	2129	1165						
5	2156	1180						
6	2174	1190						
7	2210	1210						
8	2237	1225						
9	2282	1250						
10	2300	1260						
11	2345	1285						
12	2390	1310						
13	2462	1350						
14	2534	1390						
15	2570	1410						
16	2642	1450						
17	2669	1465						
18	2705	1485						
19	2759	1515						
20	2768	1520						

TEMPERATURE EQUIVALENTS OF SEGER CONES

CONE NO.	MELTING POINT °F	°C	CONE NO.	MELTING POINT °F	°C	CONE NO.	MELTING POINT °F	°C
021	1202	650	01a	1976	1080	20	2786	1530
020	1238	670	1a	2012	1100	*26	2876	1580
019	1274	690	2a	2048	1120	27	2930	1610
018	1310	710	3a	2084	1140	28	2966	1630
017	1346	730	4a	2120	1160	29	3002	1650
016	1382	750	5a	2156	1180	30	3038	1670
015a	1454	790	6a	2192	1200	31	3074	1690
014a	1499	815	7	2246	1230	32	3110	1710
013a	1535	835	8	2282	1250	33	3146	1730
012a	1590	866	9	2336	1280	34	3182	1750
011a	1616	880	10	2372	1300	35	3218	1770
010a	1652	900	11	2408	1320	36	3254	1790
09a	1688	920	12	2462	1350	37	3317	1825
08a	1724	940	13	2516	1380	38	3362	1850
07a	1760	960	14	2570	1410	39	3416	1880
06a	1796	980	15	2615	1435	40	3488	1920
05a	1832	1000	16	2660	1460	41	3560	1960
04a	1868	1020	17	2696	1480	42	3632	2000
03a	1904	1040	18	2732	1500	* Numbers 21 to 25 are obsolete		
02a	1940	1060	19	2768	1520			

GLOSSARY

Anagama Tube-like single chamber hill kiln; predecessor of *norborigama*, a multi-chambered hill kiln of Oriental style.

Ash The residue made by burning tree, plant, or vegetable material; can be used alone or with other materials for glaze; volcanic ash can also be used.

Ball Clay Highly plastic refractory clay that fires off-white; workable, fine-grained sedimentary clay used in white bodies, engobes, and glazes.

Bat Any slab used as a base for throwing or hand-building clay; also applies to a trough used to dry slurry clay to the plastic state; usually made of plaster, press board, plywood, or other porous material.

Batch A mixture of glaze or engobe ingredients calculated by parts or weight.

Bisque, Biscuit Unglazed, but fired ware, usually accomplished in a low temperature firing prior to a glaze fire; also applies to unglazed ware fired high, as in porcelain bisque.

Blistering Bubbles formed in the glaze during the firing due to liberation of gases caused by firing that is too fast; or caused deliberately by putting into the glaze a material such as trisodium phosphate, which will promote decorative bloats.

Body A combination of natural clays and non-plastics, especially formulated to have certain workability and firing characteristics.

Bone China Porcelain of high translucency made with bone ash as the flux, produced mainly in England and Japan.

Burnishing Polishing with a smooth stone or tool on leather-hard clay or slip to make a surface sheen; the surface will not stay shiny at temperatures above 2000° F (1100° C).

Casting Process of forming shapes by pouring deflocculated liquid clay slip into plaster molds for repetitive production.

Celadon Glaze Sea-green glaze with a small percentage of iron as the colorant; fired in a reduced atmosphere, usually a stoneware or porcelain glaze, first used by the Orientals.

Centering Pushing a mass of clay toward the center with the centrifugal motion of a potter's wheel.

Ceramics Art and science of forming objects from earth materials containing or combined with silica, produced with the aid of heat treatment at 1300° F (700° C) or more.

China (1) A porcelain clay body, with up to 1% absorption, usually translucent. (2) Whiteware, vitreous and hard, sometimes translucent. (3) A general term used in trade when discussing any kind of tableware.

China Clay Primary or secondary kaolin, refractory, not very plastic, white-burning, rare in the world; used in the blending of all whiteware and porcelain bodies.

Clay Theoretically $Al_2O_3-2SiO_2-6H_2O$; earth materials formed by the decomposition of igneous rock; when combined with water, clay is plastic enough to be shaped; when subject

to red heat or above, it becomes dense and rock-like.

Coiling, Coil Building Age-old method of constructing hollow forms by rolling and attaching ropes of soft clay.

Cones Pyrometric cones, Orton or Seger brand; pyramids made of clay and glaze constituents that bend at specific temperature. Cones are placed in the kiln during firing to indicate the final heat; they are classified by numbers coded to their softening point.

Core The interior of a piece, or a framing or the stuffing on or over which work can be supported; combustible core materials burn out in the kiln; rigid cores should be removed before the clay shrinks.

Crackle Decorative and intentional fissures netting the surface of a glaze due to a variation and expansion and contraction of the glaze and the clay body.

Crawling Glaze that has separated into mounds on the clay surface during firing, generally caused by fluffy or high-shrink materials in raw glazes.

Crystalline Glazes Large crystals grown on the glaze surface during firing and cooling, primarily induced by high zinc oxide and low alumina content in glazes.

Damper Adjustable shutter to control draft at the kiln flue.

Decal Ceramic pigments photo-screened or pattern-screened onto flexible decal paper for transfer to bisque or over glaze; can be bought or made.

Deflocculation The addition of a catalyst to a clay and water slip to reduce the amount of water required.

Downdraft Kiln Kiln with fire entering at the side or base, where heat is forced around, up, and down through the ware, and exits via a flue at the back of the chamber.

Dry Foot No glaze on the foot rim; used for stoneware and porcelain, rather than the stilt method used for earthenware; stilts would warp the piece when fired to these higher densities.

Earthenware All ware with a permeable or porous body after firing; by definition earthenware has 10% to 15% absorption.

Enamel (1) Applied to pottery: low-temperature glazes applied over other glazes. (2) Applied to metals: glaze that melts lower than steel, copper, silver, or gold, on which enamel is used, fired about 1300° F (700° C).

Engobe [*pronounced on-gobe*] A liquid clay slip colored with metallic earth oxides or glaze stains applied to wet or leather-hard ware for decoration. Engobe can be covered by glaze or used alone.

Extrusion Forcing plastic clay through an auger or form, mechanically or by hand, to change its shape; can be solid or hollow.

Faience A general art-historian's word covering low-fire colored clay bodies, such as Egyptian paste.

Feldspar Mineral found in granite which melts around 2300° F (1260° C), used as a flux in clay bodies and glazes.

Fire Box The chamber of certain kilns into which the fuel is fed and in which the initial combustion takes place.

Fire Clay Secondary clay that withstands high temperature and has a varying amount of free silica in addition to the clay molecule.

Firing (1) Heating in a kiln to the required temperature for clay or glaze, at least to red heat, 1300° F (700° C). (2) Bonfiring in a pit or on the ground.

Firing Curve The track made by firing points on a graph, showing the relationship between change in temperature and firing time.

Flue (1) The passageway for flames in kilns – essentially the combustion space; the flue is the area around the stacking space. (2) The place of escape for the products of combustion from the kiln chamber.

Flux A material or mixture having a low melting point or lowering the melting point of other materials. One of the three main components of glaze; also used to increase density in clay bodies; examples include lead, borax, lime, feldspar, and frit.

Foot Base or bottom of a piece.

Frit Mixture that is melted, cooled quickly, and ground to a fine powder. Fritting renders soluble glaze ingredients, such as soda ash, insoluble, and poisonous materials, such as lead, nonpoisonous.

Glaze Glassy melted coating developed by chemicals and heat on a clay or metal surface. Glaze provides decoration and color, prevents penetration of liquids or acids, and yields a matt or glossy, functional surface.

Glaze Stains Fabricated ceramic colorants from metallic oxides mixed in combination with other elements to widen the glaze decorating palette; sold by code number, color, and company.

Greenware Finished leather-hard or bone-dry clay pieces not yet fired; raw ware.

Grog Crushed or ground-up fired clay, purchased commercially or made by the potter; used to reduce shrinkage, it yields texture; aids in even drying and firing.

Hollow Casting Pouring liquid clay slip into a hollow plaster mold to create a shell of a specific shape.

Intaglio Depressed surface decoration, the reverse of bas-relief.

Jiggering A mechanical method of producing many of the same shapes with a plaster mold and a metal template.

Kaki Glaze Traditional glaze from the village of Mashiko, Japan. Created by grinding local rock; according to Shoji Hamada it was named for the color that a persimmon is on October 24.

Kaolin Anglicized form of the Chinese word for china clay. Pure kaolin is a white-burning, high-

firing natural clay that is the essential component of porcelain bodies and an ingredient in many glazes.

Kick Wheel A potter's machine for working clay with a centrifugal motion propelled by kicking.

Kiln Furnace for firing clay, slumping glass, or melting enamels; studio kilns can achieve temperatures up to 2500° F (1370° C). They can be fueled carbonaceously, organically, or electrically.

Kiln Furniture Refractory slabs, posts, supports (called setters) for holding ware in the kiln, handmade or purchased.

Kiln Wash Half clay, half silica, mixed with water to coat kiln shelves.

Leather-hard Cheese-hard stage which clay reaches before being bone-dry; stiff enough to support itself, but still can be altered.

Luster A brilliant, iridescent metallic film on glaze, formed from certain metallic salts at a specific temperature in a reduced atmosphere, usually on the cooling side of the firing cycle.

Luting A method of putting together coils, slabs, or other clay forms in the wet or leather-hard stage by cross-hatching and moistening; the same as scoring.

Majolica The decorative application of coloring oxides and stains over an unfired glaze that fuses into the base glaze during the firing, leaving fuzzy edges. The term comes from the Balearic island of Majorca.

Majolica Glaze An opaque glaze with a glossy surface, usually white, generally opacified by tin oxide; a base for colored stain or overglaze decoration.

Matt Dull, non-reflective surface; in the case of glaze, due to deliberate composition or immature firing.

Mesh Holes per square inch in plastic screens, used for screening clay or glaze.

Millefiore A traditional technique in glass and clay where several, or many, slabs of color are combined in patterns, and cut through in cross-section to make other forms.

Mishima Carved decoration in leather-hard clay, covered with engobe and rubbed off when drier, leaving engobe inlaid in the carving.

Mold Usually a plaster form, single or multi-pieced, which will be used to reproduce any number of accurate copies of the original model in clay or plaster.

Neutral Atmosphere An atmosphere in a kiln that is neither completely oxidizing nor completely reducing.

Off-the-Hump Method of throwing small forms consecutively from one large mound of clay.

Once-firing Glazing leather-hard or bone-dry ware and firing to maturing temperature (this skips the first bisquing); frequently used in commercial production; often the method in salt or wood firing.

Oxidation, Oxidizing Fire Opposite of a reducing fire; the firing of a kiln where combustion of the fuel is complete.

Peephole A view or observation hole in the wall or door of a kiln; it should be large enough to see into the kiln easily during the firing; also used for pulling draw trials and tests during the firing.

Pinching Moving and shaping clay with the fingers.

Plaster The mineral gypsum, with the chemical composition of calcium sulfate, used for clay/mold reproduction and as a work surface.

Plasticity Workability; clay is the only mineral having real plasticity, meaning the ability to form into any shape, and to get progressively harder in the same shape on being fired to 1300° F (700° C) and above. Other materials, such as talc, can be said to have claylike plasticity.

Porcelain Mechanically strong, hard, frequently translucent, fired clay body with 0% absorption; the strongest of all clay bodies unless very thin.

Pottery A loosely used term; often means earthenware or just any clay piece that has been fired.

Pressing Forming plastic clay in a plaster mold or other form, by laying it against the mold face.

Profile Line Outside or inside line; the line formed when shape bisects space.

Pyrometer A calibrating instrument on the outside of a kiln, used with a thermocouple inside the kiln to measure temperature during the firing.

Raku A firing or a type of ware; porous, groggy ware, with or without a glaze, put into and pulled out of a hot fire and sometimes smoked. Developed in Japan in the 1600s.

Raw Glaze Unfired glaze.

Reduction, Reducing Fire Opposite of an oxidation fire; the firing of a kiln with an atmosphere of reduced oxygen, where combustion of the fuel is incomplete. Copper in reduction is oxblood red, in oxidation green; iron in reduction is celadon, in oxidation amber yellow, or brown.

Refractory Resistant to melting or fusion; a substance that raises the melting point of another material. Refractory materials are the basis of high-temperature ceramics.

Resist Wax, varnish, latex, or other substance applied in pattern on a clay or glaze surface to cover an area while the background is treated by another material or color.

Salt Firing Rock salt is thrown into the fire at the maturing temperature of the clay until an "orange-peel" clear glaze appears on the ware.

Sawdust Firing Firing with sawdust to reduce oxygen and blacken the ware.

Scoring A cross-hatch and moistening method of putting together coils and slabs in the wet or leather-hard; the same as luting.

Sgraffito A design scratched through one surface to another.

Shards Fragments of pottery; the state in which many clay works are found.

Shrinkage Contraction of clays or bodies in drying and firing, caused by the loss of physical and chemical water and the achieving of molecular density.

Silica Oxide of silicon, SiO_2; found abundantly in nature as quartz, sand, and flint; the most essential oxide in ceramics; the glass-forming oxide.

Slab Flat piece of clay from which shapes can be fabricated.

Slip A suspension of ceramic materials in water; generally refers to casting slip for molds; can mean a liquid clay engobe for decorating or a glaze slip.

Slurry Thick suspension of one or more ceramic materials in water.

Spiral Wedging Kneading clay with a pivoting motion to remove air pockets and make the texture homogeneous.

Stain Watercolor wash on bisque with metallic coloring oxides or commercial glaze stains; also a term referring to glaze stain.

Stoneware Hard, dense, and durable ware generally fired to 2150° F (1180° C) or above; a body with 0 to 5% absorption, regardless of firing temperature.

Tenmoku Japanese name for a type of glaze used especially by the Chinese during the Sung Dynasty; glaze whose rich black appearance is caused by an overabundance of iron oxide.

Terracotta Term used to describe rust-red clays; an art historian's term for low-fired, unglazed, generally red-colored ware.

Terra Sigillata Low-fired clay work with sheen resulting from burnishing; an extraordinary fine-ground clay suspension in water that shines when applied as a coating. It is always fired at low temperature to preserve the shine. It is also the surface on Attic Greek wares.

Thermocouple A pair of wires of different metals (platinum and rhodium or, for low temperature, chrome alumel) twisted together and sealed at one end. The sealed end registers the temperature; the reading is transmitted through the wires to a connector and thence via insulated wiring to the pyrometer, where the reading is measured in degrees.

Throwing The process of forming pieces on a revolving potter's wheel from solid lumps of clay into hollow forms.

Trailing A method of decorating with engobe or glaze squeezed out of a bulb from a small orifice or poured from a narrow lip.

Translucency Ability to transmit scattered light, not quite transparent.

Transparent Clear, like window glass; can be colored or colorless. Texture or decoration instantly shows through a transparent glaze.

Underglaze or U.G. Pigments designated as underglaze stains, overglaze stains, and body stains, according to usage. Also a name used by commercial manufacturers for a glaze product that stays put and does not melt.

Updraft Kiln Kiln in which the fire is underneath or at the low end of the tube or chamber; heat moves up through the ware and out of a flue at the top.

Viscosity Property of a flow; a highly viscous glaze is "stiff" and does not flow much during firing. A glaze of low viscosity is fluid, and can cause other glazes or decoration to become fluid.

Vitreous Glass-like, hard, dense.

Wax Melted paraffin wax (which is not water-soluble), mixed with kerosene or benzine for ease of application, used for resist techniques; also commercially produced water-soluble waxes such as Ceremul A.

Wedging Kneading a mass of clay to expel air and make the mass homogeneous.

Whiteware All ware with a white or ivory clay body after firing.

LIST OF ARTISTS

Patricia Lay *168*
Teaching: Montclair State College
Studio: Jersey City, New Jersey
Bernard Leach *13, 14*
Deceased, St. Ives, Cornwall
Jim Leedy *141*
Teaching: Kansas City Art Institute
Studio: Kansas City, Missouri
Enid Legros-Wise *26*
Studio: Quebec, Canada
Marc Leuthold *85*
Teaching: State University of New
York at Potsdam
Studio: Potsdam, New York
Marilyn Levine *30*
Studio: Oakland, California
Lucy Lewis *38, 48, 126*
Deceased, Acoma Pueblo, New
Mexico
Michael Lucero *150*
Studio: New York City
Marilyn Lysohir *160, 171*
Studio: Moscow, Idaho
Warren Mackenzie *88, 106*
Retired, University of Minnesota
Studio: Stillwater, Minnesota
James Makins *87*
Teaching: Philadelphia College of
Art
Studio: New York City
Richard Malmgren *106*
Studio: Annapolis, Maryland
Kirk Mangus *10, 131*
Teaching: Kent State University
Studio: Kent, Ohio
Heidi Manthey *24*
Studio: Nevendorf, Germany
Maria Martinez *37, 125*
Deceased, San Ildefonso Pueblo,
New Mexico
John Mason *13,* 14, *29, 41, 97,
162*
Studio: Los Angeles, California
Karen T. Massaro *101*
Studio: Santa Cruz, California
Patriciu Mateiescu *49*
Studio: Dayton, New Jersey
Berry Matthews *171*
Teaching: State University of New
York at Plattsburgh
Studio: Plattsburgh, New York
Don McCance *149*
Teaching: Georgia State University
Studio: Tyrone, Georgia
Harrison McIntosh *68*
Studio: Claremont, California
Ray Meeker *77, 137*
Studio: Pondicherry, South India
Jim Melchert *166*
Studio: Oakland, California
David Middlebrook *41*
Teaching: California State University
at San Jose
Studio: San Jose, California
Greg Miller *71*
Studio: New Castle, Pennsylvania
Keisuke Mizuno *156*
Studio: Mesa, Arizona
Cara Moczygemba *144*

Studio: New Orleans, Louisiana
Gertraud Mohwald *144*
Studio: Halle, Germany
Steven Montgomery *152*
Studio: New York City
Judy Moonelis *140*
Studio: New York City
Emily Myers *77*
Studio: London, England
Ron Nagle *141*
Teaching: Mills College
Studio: Oakland, California
Charles Nalle *53*
Studio: Melbourne, Florida
Grete Nash *127*
Studio: Kristiansand, Norway
Richard Notkin *16, 50*
Studio: Helena, Montana
Jeanne Otis *167*
Teaching: Arizona State University
Studio: Tempe, Arizona
Nori Pao *159*
Studio: Tempe, Arizona
Dennis Parks *42*
Studio: Tuscarora, Nevada
Bill Parry *161*
Retired, New York State College of
Ceramics, Alfred University
Studio: Alfred Station, New York
Richard Peeler *22*
Studio: Reelsville, Indiana
Rina Peleg *11, 39*
Studio: New York City
Jan Peterson *34, 44*
Studio: Carefree, Arizona
Susan Peterson *43, 55, 60, 67, 92,
116, 121*
Retired, Hunter College, City
University of New York
Studio: Carefree, Arizona
Taäg Peterson *57*
Studio: Arlee, Montana
E. Jane Pleak *151*
Teaching: Georgia Southern
University
Studio: Statesboro, Georgia
Arthur Pogran *35*
Studio: New York City
Faith Banks Porter *106*
Studio: Pacific Palisades, California
Sally Bowen Prange *104*
Studio: Chapel Hill, North Carolina
Ken Price *13, 14*
Teaching: University of Southern
California
Studio: Venice, California
Liz Quackenbush *99*
Teaching: Penn State University
Studio: Pleasant Gap, Pennsylvania
Juan Quezada *141*
Studio: Mata Ortiz, Casas Grande,
Mexico
Elsa Rady *26, 68, 139*
Studio: Venice, California
Brian Ransom *9*
Studio: St. Petersburg, Florida
Lisa Reinertson *145*
Studio: Davis, California
Don Reitz *128, 132*

Retired, University of Wisconsin
Studio: Clarkdale, Arizona
Sally Resnik *108*
Teaching: Moorehead State
University, Minnesota
Studio: Moorehead, Minnesota
Paula Rice *125, 156*
Teaching: Northern Arizona State
University
Studio: Flagstaff, Arizona
Tom Rippon *152*
Teaching: University of Montana
Studio: Missoula, Montana
Annabeth Rosen *21*
Teaching: University of California at
Davis
Studio: Davis, California
Betsy Rosenmiller *51*
Studio: Tempe, Arizona
Carol Rossman *21*
Studio: Dundas, Canada
Fritz Rossmann *115*
Studio: Hohr-Grenzhausen,
Germany
Jerry Rothman *14, 32, 33*
Retired, California State University
at Fullerton
Studio: Laguna Beach, California
Anthony Rubino *167*
Teaching: New York City Public
Schools
Studio: Jamaica, New York
Judith Salomon *42*
Teaching: Cleveland Institute of Art
Studio: Cleveland, Ohio
Maurice Savoie *142*
Studio: Quebec, Canada
Adrian Saxe *103*
Teaching: University of California at
Los Angeles
Studio: Los Angeles, California
Edwin and Mary Schirer *85*
Retired, University of New
Hampshire
Studio: Green Valley, Arizona
Jeff Schlanger *146*
Studio: New Rochelle, New York
Imre Schrammel *151*
Studio: Budapest, Hungary
Lilo Schrammel *35, 88*
Studio: Vienna, Austria
Nancy Selvin *105*
Teaching: Laney College
Studio: Berkeley, California
Vaslav Serak *163*
Studio: Prague, Czech Republic
Sandra Shannonhouse *39*
Studio: Benecia, California
Richard Shaw *155*
Teaching: University of California,
Berkeley
Studio: Fairfax, California
Tzaro Shimaoka *90*
Studio: Mashiko, Japan
James Shrosbree *143*
Teaching: Maharishi University,
Fairfield
Studio: Fairfield, Iowa
Sandy Simon *79*

Studio: Berkeley, California
Kripal Singh *10, 18*
Studio: Jaipur, India
Helen Slater *100*
Studio: Corralitos, California
Richard Slee *149*
Studio: Brighton, England
David Smith *143*
Studio: Stoughton, Wisconsin
Deborah Smith *77*
Studio: Pondicherry, South India
Gay Smith *76*
Studio: Bakersville, North Carolina
Nan Smith *148*
Teaching: University of Florida at
Gainsville
Studio: Gainsville, Florida
Richard Zane Smith *90*
Studio: Glorietta, New Mexico
Paul Soldner *14, 126*
Retired, Scripps College, Claremont
Studio: Aspen, Colorado
Linda Speranza *66*
Teaching: Mesa Community
College
Studio: Mesa, Arizona
Robert Sperry *5*
Retired, University of Washington
Studio: Seattle, Washington
Victor Spinski *49*
Teaching: University of Delaware
Studio: Newark, Delaware
Chris Staley *76*
Teaching: Penn State University
Studio: State College, Pennsylvania
John Stephenson *158*
Teaching: University of Michigan
Studio: Ann Arbor, Michigan
Susanne Stephenson *88*
Teaching: Eastern Michigan
University
Studio: Ann Arbor, Michigan
Bill Stewart *152*
Studio: Hamlin, New York
Tom Supensky *143*
Teaching: Towson State University
Studio: Baltimore, Maryland
Øyvind Suul *155*
Studio: Oslo, Norway
Goro Suzuki *133*
Studio: Aichi, Japan
Toshiko Takaezu *22, 59*
Retired, Princeton University
Studio: Quakertown, New Jersey
Akio Takamori *146*
Teaching: University of Washington,
Seattle
Studio: Seattle, Washington
Joan Takayama-Ogawa *103*
Studio: Pasadena, California
Sandra Taylor *100*
Studio: Buccarumbi, NSW, Australia
Sue Taylor *79*
Teaching: Firehouse Ceramics
Studio: Norman, Oklahoma
Neil Tetkowski *57*
Studio: New York City
Jack Thompson *142*
Teaching: Moore College of Art

INFORMATION SOURCES

Most countries have a Craft Council or similar organization; some have a museum or gallery associated with the organization, such as the American Craft Council and the American Craft Museum in New York City, USA, and the British Crafts Council and the Crafts Council Gallery in Pentonville Road, London. Also in London is the Craft Potters' Association and its shop and gallery in Marshall Street. Generally these craft organizations provide resource materials such as slides, movies, videos, and publications.

The International Ceramic Society headquarters are in Geneva, Switzerland, at the Ariana Museum.

There are a number of ceramic residency opportunities in the world where clay artists can be invited and subsidized to work for short periods, or where less well-known or beginning clayworkers can pay to work. A few of the most important are:
The Clay Studio, Philadelphia, Pennsylvania, the Bemis Foundation, Omaha, Nebraska, the Joe L. Evins Center for Appalachian Craft, Smithville, Tennessee, in USA; Netherlands Ceramic Center, Den Bosch, the Netherlands; the Ceramic Center, Shigaraki, Japan.

Suppliers of ceramic materials and companies that manufacture ceramic equipment are fixtures in most countries. Their catalogs and data books give necessary information about their products. Clay mines, frit and stain manufacturers provide important technical brochures. Finally, commercially prepared clay bodies, under- and overglaze pigments, and ready-to-use glazes, as well as helpful information bulletins, are supplied universally by these corporations.

Ceramics magazines around the world include:

AUSTRALIA
Ceramics: Art and Perception
and *Ceramics Technical*
35 William Street
Paddington, Sydney, NSW 2021

Crafts Art Magazine
P.O. Box 363
Neutral Bay Junction, NSW 2089

Pottery in Australia
2/68 Alexander Street
Crow's Nest, NSW 2065

CANADA
Contact
429–12th Street NW
Calgary, Alberta T2N 1Y9

FRANCE
L'Atelier, Société Nouvelle des Editions Créativité
41 rue Barrault
75013 Paris

La Céramique Moderne
22 rue Le Brun
75013 Paris

La Revue de la Céramique et du Verre
61 rue Marconi
62880 Vendin-le-Vieil

GERMANY
Keramik Magazin
(editorial) Bensheimer Strasse 4a
D-64653 Lorsch
(distribution) Verlagsgesellschaft
Ritterbach mbH
Rudolf-Diesel-Strasse 5-7
D-50226 Frechen

Neue Keramik
Unter den Eichen 90
D-1000 Berlin 45

GREECE
Keramiki Techni
P.O. Box 80653
185 10 Piraeus

ITALY
Ceramica Italiana Nell'Edilizia
Via Firenze 276
48018 Faenza

NETHERLANDS
Foundation COSA
P.O. Box 2413
3000 CK Rotterdam

Kerameik
Kintgenskuun 3
3512 GX Utrecht

SPAIN
Bulleti Informatiu de Ceramica
Sant Honorat 7
Barcelona 08002

Ceramica
Paseo de las Acacias 9
Madrid 5

TAIWAN
Ceramic Art
P.O. Box 47-74
Taipei

UK
Ceramic Review
21 Carnaby Street
London W1V 1PH

USA
American Ceramics
9 East 45 Street
New York, NY 10017-2403

American Ceramic Society Journal
757 Brooksedge Plaza Drive
Westerville, OH 43081-6136

American Craft Magazine
Spring Street
New York

Ceramic Industry
5900 Harper Road, Suite 109
Solon, OH 44139

Ceramics Monthly
P.O. Box 4548, 1609 Northwest Boulevard
Columbus, OH 43212

Clay Times
P.O. Box 365
Waterford, VA 20197–0365

Studio Potter
P.O. Box 65
Goffstown, NH 03045

INDEX

BIBLIOGRAPHY

Public libraries, museum libraries, university and college libraries are filled with books on ceramic art, history and technology. Please make yourself aware of these great repositories at some point in your study. New treatises are continuously being added to the long list of in and out of print ceramic books – visit your local book stores often.

The following books will serve as a basic introduction to the general subject. I have tried to recommend only books that are currently in print; libraries will give you access to previously well known volumes.

Books of general interest:

American Ceramics, The Collection of the Everson Museum, Barbara Perry, Rizzoli, New York, 1989

Art Deco and Modernist Ceramics, Karen McCready, Thames and Hudson, London, 1995

Ceramics of the World, ed. Lorenzo Camusso and Sandra Bortone, Harry N. Abrams, New York, 1992

Chinese Pottery and Porcelain, S. J. Vainker, British Museum Press, London, 1991

The Craft and Art of Clay, Susan Peterson, Prentice Hall, New Jersey; Overlook Press, New York; Laurence King, London, second edition 1995

The History of American Ceramics, Elaine Levin, Harry N. Abrams, New York, 1988

A History of World Pottery, Emmanuel Cooper, Chilton, Radnor, third edition 1988

Illustrated Dictionary of Practical Pottery, Robert Fournier, A & C Black, London, revised edition 1992

Iznik, The Pottery of Ottoman Turkey, Nurhan Atasoy and Julian Raby, Laurence King, London, 1994

Pioneer Pottery, Michael Cardew, revised edition Oxford University Press, New York, 1989

The Potter's Art, A Complete History of Pottery in Britain, Garth Clark, Phaidon, London, 1995

Pottery by American Indian Women, Susan Peterson, Abbeville Press, New York, 1997

Smashing Pots, Works of Clay from Africa, Nigel Barley, Smithsonian Institution Press, Washington D.C. 1994

Turners and Burners, The Folk Potters of North Carolina, Charles Zug, University of North Carolina Press, Raleigh-Durham, 1986

The Unknown Craftsman, Yanagi Soestsu, Kodansha International, New York, revised edition 1986

Monographs

The Art of Peter Voulkos, Rose Slivka, Karen Tsujimoto, Kodansha International, New York, 1995

Bernard Leach, Hamada, and Their Circle, Tony Birks and Cornelia Wingfield, Phaidon, London, 1990

David Gilhooly, Kenneth Baker, John Natsoulas Press, Davis, CA, 1992

Hans Coper, Tony Birks, Icon Editions, Harper & Row, 1983

Howard Kottler, Patricia Failing, University of Washington Press, Seattle, 1995

I Shock Myself, Beatrice Wood, Chronicle Books, San Francisco, 1988

The Living Tradition of Maria Martinez, Susan Peterson, Kodansha International, New York, revised edition 1996

Lucie Rie, Tony Birks, Chilton, Radnor, 1989

Lucy M. Lewis, American Indian Potter, Susan Peterson, Kodansha International, New York, 1984

The Mad Potter of Biloxi: The Art and Life of George Ohr, Garth Clark, Abbeville Press, New York, 1989

Maija Grotell, Jeff Schlanger and Toshiko Takaezu, Washington Press, Seattle, 1995

Picasso's Ceramics, Georges Ramie, Viking, New York, 1976

Shoji Hamada, A Potter's Way and Work, Susan Peterson, revised edition, Weatherhill Press, New York, 1996

Warren MacKenzie, David Lewis, Kodansha International, New York, 1991

Technical Books

Ceramic Glazes, C. W. Parmelee, C. G. Harmon, Cahners Books, Boston, second edition 1973

Ceramic Masterpieces, Art, Structure, Technology, W. David Kingery, Pamela B. Vandiver, The Free Press/Macmillan Inc., New York, 1986

Ceramic Science for The Potter, W. G. Lawrence, Chilton, Radnor, second edition 1982

Clay and Glazes, Daniel Rhodes, Chilton, Radnor, revised edition 1995

Glazes and Glazing Techniques, Greg Daly, Kangaroos Press, Australia, 1996

Hands in Clay, Charlotte Speright, Mayfield Press, CA, revised edition 1995

The Kiln Book, Fred Olsen, Chilton, Radnor, revised edition 1998

Luster-ware, Alan Cager-Smith, Faber and Faber, London, 1985

Mold Making for Ceramics, Donald Frith, Chilton, Radnor, 1985

Out of the Earth into the Fire, Mimi Obstler, The American Ceramic Society, Westerville, Ohio, 1996

A Potter's Dictionary of Materials and Techniques, Frank and Janet Hamer, Pittman/Watson-Guptill, revised edition 1986; A & C Black, London, 1990

Raku, A Practical Approach, Steve Braunfman, Chilton, Radnor, 1991

Smoke Fired Pottery, Jane Perryman, A & C Black, London, 1995

Stoneware and Porcelain, Daniel Rhodes, Chilton, Radnor, revised edition, 1975

PHOTO CREDITS

A considerable number of the photographs in this book were taken by the author. Among other photographers, to whom the author and publishers would like to express their sincere thanks, are:

Vanessa Adams, Anders Bergersen, R. de la Cruz, Anthony Cunha, Susan Einstein, Takashi Hatakeyama, Paula Jansen, Kelley Kirkpatrick, Vineet Kracker, Peter Lee, Mahatta, Gail Reynolds Matzler, Lee Milne, Hiromu Narita, Steven Ogawa, Brian Oglesbee, Rick Paulson, Renwick/Smithsonian, Hugh Sainsbury, Joshua Schreier, Bill Scott, Mike Short, Bernd Sinterhauf (Berlin), Craig Smith (who took the process photographs), Gakuji Tanaka, John Tsantes, Olga L. Valle, Malcolm Varon, Paul Warchol.

Galleries and other institutions which kindly supplied photographs are listed below:

Garth Clark, New York City, NY; Charles Cowles, New York City, NY; Habitat, Minneapolis, MN; Hand and Spirit, Scottsdale, AZ; Paul Klein, Chicago, IL; LA Louver, Los Angeles, CA; Leedy-Voulkos, Kansas City, MO; Frank Lloyd, Los Angeles, CA; Nancy Margolis, New York City, NY; John Natsoulas, Davis, CA; Netherlands Ceramic Institute; Perimeter, Chicago, IL; Schopplein Studio; Shigaraki Ceramic Cultural Park, Japan. Special thanks are due to Cyril Frankel at Bonhams, London.

Centerville Library
Washington-Centerville Public Library
Centerville, Ohio

DISCARD